Praise for *Like a Drop of Ink in a Downpour*

"*Like a Drop of Ink in a Downpour* is more ambitious than the average memoir. It's informed by Galina's and her parents' lessons on the value of art and culture and enriched by Alëna's beautifully constructed images and Galina's poetry. Yet their tale always feels honest both in its broad strokes and finer details."

—Herb Randall, *The Los Angeles Review of Books*

"*Like a Drop of Ink* pulls readers into the raw realities faced by Jews who tried to emigrate from Soviet Russia. While focused on Leningrad in the 1970s and '80s, the account has new relevance today. The precise details, recalled from the separate viewpoints of a young daughter and her mother, are shocking but all too familiar for many. Reactions to the loss of their home, false imprisonment, anger, and stubborn ambition to survive are expressed with harsh and often poetic honesty. The profound influence of their father and grandfather, artist Felix Lembersky, his belief that art and integrity are crucial, is a constant and sustaining theme of their chronicle of life in limbo."

—Alison Hilton, Wright Family Professor of Art History, Emerita, Georgetown University, author of *Russian Folk Art*

"This is a profoundly powerful and poignant memoir, both significant and stunning. It combines an incomparable and sweeping overview—of a time and place of great horror and sometimes hope that remain completely unknown to those who did not live it—with an artist's eye for intimate detail and a poet's ear for metaphor and simile."

—Ori Z. Soltes, Teaching Professor of Jewish Civilization, Georgetown University

"A gripping memoir about outwaiting political injustice, outwaiting political anti-Semitism, and about the nonnegotiable price of winning. A miracle—accomplished in great measure by the understated love and loyalty, beautifully crafted and presented, between mother and daughter."

—Rabbi Joseph Polak, author of *After the Holocaust the Bells Still Ring*

"Unsparing, with devastating clarity, this extraordinary mother-daughter memoir is like a drop of ink that seeps into every crevice of Soviet life in the 1970s and 1980s. It captures the fierce devotion of three generations of women to each other, their commitment to preserve Felix Lembersky's art (including his rare Babi Yar paintings), and resilience through brutal imprisonment, painful family separations, and challenging obstacles to immigrate to the United States as Russian Jews. The honest, lyrical coming-of-age narrative intersects with the unflinching candor of a Soviet mother's perspective, which together form an unforgettable story of heartbreaking truths and tender memories."

— ChaeRan Freeze, Frances and Max Elkon Chair in Modern Jewish History, Near Eastern and Judaic Studies, Brandeis University

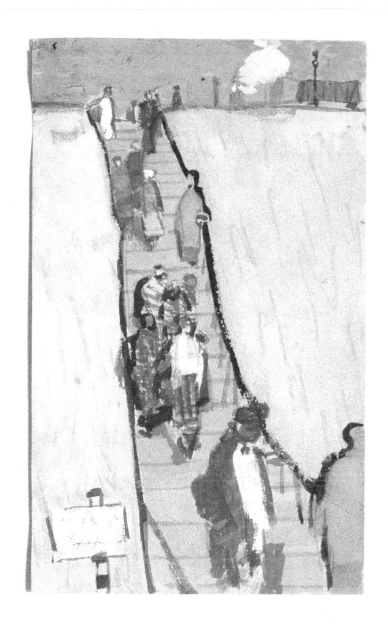

Like a Drop of Ink

in a

Memories of Soviet Russia

Downpour

Yelena Lembersky
Galina Lembersky

Cherry Orchard Books
Boston 2022

Also by Yelena Lembersky

Felix Lembersky: Paintings and Drawings

Contents

Note on Names

Following are the names of the coauthors and their immediate family. Yelena and Galina Lembersky's names are followed by the nicknames or the diminutives by which they were known in Russia. All other people in the account—friends, neighbors, coworkers, or prison inmates—are real, but some names have been changed.

Alëna (pronounced Ale-yóna), aka **Alënushka, Alënka, Alëshenka, Yelena Lembersky**: daughter of Galia and narrator of Parts One and Three

Galia, Galka, Galina Lembersky: mother of Alëna, daughter of Felix and Lucia Lembersky, and narrator of Part Two

Felix Lembersky (1913–1970): grandfather of Alëna, father of Galia, husband of Lucia. A prominent artist born in Lublin, Poland, raised in Berdichev, Ukraine, educated at Kultur-Lige and the Art Institute in Kiev, and the Academy of Art in Leningrad

Lucia, Lucy, Lucinka Lembersky (1915–1994): wife of Felix Lembersky, mother of Galia, and grandmother of Alëna

Mikhail Ksendzovsky: uncle of Lucia Lembersky. Singer, actor, and director of the Theater of Musical Comedy and the Summer Theater at Sad Otdikha in Petrograd-Leningrad in the 1910s and '20s

In the Woods

A KNOCK ON THE DOOR, a muffled, tentative thud. Not Mama's.

All that morning, September 15, 1981, I had walked holding my thumbs folded into my fists—a Russian superstition: hold your thumbs and think of someone to bring them good luck. Mama does it for me when I have a test at school or go onstage to read her favorite poem: "Comrade Lenin, I report to you—not a dictate of office, the heart's prompting alone." Vladimir Mayakovsky. The Soviet avant-garde. She taught me to recite it with feeling, raising my voice at "The quotas for coal and for iron fulfill" and then lowering it for "But there is any amount of bleeding, muck and rubbish around us still."

She did not let me come with her to the trial. "You don't need to see this circus."

Some had advised her to "take the child—for leniency and the compassion of the jury."

"Like hell they will have compassion," she said.

I watched from my window as she walked down the muddy footpath, stepping on islands of broken concrete. She went toward the Leninsky Avenue metro station and did not detour to Schastlivaya (Lucky) Street, even though I asked

her to. That's too bad, I thought. She turned around to face me and kept walking backward. "Good luck! Good luck!" I yelled out so she could hear me. And then, quietly, so that luck would fly to her like a swarm of bees, I waved to her hard, so I would feel pain in my wrists. Just in case.

I would recognize Mama's footsteps—*rap-a-tap* with the echoing off the stairway, the loud smooch of her plum handbag against the door, her keys giggling inside it, playing hide-and-seek with her hands. The door would swing open and she would sail in on a blustering wind with plans and ideas, new assignments for me and a review of everything I had done in her absence.

This knock is not hers. I open the door. It's Zhenia. One of Mama's many work friends. Zhenia stands on our landing, thumbing her wrinkly purse, crossing and uncrossing her feet in short booties trimmed with a thin strip of fur. She can tip over standing like that, I think. Zhenia, once a schoolteacher, now a hairdresser. Standing before me, she is rustling in her mind through pages of textbooks on preteen psychology, readying for a difficult heart-to-heart conversation.

I cut her off. "Should I get my things?"

On our way to Zhenia's home, she keeps looking at me sideways, waiting to see my eyes turn swollen and red. They won't. Not when we go down into the pit of the metro station with the stench of burned rubber. Not when we stand at the platform strewn with dirt and sawdust that a janitor mops up around our feet. Not when a train jolts and thrashes and we grip the handrails and the coats of passengers to stay upright. Not after we eat a dinner of hot dogs and mashed potatoes, and Zhenia makes up my bed, moving her son to a folding aluminum cot. She tells him, "Alëna's mother has

gone away. Alëna will stay with us until she comes back."
I am not glad for her hospitality. It is not her fault.

Zhenia tells me that school representatives will come to her
home to inspect my new accommodations. She lowers her
voice. "It is very important. They will decide if you can stay
with us or be shipped off to an orphanage."

I imagine an orphanage—a house of dark-red brick,
where children with blue veins on their temples look out the
windows and wave to passersby. I feel a sudden affinity for
them. I picture living among those children, all of us without
parents, bonded by our misfortune.

Zhenia keeps talking: "A children's asylum is worse than
prison. Have you ever read Dickens?"

My homeroom teacher comes the next day. She is
young and new in my school. Zhenia looks deeply into her
eyes, with gravity and understanding, teacher to teacher. My
young teacher looks down at her feet. "Please excuse me.
I have to see where Alëna will live."

She too does not want a heart-to-heart conversation.

Zhenia slides down the corridor. "Here's our living room
and the library. We have the multivolume set of the children's
encyclopedia. And the classics—Jules Verne, James Fenimore
Cooper, Thomas Mayne Reid, Harriet Beecher Stowe."

"Hm, hm." My teacher nods and tiptoes behind her.

Zhenia shows her son's bedroom, his bed where I will
sleep and his desk where I will do my homework. She offers
my teacher tea.

"No, no, no! Please don't worry, I have seen what I need."

She and my school principal, Rimma Pavlovna, make

the pond. It's a barren tree with thick, twisted branches that look like a ribcage or a spiral stair for me to climb up. No one else here besides me and my tree. I sit on its bough, hang my backpack on its snag, and take out a notebook. I am going to write a letter to Mama. On a drizzly day, the paper soaks up the rain and the ink blurs on the swollen pages. It's all right.

Butterflies seem careless when they flutter from place to place. But they are vigilant. When I think one is about to land and I can just hop over to it with my net and catch it, the butterfly will suddenly lift off and fly away in a broken zigzag. Dragonflies are the other way around. They seem invincible, flying in their long brazen arcs. But in fact they are vulnerable. When they land, I can get very close without scaring them off. The eyes of the dragonfly look like aviator sunglasses. Its translucent wings with turquoise capillary mesh iridesce in the sun. At the beginning of the summer, there are only small dragonflies. The giants come along later. Slávka used to call them broilers or cannibals, because they are predators. Once, I remember, he yelled to me, "Come over, I want to *show* you something!"

He stood in tall weeds, holding two dragonflies by their wings, one in each hand, a giant and a miniature. When I stood next to him, he moved his hands closer . . . closer . . . closer . . . until the heads of the two dragonflies touched. The giant opened its jaw and bit into the other. There was a soft crunch. A gap. Small black poppy seeds rolled out of the eye of the smaller one. The tip of its tail twitched and curled in. Slávka kept turning it for the cannibal to bite and chew, bite and chew. Its jaws worked rhythmically, like moving gears. I stood, mesmerized, then I woke up. "Stop it, Slávka! Let them go!" He opened his hands. The giant took off in a brash,

swift wide arc. The little one, now a piece of litter, fell down into the grass.

Slávka said, "That's how nature does it. The strong prey on the weak."

I look at the pond. On a quiet day it is smooth and silver, with blue blotches of reflected sky. On a cold day, the fog hovers over it. When it's windy, the pond ruffles and looks worried. When it's drizzly, its surface looks like goose-bumps or cellulite. Throw a stone into it, it will chuckle and pucker, then throw hoops right back at me. How are things, Pond?

My pond is quiet and still but not silent. It listens to me and talks in whispers. It lets me forget the unimportant things. In quietude, I meet what has been lost. My memories awaken. The world swells up like a tent city on a cloud. And there is my mama, and we are together.

From the Beginning

"WHAT WAS IT LIKE to live in Russia?" people will ask me years later when I move to America.

RRRu-usha . . . Ruuu—sh-sh-sha . . . Who came up with that silly name? How did the graceful name *Rossíia* turn into the infantile toy-word *Russia*?

Memories flutter like spooked chickadees. Like a view from an airplane window at liftoff, they become smaller and farther away each day, letting go of details, turning into caricatures, then a blotch, then a dot. I try to pick something out. Here is a bright aspen tree on an autumn day, which turned color, with islands of leaves that we gathered to weave a "carpet." Here is an anthill. From a distance it looks dead, like a solid black lump. But come closer, it is teeming with life—little ants dragging pine needles and bugs in and out of its burrows, then back in a file to forage in the forest. Go ahead and tear off a twig, peel its bark with a pocketknife, and lay it down on the anthill. Then pick it up and shake off the ants. The twig will taste like a lemon lollipop.

Here is Slávka's green turtle with a dry, crimped neck, flipped over in my hand, head down, legs flailing. And now Slávka's Siamese cat Zimphira, the color of exhaust fumes, hazy yellow eyes with pupils shaped like exclamation marks.

I am on an overnight train, Leningrad to Odessa. The wheels glib-glob underfoot. Trees and electric posts melt into a *crêpe de chine*. The small four-person sleeping compartment smells of rubber, Swiss cheese, black rye bread wrapped in old newspaper, and sweat. It is hot on the train. A middle-aged man, a stranger, has taken off his shirt. He has a tattoo of the word *Mama* on his shoulder, which he got in the army—compulsory draft at eighteen.

I remember our old landlady at the summer dacha. Her son was in the army, near the end of his tour. She liked to muse about the day he would return. She said, "I will stand waiting for him by the gate, heat or rain, I will stand there all day, but he better come to me first! Not his girlfriend. Och, that hussy . . . If he comes to me with her on his arm, I will banish them both."

In Cambridge, Massachusetts, where years later I would make my new home, there are three residential towers, three brick blocks with pinhole windows.

"The projects," my new American friend says in a hushed voice, "are ugly. Do you understand *u g l y*?"

"They are not. They are . . . life," I protest.

"But what kind of life?" he asks. "No life! Drugs and crime. A bad life. They look like a prison."

He tells me that people need to live in houses, with a lawn and a garden, so you can plant flowers.

I tell him, "I grew up in such a building in Leningrad and there was life."

I have no English words. I want to explain that my home had nine stories and it was made of white brick. It had many flats

omens, but Galia, my twenty-five-year-old mama, did not give it much thought. From the maternity ward she brought home a tightly swaddled baby girl, me, whom she delivered after two days of labor without painkillers and with no family by her side. She called me Alëna, Alënka, Alënushka, or anything but my formal name, Yelena, which she did not like. My father, whom she called "your *pápochka,*" chose it for me.

Mama was married. The evidence of her marriage was tucked away on the back page of her photo album—she lovely in a knee-length white dress, loose at the waist, carrying a bouquet of carnations, and he, a stumpy and unremarkable man in a gray suit, a step behind her, by the door to the House of Marriage Certificates. Your pápochka, Mama always said, or, with irony, *muzh ob'elsya grush,* husband-dear-ate-a-pear.

Pápochka did not live with us. He traveled for work and came to us for brief snatches. He still kept a room of his own, just in case. This suited Mama just fine. If I were to ask her why she married, she would have said, "I didn't know any better." My grandmother Lucia would have said, "Such were the rules." And what would Pápochka say? I don't know. Perhaps he hoped for a happy family. Lares and Penates. Self-delusion on the part of all.

Mama has long days of chores ahead. She busies herself in the rhythms of her new life—in the mornings, she rinses out cloth diapers in cold water, boils them in a pot on the stove, and hangs them on a line stretched across the main space of the studio, with newspapers and aluminum pails on the wooden floor to collect the drips. She irons and folds the laundry, nurses me, and tucks me into my crib. When I am fast asleep, she glides through icy winter streets to the farmers' market to buy us milk and cottage cheese.

To get back to the studio, Mama has to walk through a dark gateway and untended backyard, hidden from the street, with the feel of an Edgar Allan Poe setting. From there, a rickety back stairway, narrow and steep, leads up to the sixth-floor landing and our entryway. Inside the studio, there is a wall of glass facing north, which makes this former storage space suitable for an artist. When I am old enough to sit up in my crib, I look out the window. The view is not much. Flat black tar roofs and charred brick chimneys, smoke, rain, snow, and an endless Leningrad sky with crinkled gray clouds. But when I turn my head inward toward the studio, suddenly everything is ablaze. Yellow, crimson, indigo, and periwinkle, painted with Japanese oils with Italian names, which many years later I will learn. Cadmium yellow. Ocher. Cobalt. Umber. Sienna. In Grandfather's paintings, the roofs are emerald-green or red, the houses orange, and the fields flushed like my mama's cheeks when she comes in from the frost. Garden fences turn into creatures and people into clouds. Grandfather's imagination lay down the substrate of my subconscious.

I do not remember him. We met at the brief intersection of our lives—before I developed the ability to retain memories and after he had begun to let his go.

"Wondrous," Grandfather says when Mama brings me to her parents' room, where he is bedridden. "Wondrous," he repeats, looking either at me or into the maw that is waiting, ready to take him in.

He lived through the Russian Revolution, two world wars, the Siege, the murder of his parents by the Nazis. Now he is coming to the end of his allotted time. Lucia takes care of him, refusing to put him in an institution. She says that

those places hasten death, no one of hers will go there. She looks after him as he reverts to infancy. No disease is worse than losing one's memory, she says. She lets us know that she wants to die of a heart attack in her sleep. Lie down at night and not wake up. Done. No doctors, no pain, no hassle for anyone.

But years later, I think it's not so black-and-white. Grandfather was letting go slowly. As the disease progressed, the past dissolved and the future was nothing. Only the efflorescent "now," the fleeting, enigmatic present moment, was real. And when that moment was fine, perhaps, nothing else mattered. No regrets. No reservations. Only a melting succession of good moments. He gradually left behind the burden of memory, the guilt of his survival, the pain of losing those who had been the fabric of his life. Becoming physically infirm, he lost awareness of his powerlessness. He no longer felt the urgency to repair what he could not, to bear witness to events no one dared to speak of in the open. At the beginning of his illness, he told his wife, "I have to race against time to put everything down on canvas." Now the time was up, and it had no meaning. He said to Lucia again and again, "I love you," and he recognized her long after he stopped remembering anyone else. Maybe, during those times with her, he was content.

Grandfather dies soon after my first birthday. But several months before that happens, the Leningrad Union of Artists reassigns his state-owned studio to another artist. Mama and I, and several hundred of his paintings, are about to be evicted. We are on a waiting list for new state housing (all housing is state-owned) but it would not be available for several years. We are about to become homeless.

Pressed by our desperate circumstances, my grand-mother Lucia does what seemed inconceivable for her—she goes to the meeting at the Artists' Union, gets to the podium, and raises her voice. She reminds the distinguished audience that she and her husband have served the arts community without ever asking for favors. That new living spaces are assigned to the privileged while her dying husband's lifework is thrown onto the street. That she has earned the right to basic dignity. Shame on them that she must stand there and beg. She lifts a glass carafe resting on the podium and puts it down with force. The carafe cracks. Everyone is stunned. Sweet Lucinka they have known for decades! Perhaps the respected art officials remember that long ago, when they were students, she was a personal assistant to the director Isaak Brodsky at the Academy of Art. Back then, it was they who came to her asking for favors. And during the war, she oversaw the evacuation of the Academy from besieged Leningrad.

One way or another, Lucia receives not a one- but a two-bedroom apartment on the outskirts of Leningrad. A state-owned apartment under the authority of the Artists' Union. Mama and Lucia decide that the four of us should move in together. They swap this apartment and the room on Marat Street, where Mama grew up, for a three-bedroom flat in a new high-rise in a newly built part of the city.

Mnogo-etázhka in *novostroiki*, the newly built neighbor-hood of the 1970s. Our private flat with morning sun, on the second floor, low enough for me to see birds in the shrubs from the balcony. In a building dressed in white brick. On a cool, sunny day, the brick is warmer than the air. Press your face against its silky, balmy, glazed surface, and your cheek

My friend Slávka finds rusted bullets in the woods near our home. "Watch out," he warns me. "They may still explode."

On Victory Day the streets are in full bloom with bouquets of flags, mounted on lampposts and building corners, pink as sunset, blue as poetry, red as the spilled blood. The week before, workmen drive around the neighborhood in a dusty pickup truck carrying heaps of flags and rolls of red banners with the slogans "Peace to the world" and "Lenin's bequest is immortal." Neighbors bring fresh flowers to the Leónya Gólikov memorial—carnations bought at a store and forget-me-nots picked from a field. Old men put their medals on their worn jackets and don their garrison caps, flight caps, and sailors' berets, oiled and frayed by time. In the veterans' parade they walk down the street slowly, in an uneven column, eyes damp. From the edges of the sidewalk we children salute them.

Scratchy wartime songs play on a loudspeaker, like "In a Dugout, Soldier Walked On, Boys of Leningrad":

> *During grim wartime years ago*
> *As artillery thundered,*
> *Men and boys stood up*
> *To defend our city, our Leningrad.*

My Leningrad! I imagine Slávka and me lining up with those battalions in those dugouts. I want to rush into battle to avenge Leónya. And Grandma's younger brother Lévushka, whom I never met. In our tiny photo, he is still a toddler with chubby cheeks.

Grandma has medals for taking part in the Siege. She tells me that during the Nazi air raids she took her turn standing watch on the roof the Academy of Art where she

was stationed. When the roof caught fire, she threw sand on it from a bucket. The Academy building stood on the banks of the Neva, where the river was wide, with nothing to break shock waves. To keep its windows from shattering, people glued strips of paper crisscross onto the glass. I imagine those tall windows, each of their panes with its paper *X*, like a game of tic-tac-toe but without the *O*s. Every winter, when Grandma and I boil wheat glue to paste strips of paper along our window frames to insulate them from cold drafts, I imagine her during the Siege.

More than thirty years have passed since the war, but it still persists in our neighborhood. There are few men over fifty, and old ladies pamper them. When our old neighbor comes downstairs to sit on a bench by our front door, women sweep back locks of their gray hair and stop gossiping. "What a sweet-scented day, Ivan Ivanovich, just marvelous!" Ivan Ivanovich nods with dignity; he knows he is both rare and revered.

Most old men are veterans; many were wounded or disfigured. "Do not stare," Grandma tells me when I catch sight of the amputee who lives across the street. He has short stumps instead of legs and gets around on a low, flat skateboard, which he fashioned out of plywood and tiny wheels he took off a children's scooter. On his skateboard, he is shorter than me. He sits on it and pushes himself along with two wooden blocks. When I see him I get a knot in my stomach—the feeling that something bad will happen that day.

There is also another kind of old man in our neighborhood. In the evening I see one of them sleeping on the

bench, knees to his chest like a baby. Just before lying down, he pees onto a tree and vomits yellow puddles onto the footpath. "Don't look there," Grandma says and takes me by the hand to cross the street.

In America, there is a term for his condition—PTSD, post-traumatic stress disorder. But in Russia back in the '70s, we knew them simply as alcoholics. Boozers. Untouchables. They sit in the back of our common yard, behind a poplar tree and a dumpster. There they have a table and seats made of crudely sawn planks that give you splinters if you are not careful. Their sleeveless undershirts are rarely washed. They have tattoos and gray stubble. A van delivers a cistern of beer to our common yard and they all line up. Then back to their seat to play dominoes—the loser buys the next round. The table is sticky and damp, with a sour smell. They drink from aluminum mugs, smoke cheap tobacco rolled in newspaper, and cough up phlegm. Grandma does not let me go there, because the ground is covered with spit and broken glass. The spit is multicolored: white-and-yellow from the flu; gray-and-green from smoking; gray-and-black with a smudge of red from tuberculosis. The spit coalesces with the tobacco ash. Smoke and profanities hang in the air. The men's eyes are pink, the napes of their necks maroon, with black dirt trapped in their wrinkles. After the game, they stagger off. They have no women, despite the shortage of men. Grandmothers stay away.

The Russian language is rich with drinking nomenclature: to hit the bottle, go sippin', get plastered, sloshed, sozzled, booze, or *zu trinken* (from Yiddish). To come under "a degree," "in merriment" (*na veselé*), to be on "hops," or under "a fly." You can also say it without a word: snap your

finger on the side of the neck. The drunks drink anything they can find. Beer is for beginners or a morning pick-me-up. Cognac is for tipplers with education. Vodka is for the entrenched boozers. And the very hopeless, at the end of his line, will drink grain alcohol used as a disinfectant or cheap cologne sold in a drugstore. They drink in groups. You should never turn down their invitation to share a drink—it's a sin. A man needs his drink and he needs company, because as everyone knows, only alcoholics drink alone. Good men drink in company. So join in—to save a man from the abyss. Raise a toast. For health! For prosperity! For happiness! For good luck! Never say, "I've had enough." To refuse is to jinx the good life.

When they start drinking, they become merry. When they drink hard, they brood or weep. Then they can't find their way home. They lie down on subway seats or garden benches. Police pick them up and take them to a *vitrezvitel*, a drunk tank. They walk holding walls, like toddlers, wibble wobble. Why is the street a crumpled cotton ball—who let it be that way?

Women don't drink nor do they ask you to drink. They will make you eat sweets. At first, you should say no, but don't refuse too long. They will persist until the end of time. When we first moved in, our women neighbors brought us cups of sugar, "for a sweet life in your new home." Now they knock on our door to ask for something. The neighbor from the flat to the left comes to ask Grandma for two eggs—she is making a cake. Soon the smells of burnt crust, vanilla, and custard seep from her flat into ours. She returns with three

and turn, linger, then float away. I want to fly with the smoke. Sahnya coughs. Grandma dutifully asks, "May I serve you some homemade fruit wine?"

He nods, and she pours it into a glass. He drinks it up and waits. She takes out a bottle of vodka from the freezer, which she keeps just for him. He pours himself a shot and solemnly drinks. He doesn't look at me anymore. He eats a pickle and rye bread with garlic that Grandma serves him. Another shot. And another. He thanks her for the company, and hastily leaves. I watch him from my window as he walks down to the liquor store to spend the money he has made. He had a long day.

The front door to our high-rise is called a *paradnaya*, grand formal entrance, which leads to a small and hardly grand hallway, then to a dim concrete stairwell and a tiny elevator with automatic doors and plastic laminate that has delaminated and rattles when the car is moving. Slávka and I ride it for a thrill. Going up, I feel heavy. Down, weightless, it feels like jumping on the moon. Sometimes we play gangsters in the basement of our building, where warm heating pipes hiss and the plumbing drips cold sweat. Feral cats live down there. Stray dogs live outside. When a cat steps outside, a stray dog goes after it. Lickety-split, the cat runs up the poplar tree and meows from the top, it can't get down. An older boy has to climb up the tree to rescue him.

Our building is always clean but it's full of smells that haunt me like invisible trolls. There are large buckets on the landings between floors that smell of potato skins and onions. We neighbors put our kitchen scraps there. Early in

the morning, the groundskeeper carries the full buckets down to a dumpster. Once a week, a man arrives with a dump truck and pours the slop into its back to take to a state-run farm to feed the pigs. On the day the slime-dripping truck drives away, flies zip madly in circles above the empty dumpster. The tart reek lingers in the common yard. It is both repulsive and comforting, the smell of home.

Every hallway of our building smells of soup. We all have soup every day and eat it with anything—with bread, pie, dry crust, or on its own. We don't serve soup in a cup, as they do in America, because Soviet soup needs room. Pour it in a deep dish with a wide brim where a spoon can rest with dignity. Soup is not called "a starter" in Russia but "the first," the anchor of a memorable meal. Mothers-in-law tell their new daughters to greet their husbands at the door with a plate of soup. Healthful things are chopped into large chunks for everyone to see the cast of its characters. Grandma says it is good for my health, and if it is not tasty, I must take it like medicine. Chicken soup is for the flu, *borscht* for digestion, a cold soup made with *kvass*, fermented rye bread drink, for the summer, hot *shchee*, a cabbage soup for the winter.

Each neighbor has a different recipe from the same ingredients we all buy at the grocery store. What can be done with plain cabbage? Quite a lot! Sauté it with potatoes and carrots in sunflower oil for a vegetarian meal. Stir in fried sauerkraut for a sweet-and-sour. Add a beef bone, no good for anything else—soup for a carnivore. Slice up a sickly, cyanotic hot dog or the doctor's *kielbasa*, bologna, add a chopped-up cabbage stalk and call it *soliyánka*. Every soup has its own name: *Okróshka* (cold kvass with vegetables

and sour cream); *Rassólnik* (with pickles and barley); *Ukhá* (bouillabaisse); *Kholodník* (cold borscht).

But truth be told, soup is not only good for you. It is cheap. It can take in foodstuffs that begin to go bad. You can make lots and it will stay fresh for days, it gets better with time. And when it starts to go off, just boil it. But don't forget to add a bay leaf for flavor. Bay leaf is a modest name for the laurel for champion and warrior in our kitchen.

Slávka and I have stay-at-home grandmothers. So does Díma from the top floor and the twins from the seventh. This means that we have hot porridge in the mornings, blintzes, and homemade pies with tea in the afternoon. Our rooms are clean, our clothes washed, our worn-out socks patched and darned, and the buttons that hang by a thread are stitched back tightly. We, the children with grandmothers, have combed hair and clean noses in every season, even in the winter when boggy Leningrad weather spreads the flu.

Our entire neighborhood is the kingdom of kindly old fairies. I see them on the bus, in the grocery store, at the playground, and at the school drop-off, holding the pudgy hands of their grandchildren. After our parents go to work—as everyone must work in our country—our grandmothers emerge from their apartments and run the streets until dark.

Women age early in the Soviet Union and don't fret about looking young. There are no homes for senior citizens like the ones I will see in America. Here the elderly live with their children if they can. I don't know the moment when a comely young woman like my mama turns into a grand-mother. First that woman must become middle-aged. She

begins to wear a black knee-length skirt and black shoes with sturdy heels, mass-produced by the state-run factory Red Triangle and bought at a nearby store that doesn't have long lines. She puts on thick mascara that dries in black curds on her eyelashes, and dusts the top of her cheeks. She twists her hair into a tight bun and keeps it up with bobby pins. The middle-aged woman has a swollen face—from eating salty foods late at night, waiting in endless lines, doing laundry by hand in a bathtub, and standing on a crowded trolley bus. The middle-aged woman has no waistline. She rarely smiles and often yells.

A few years later, when I start going to school, I see many such women. Take our English teacher. In the mornings, she comes to class in dark glasses. When she takes them off, there are brown bags under her eyes—an early sign of heart disease. To keep us from feeling pity for her, she calls us goons, potheads, mutton-brains, dawdlers, and scalawags. "Young gawks will lead this caravan," she quips and gives us a surprise quiz. And yet we love her. We love her because we know she is middle-aged, like our mothers, and her life is hard. We know that though she is rude to our face, she will not stab us in the back. You can trust her. She will not snitch to our parents or the school principal. And every Russian knows that there is no sin more vile than being an informant.

But all of a sudden, this tired woman turns into a grandmother, like a pupa into a butterfly. One bright day, she sets aside her mascara, takes off the black-heeled shoes and puts on flat soles. Having let go of melancholy and regrets, she sets on a mission to poke and pry, and repair the world. She

minds everything and gives everyone a piece of her mind. Don't walk on the grass! Give up your seat to an old woman! Why are you wearing that ugly skirt, who will marry you? Fairies or witches, depending on one's luck.

But there are kids in our neighborhood who live without their grandmothers and roam the streets on their own. Meet Sinyák, the Bruise, a third grader. On Monday mornings, he comes out to the common yard, cranes his head, and hollers, "Gríí-ee-enya-aah!"

Grínya leans out the top of the fourth-floor window, bare feet and knees pressed against the glass.

"Co-mm-me down," the Bruise yells, then coughs like a smoker.

He earned his moniker for the islands of bruises on his bony legs, blue and yellow, that change shape but never go away because he gets new ones before the old ones heal. He wears the same battered shorts until the winter snow. His face is pewter, with blue veins in his temples and a shiner. Rarely do I see his mother. Some Sunday mornings, she walks down to the store, looking tired and glum, and returns with the stench of liquor on her breath.

In the yard, the Bruise pulls out a slingshot made of a twig and a rubber band. He shoots pebbles at pigeons and crows. When he and Grínya start a game of soccer, Slávka and I never join, because it always ends in a brawl. Sometimes the duo climbs into a dumpster and look for useful things, like the leg of a broken chair, which they turn into a rifle. After ransacking, they set it on fire to watch things melt and glow. Chemists in the making.

"You no-goodniks," the fairies yell at them from the bench. The Bruise doesn't care. He has calluses in his ears from their yelling and no longing for these ladies' love. He wants everyone to be afraid of him. And to be honest, I *am*. Even though I fear nothing and want to be an infantry soldier and to jump out of the trenches into battle. Even though he does not pick on me, because it is beneath him to fight a girl. Still, I get a chill at the sight of the Bruise and Grínya. They instill a visceral fear, like long-headed Gauls. When I walk up our unlit stairwell, I imagine them hiding behind an elevator shaft with their handmade rifles and slings. I picture them jumping out, twisting my arms, dragging me to the top floor, breaking open the elevator door and throwing me down the shaft. I imagine falling down and wondering, should I grip the electric wires to stop the fall? But you should never touch live wires. So is it better to plunge to your death?

Speaking of which, I am afraid of manholes. Manholes often sit without covers in our neighborhood, hot white steam billowing out. There are rumors of people falling into them. So mind your step. And if you fall in by accident, Grandma says, spread your arms wide, hold on to the edge and cry for help. I imagine falling to the bottom and seeing nothing but a small circle of sky. I mind my step, and the steps of Grandma, and Slávka, Díma, Marína, and Véra, and maybe even the Bruise. Marína laughs at me and jumps on a manhole cover to see me cry.

I am afraid for Mama and Grandma. What if they get sick and die? Grandma says that health is everything. She doesn't want to become ill, and says she wants to die in her

sleep. In the mornings, if she is still sleeping, I stand by her side and watch her breaths. I worry about Mama—what if she won't be with me? I don't want to live without her and Grandma. I think I would rather die before they do, or all of us in one day, like in fairy tales.

I am also unnerved by our butter knife. This is not fear, but woe. This knife used to have a shiny black plastic handle, but one day it lay on a cooktop too close to the lit burner and the plastic melted. Now it's shapeless and bubbly, like a third-degree burn.

That is all. With the exception of the table knife, and manholes, and the Bruise, and life without Mama and Grandma, I fear nothing. Not heights, cars, germs, mildew, or fungus. Not afraid to stay alone at home or in the forest. Not afraid of neighbors or drunks. Or dogs, I love them, even the menacing Alba that barks and is known to bite. No worries about climbing onto the roof of a garage in our yard and jumping into the snow with an open umbrella like a parachute.

I *am* very much afraid that someone might disapprove of me. It is a different kind of fear, though the word is the same. I want to be loved. To be a good girl, well-behaved and obedient.

I am five, and a smaller girl next to me has just fallen to the ground. Her grandma yells at me, "What a horse to bully such little suckling!" She does not know that I only wanted to hold the girl's hand and pushed her accidently. I am seething with hurt and leave the yard *forever*. Until the next day.

The next day, the old fairies sit as usual on the bench in front of our main door, arms folded over their soft bellies,

wearing gray down shawls pulled over their foreheads to their eyebrows, woolen long johns, and bathrobes over nighties that they wear all day. They chat about the news of the day, that is to say, gossip about the neighbors. Grandma asks one of them to keep an eye on me while she makes a quick run to the store, and I play in the yard. No sooner does Grandma vanish around the corner than the fairy beckons me with her finger. She pulls out a sticky toffee from her pocket, and while I am transported into toffee heaven, she asks me about my mother and father, and why my father is never home. I am blushing from the sugar and their attention, and given my growing vocabulary, I reply at length.

"Mama does not love Papa, and Papa is a drunkard. He comes home and falls down on the floor. Grandma loves Mama and also loves me very much, and speaks to Papa with the formal *vi* and looks for his boots when Mama tells him to leave."

She keeps asking, other women listen and laugh. When Grandma returns, I repeat everything to her, word for word, so she too will get a laugh. She takes me home. In the evening, Mama calls me up to the living room. "We need to talk."

Her nostrils flare in the shape of penguins. I lose my breath. I want to put on a see-me-not hat and trickle out, drop by drop, through the wooden floor. She does not yell. This makes it worse. She says, "You see these building blocks? They are yours. You may give them to Slávka or someone else. You may lend them or give them away forever. Now, this scarf is mine. You cannot give it to anyone, because it does not belong to you. The same goes for stories. My stories are mine, and you may not give them away. Stories about yourself—what you did, where you played—yes, you may tell

your stories. But you would be better off if you kept those to yourself. Don't chatter idly."

"Words are silver, silence is gold," Grandma adds, and smiles at last.

In the mornings I wake up and run down the corridor toward the chiming of Mama's spoon stirring sugar in a cup of tea. She hugs and kisses me, and leaves for work. At the end of the day, she brings me a little chocolate cake that looks like a whoopie pie. After supper, she sits at her table, which folds out from our bookcase like a medieval bridge, and reads books without pictures about Freon under pressure in sealed tubes. Sometimes, she packs her suitcase and goes away on a business trip. Grandma and I miss her and wait for her to come home.

On the weekends when Mama is back home, she takes me to Leningrad's center. We take a walk down Nevsky Avenue, starting at the Moskóvsky train station and stopping at the cafés along the way. At Café Lakomka, Mama buys me a puff cake with whipped cream, which you can't get anywhere else. At Café North, a cake called *Kartoshka*, meaning "potato," has nothing to do with potatoes; it is chocolate and sweet, with a fine hint of liquor. If we are lucky, there's an ice-cream cart parked in the middle of a sidewalk, serving vanilla ice-cream in a chocolate casing, a rare delicacy. We spot it at the end of a long queue that weaves down Nevsky. Anytime you see a line, you should take a place right away and then decide if you need what is being sold. At the end of our walk, we arrive at the Palace Square by the Neva and I am in awe of its majestic beauty. I think it must have come from another world.

In the evenings, our phone rings nonstop. Mama's friends calling. She sits down in an armchair with armrests carved into lion paws and a broken spring that pokes through the thinning upholstery. She isn't bothered. She sits with the receiver propped between her ear and shoulder, a pen and sketch pad in her lap. She talks and doodles. Her infectious laughter rolls up and down our flat. "No way! Tell me . . . And what did you say? Brazen! He won't do that to you! No, you'll get there first."

"What is she saying, Mama?" I ask.

"Go to your room. The adults are talking."

Then into the receiver, "Why are we still on the phone? Come over! No, you come . . . I have burgers and Opals to smoke. I'm hanging up, and you'll be here in thirty." She puts down the receiver and, still sitting in the armchair but with her back straightened, "ALËEEE-OOONA! Friends are coming. Cleanup time!"

"Who's coming?"

"You'll see! Quick. Pick up your feet, *nogi v ruki*, and go! Your things are all over!"

"Your things, too," I dare to say.

"The clock is ticking!"

The adults are talking—a headache for children. I zip back and forth, hell for leather. No time for sorting. I cram my things into a wooden armoire and push on its door until it clicks shut. The doorbell rings. It's Rita. Or Inga. Or Lyda. Or gorgeous Lena from Mama's work, wearing a cream-colored pantsuit, with smoky eyes and silver-ash highlights in her blonde hair. Or one of the many other of Mama's best friends.

They sit in the kitchen, and I have to keep out because

of the cigarettes and adult conversation. I find reasons to go in. They send me out. Then Grandma puts me to bed while they linger in the kitchen, talking and laughing like school-girls. Sometimes—many times—one of them needs a place to stay. Mama pulls out our folding camp cot. It creaks every time anyone lies down on it and turns from side to side. But someone will have to sleep on it, and usually it's Mama, because her friends come first and she will let them have the soft, wide bed in her bedroom.

Once a month and on big holidays, Mama hosts a dinner party, which takes a full week to prepare. Gone are Grand-ma's soups and sauerkraut. Mama takes over the kitchen, where she is an artist, a poet, a scientist, and an inventor. She expects from us full compliance. "Do as I say, or leave, but remember, these who don't work do not eat." Her food is too scrumptious to make it a choice. Grandma and I stand by the door and wait for instructions. Peel potatoes. Cut the onions. Wash the dishes. Don't talk and don't take up room. *V boi*, up and at 'em.

She makes bright and unusual dishes that depart from convention. Sweet and salty. Fruit and spice. Meat with dried apricot. Cheese with persimmons she buys off an Uzbek trader at a farmers' market. Armenian-style eggplant caviar. Pressed pan-fried chicken with Georgian herbs. Cutlets à la Kiev. Soviet-style fusion cuisine. She never follows a recipe, so nothing she makes can be made twice. There is no variety of foods in the stores, spices are limited, fresh fruit and vegetables are mostly gone in the winter. This doesn't stop her. Neither does the fact that we have no electric tools. We

make everything by hand. Grind meat in a hand-grinder. Beat egg whites with a fork until they become a foaming tower. Soviet festive food is all about suffering. And taking risks. Hissing butter in a piping-hot pan shoots projectiles at her arms, leaving red burned dots. The pressure cooker spews out steam. "Don't come into the kitchen," Mama tells me. "The pressure cooker can explode."

"So why are you there, Mama?"

She waves me off.

Years later, we will bring recipes for Russian food to America. But instead of making any of it at home we'll buy it for special occasions at delicatessens called Bábushka, Bazáar, Carrot Top, and Beryeózka, the Birch, setting aside for a day or two the American abundance of fresh produce, seafood, grains, and exotic foodstuff from around the world out of a faint, irrational nostalgia for scarcity, long lines, and the bliss of scant delicacies that seemed so fabulous when Mama reigned in our small, spartan kitchen making things with her imagination and grit.

Who is coming to the dinner party? Mama's childhood friends, their friends and children, the people she knows from college and work, someone's third cousin, a student from Moscow who is visiting. She will introduce everyone to one another and set up single men with her divorced girl-friends. Some will get married and reminisce for years about their first date at Galia's, where there was so much food, drink, laughter, and unending cigarettes.

Oh, cigarettes! Every pack comes with a printed warning: Smoking is harmful for your health. "So why do you smoke, Mama?"

"You know what I teach you? Look at me and do the opposite."

Oh, what I wouldn't do to make her quit! I hide those cigarettes, drop them in water, and break them in half. I throw them out, one by one, so the pack is done sooner.

"Where is my new pack?" she asks me.

"I don't know."

"Your eyes are lying."

She is off to the corner store to buy more.

"They are all unhealthy, Mama!"

"Arrgh, everyone smokes. And you are a killjoy."

On the day of the party, she locks herself up in her bedroom for a makeover. She sits in front of three mirrors—large, small, and magnifying—with pencils, brushes, and foreign-made beauty products bought from Lena, whose husband travels abroad with the Soviet merchant marine. She first rubs on foundation cream (made in Hungary) to wipe out all her freckles. Then, with a soft brush, she puts on eye shadow (Czech, a rarity). She lifts an eyeliner wand, raises one eyebrow, and draws a perfect wing like an Egyptian pharaoh. With a thick brown pencil, she redraws the outlines of her lips and fills them in with Lancôme lipstick. Stained cotton balls multiply. Mama keeps at it until every flaw, perceived or imagined, disappears under an overlay of imported cosmetics, and every micron of her face is replaced with a dream conjured up by Burda or some foreign fashion magazine. A portable hair dryer that looks like a record player appears with a plastic helmet and a garden hose. Her

damp hair in curlers, she sits down. The garden hose shudders, hot air blasts out, cotton balls ping-pong off the wall. She sits unfazed. Then she combs her hair up into a shimmering celestial object, and wraps a long strand along its orbit, a festive ribbon on the gift for the party.

The company should arrive at any minute. She dresses quickly in her fitted blue dress. The doorbell rings. "I'll get it!" she shouts, pulling on her black platform boots and sprinting to the door.

For a second, she stands in front of the hallway mirror, shoulders back, head slightly tilted. Then she flings open the door. A young man stands in the hallways with a bouquet of carnations and some oranges. He is motionless, not recognizing the deity before him. She takes one step back and gazes at him in still silence. Enigma. Intrigante. She curves her eyebrow in faint surprise and suddenly switches to the formal *vi*, you. "*Vi ko mne?* Are you here to see me?"

Yuri has come first, alone. Sergéy arrives next, with his son Seryózha. Big Sergéy and Little Seryózha. Rita comes with her son Sasha. She is a young widow looking for a beau, Mama wants to set her up with Yuri. Lyda is next, with her husband Edik, their son Élichka, and Lyda's sister Inga, Mama's childhood friends. Lyda tells Mama, rapid fire, that the crowds on the metro were unbearable, Edik should have taken his car but he doesn't drive in the city, and now her new nylons got ripped by someone's umbrella, she better seal the run with nail polish. Then, in one quick motion, she sheds off her camel hair coat and beret, rolls up the sleeves of her chiffon blouse, and goes to help in the kitchen. The doorbell keeps ringing.

Finally, Mama says, "Everyone is here! The food is getting

cold." And everyone shuffles to the table. The grownups sit around the table in the living room on whatever Grandma and I have dragged up to it—the red couch, the antique armchair with lion paws and a broken spring, mismatched chairs, and a swivel piano stool. The children sit around the coffee table on stacks of books and telephone directories. Someone begins the toasts. "To our coming together!"

"To new friendships."

"To new love," Big Sergéy roars.

Yuri looks at Mama and says nothing.

"To our children," says Lyda.

"Is there juice for the children?" Rita asks. We forgot the juice.

"Give me some jam and water, I'll mix them a drink," Big Sergéy booms.

We clink our glasses with Moldovan wine, our home-made fruit wine, and jam water. Sergéy starts telling jokes.

"What did he say, Mama?"

"You'll know when you grow up."

He continues. "To our hostess! Galia, when will you make a choice?"

"What choice, Sergéy?"

"We have a triangle here—you, Yuri, and me."

"You are a clown!"

Done eating, we children go to my room to play "house," making rooms with sheets draped over chairs. Then we go outside and walk to my forest. Sasha catches a newt in the pond with his butterfly net and shows us its markings before letting it go. He says he wants to be a marine biologist, but his mother, Rita, wants him to be a doctor. Then we remember about dessert waiting for us and run back home.

Mama opens the window to wave out armfuls of smoke. Plates are passed from hand to hand with cakes that we have baked and our guests have bought in the store: éclairs, cream horns, ice cream, and *pastila*, a Russian marshmallow made with apple juice. The children are in paradise.

Guests begin to leave, and Mama packs up leftover cake and wine for each of them. They refuse. She insists. "We have enough. You know I don't drink." They crowd in a hallway rummaging about for their umbrellas, handbags, scarves, and mittens, then stand at the doorway, jostling one another, still chatting.

Thick dove-colored smoke floats in the living-room air, turning our red couch monochrome. Yuri is the last to leave. But I want him to stay. I do. I wish he would come here without other guests. Yurik. Sir. Mister Groovy. He does not smoke or drink hard liquor. His everyday clothes are the same as his festive ones, simple and clean. His light-colored shirt is ironed and tucked in. His suede jacket smells of pepper and soap. He wears his brown velvet cap level and straight, the way a military officer wears his cap. But Yuri is not an officer, he is a doctor, an anesthesiologist, a job that demands precision and an economy of means, where a micron changes the outcome.

The little we know about Yuri comes from Lyda and Edik, friends of his from medical school. He has had no home of his own since separating from his wife and leaving their apartment to her and their son, Ilyusha. Now he rents a room at someone's home. We heard that his younger brother was a dissident who died and one can presume was murdered. Yuri never speaks about this, and friends don't dare ask. One thing is certain—Yuri doesn't tolerate intrusive

questions and takes no prisoners when presented with them. He was born in 1941, the year of the Nazi invasion of the Soviet Union, but we know nothing about his childhood or his parents. Nothing about his work in the past. Many years later, I will find out from a newspaper article honoring him as a chief doctor at a major hospital that after graduating medical school he started off as a sanitation doctor, the most basic medical job, in a small provincial town.

At the time of our meeting, Yuri works with the medical emergency services. I think it's glamorous. I imagine him riding in a white van with flashing red lights and a siren. I picture Yuri breaking through a crowd of gawking bystanders to get to the patient, quite possibly me, whose heart has stopped, him kneeling down to perform CPR. His mustache would tickle. Yuri works twenty-four-hour shifts, and no one knows what he does in his free time. Only that he is always there when Mama needs him. He can be funny and come back with a sharp remark that makes everyone laugh. More often, he carefully listens to decide how he can help. Does he ever take time off to relax and have fun? The Soviet mindset of the 1970s holds the words *fun* and *relax* in contempt. Fun is for airheads. Relaxing is for the spineless or the drug-addicted. These states are unbefitting to men.

The guests have all left. Yuri lingers in the hallway, holding his velvet cap. I think, It is cold outside, and he needs a warmer hat. The door to the living room is wide open. Mama leans back against its frame and says, "Stay a while longer."

She says it kindly, but she is tired. Behind her, the smoky pewter light erases the sharp edges. I stop breathing.

I imagine Yuri hanging his cap back on the hook, taking off his suede jacket, sitting down in our armchair with the lion paws. I imagine how his polished belt buckle would twinkle hanging in our closet. Our bathroom would get a new shaving brush, and foam, and a striped dark blue towel. The next morning, I would get up at dawn and bake a pie. Who's the pastry chef here? he'd wonder. Mama would make coffee and tea. Yuri would stir sugar in a cup with his chiming spoon, his mustache would be dewy from steam. We would sit for breakfast in the kitchen and talk in soft morning voices. Mama would wear her pink cotton robe and slippers, the light from a window will reflect in her eyes.

"It's time to go," he says, without moving.

My calm and collected Yuri. I want to take him by the edge of his sleeve and yell to Mama, Yes, have him stay! It's too cold outside! She says nothing.

He nods toward me. "Little booger-nose pipsqueak should go to bed." He puts on his cap and leaves.

Booger-nose what-what? I want to kick him. I will not talk to him ever again! For weeks I won't even say hello when he phones, I hand the receiver to Mama with "*That one* for you," so he can hear it. But one sunny day the pipsqueak will forget she is angry, and hearing his voice will say, "Mister Groovy!"

And he will let go of his composure and laugh. "How're you, Alënka?"

Fairies and unicorns! He remembers my name.

The Rain and the Frost

THE RAIN SETS IN about mid-September. Leningrad's rain is not impulsive or passionate, like a Shostakovich symphony. It's not brash. No! It is depressing, slow, cold, and shallow—a persistent, lingering drizzle that penetrates clothes and lungs. A dull grayness comes with it. The worn-out pastels of Khrushchev apartment buildings turn drab. Roads blacken. Heavy clouds that look like beef broth congeal overhead. My neighbors put on gray garments so that splatters will blend in. Gray raincoats, hats, and shawls. Gray *vatniks*. My heart turns gray. Rain seeps into my boots from the top and from the bottom through cracks in the soles. Wet socks. Runny nose. Sidewalks are littered with soggy cigarette stubs. I have to watch my step. Water seeps below doorways into our foyer. Now and then, the drizzle brings in a tender scent from the Gulf of Finland, but more often it is the stink of the overflowing storm drains. Puddles form at the side of the road. Cars drive through them too fast. Blasts of water and mud shoot up like flicks of black ostrich fans. Pedestrians leap away. The burlesque of Leningrad's rain, the contest for the biggest mess.

And then there are brief moments when the sun comes out and veins of blue sky break through the clouds. Then

the puddles sparkle in lapis lazuli and pearl. Drops of gasoline play shenanigans with rainbows on the wet asphalt. My white brick apartment building stands tall as a lighthouse in our pallid neighborhood. In those moments I feel that everything will always turn out well, and my heart brims with gratitude.

At the end of a day in November, Grandma closes my curtains with their pink peonies on the muddy slop outside. The next morning, I look out the window and . . . aaah! Hoarfrost has wrapped everything in white terrycloth. Branches shimmer. Translucent icicles hang like crystals from fairy chandeliers. The morning of the first frost is silent, bewitching. I lose myself in it.

Soon snow will come in flakes, wafers, tufts of fleece, and serpentine. Snow will hide the footpath and manholes. It will turn the street inside out to resemble a bed made up with white sheets. It will soften the brusque clanging of trucks, the hoots of cars, the screeches of buses. My breath will float away in puffs of white. Bus windows will sprout psychedelic ferns of frost. Oncoming cars and traffic lights will color them up with Christmas-themed greens and reds. Women, gray in the fall, will now wear bright fur coats and hats made of red sable, white rabbit, and purple mink, incomprehensible cruelty to repulse me years later. Here and there, I will see faux fur in cerulean, pink, and a leopard pattern, still a novelty from abroad, a bold new look for gutsy women with foreign connections.

My school starts when it is still dark, and I want to be back home under a warm blanket. Our foyer becomes a coatroom, with rows of metal racks holding our winter jackets, snow pants, hats, and scarves. Everything

drips—*tip-tap-kahp-rrrahpp-tap-tap*—the jazz bebop of Leningrad's winter.

After school, Slávka and I run outside to build a snow fortress. We have snowball fights and play hide-and-seek among snowbanks and snowed-in garden furniture. In the evening, Sahnya the plumber and other men from the neighborhood come out to groom our ski trail by skiing in circles one after another around the common yard until the deep tracks harden. They build a skating rink, setting up wood planks to hold water. Sahnya connects a hose to someone's ground-floor kitchen faucet, the water flows into the rink, the ice sets, and the men smooth it with boards and brooms. Here boys play hockey, and girls figure skate, imagining ourselves as Irina Rodnina, the Olympic champion. Our grandmothers stand in pairs, hopping on one foot and tapping with the other. Grandma wears her *muftah*, the black fur hand-warming muff she's had since her youth. "Look at this marvelous muff," she says to me. But I have no use for it, I need my hands free. I turn my palm upward to catch snowflakes, magic aliens, messengers from the constellations. Here is one . . . and another, and one more from Big Bear.

The frost burns my face. I pull my scarf up, but my breath melts the snow, the wet droplets freeze, and the wool turns to iron. My eyelashes are rimmed with ice. I cannot blink. I stop feeling my toes and fingers.

"Let's go home, Alënushka," Grandma says. "You'll get frostbite."

I step through the snow slowly to hear it crunch. I don't feel my toes, my cheeks begin to turn white. Grandma puckers her lips and rubs my face with her warm hands. In the house, as I thaw, a relentless, blunt pain begins to

rise. It comes from my toes to my knees, from my fingers to my shoulders, until every numbed nerve ending begins to burn. This pain sinks deep into my bone marrow. It comes on slowly, then grows, swells, and spreads out. It comes despite layers of mittens, socks, and wool undergarments. I could warm up more quickly if I put my feet into a tub of hot water. But then the pain would come all at once and would be unbearable. There is no remedy for it, only patience and time. I have to make peace with this pain. It belongs to Leningrad winters—the price for skiing, skating, sledding, and for the snow, for the joys of my childhood.

Another price is the flu. I get sick, and Mama takes days off work to take care of me. She calls a doctor in from a neighborhood clinic. The doctor comes the same day, on foot, blizzard or sleet. Her visits are free of charge. She hangs her coat on a hook and goes to my bed to look into my throat and listen to my lungs. She prescribes nose drops, eucalyptus vapor, and mustard plaster. Mama gives me aspirin with tea and raspberry jam. Raspberry is a big flu fighter. Also, a spoonful of vodka to heat things up, with burnt sugar to mellow it down. Then on to a sweat bath. I sit with my feet in a bucket of hot water.

"It's too hot, Mama!"

"Be patient!" she cuts me off.

Back to bed. Mama gives me onion juice drops for congestion, a traditional folk remedy. I don't recommend it. Then a mustard plaster. She dips sheets of paper coated with mustard in hot water and puts them on my chest and my back. Wet mustard heats up and burns. All of this helps and the flu goes away. But I catch the next one three weeks later. That flu turns into bronchitis, then pneumonia. More

mustard plaster and many trips to the neighborhood clinic for deep heat with quartz and blue-light lamps. I spend most of my winter in bed.

Finally, the snow slowly melts in March. The lily-of-the-valley blooms in April. The lilac comes out at the community garden plots in May. Our poplar in the yard grows furry red catkins that we wear as earrings. Days stretch like rubber bands until the sun is too lazy to set. The white nights shimmer like sturgeon in June. School is over and I have three months of vacation. Only then do I feel well and whole again.

In June, Grandma and I board the train for Odessa, with bulging suitcases and a three-day supply of sandwiches. Three days of playing cards and solving matchstick puzzles with complete strangers, our fellow travelers, in our four-people sleeping train compartment. Three days of looking out the window at the smudged, glittering ribbons of trees and electric lines, at the endless fields of Russia, then Belarus and Ukraine. On the third morning, the train rolls into a palatial train station with Corinthian columns, and the voice over the intercom blissfully says, "Odessa!"

In Odessa, black and yellow mulberries fall, like embers, on the hot sidewalk. Old men sit in the shade along Deribasovskaya Street, playing chess and drinking sour-cherry juice from their thermoses. On our way to the beach, Grandma and I stop by Lunapark, an amusement park, and I take a ride called "The Cave of Horror." Then a stop at a soda dispenser where a faceted glass with a chipped edge is shared by everyone. Just rinse it, choose a syrup, black currant or sour cherry, and a bubbly seltzer flows out in a hissing jet.

"Do not drink from the glass," Grandma warns me and

fashions a cup out of a sheet of paper from her notebook.

Then we walk down a narrow, winding stairway counting steps . . . thirty, forty . . . , losing track and starting over. Other beachgoers race ahead. I don't see anything behind tall bushes, but suddenly—aaahhhh! The sea is vast, foaming at the shore and fading into the sky. I feel uneasy at its relentless beauty. I yell to Grandma, "Come on! Let's run down!"

I toss my shoes aside and run over the molten sand, burning my feet, then plunge into water that feels icy in the hot sun. I swim into the sea, stirring mud and seaweed. The prickly bottom gradually vanishes. I float, licking salty water off my lips. Little brown fish form acute angles in the cloudy green and disperse into chaos, frightened by my shadow. I swim to a concrete jetty a few dozen meters offshore and rest there. Clusters of black mussels and emerald algae cling to its surface, flowing back and forth with the oncoming waves.

At the end of the summer, Grandma and I return to Leningrad, tan, rosy, and buff, unrecognizable to the pale bench dwellers of our neighborhood. I am ready for a school year to begin.

The Lessons and the Unspoken

ON THE FIRST OF SEPTEMBER, the air smells sweet with a hint of petrichor. I put on my brand-new uniform, a brown dress with a lacy white stitched-on collar and a white apron that Grandma boiled and starched the night before. My hair is an Assyrian garden of braids and nylon ribbons. I carry a satchel with books and three gladiolus stems, a gift for my teacher. Everyone gathers in the schoolyard and lines up in a *U*-shaped formation. Songs about the motherland blast from the loudspeaker.

A gym teacher yells, "Faaaa-all in! Aaaatten'tion!"

The school principal speaks into a microphone, and I can barely make out her words.

"Children kha-khe-chi-di work-hard-tee-kha-h respect-your-teachetam eche-tikha . . ."

The girls patiently listen. The boys fidget and pull at our braids. Then the school's oldest students take us, the first-graders, by our hands and lead us to our new classroom. We take our seats. The teacher walks in and everyone rises.

"Hello, children!"

"Hello, teacher!"

"Sit down, children. Fold your arms one over the other along the edge of your desks. And be quiet."

She gives us our new seats, two per desk, girls with boys, the well behaved with the pranksters.

One boy pokes his desk mate with a ballpoint pen. The teacher walks to him slowly, takes him by the collar, and yanks him up. "Do you know what 'be quiet' means? You sluggard, bonehead, dunce, goon, dumb-dumb!"

He does now. She goes back to her lessons. She tells us about our grandfather, Vladimir Lenin, and his little straw hut, where he hid from the tsar's police before the Revolution.

"Lenin gave us the gift of freedom from the yoke of the rich. And from the deceiving clergy. That's right, children! Priests and rabbis used to tell people lies that god lived in the clouds. But we built airplanes and spacecraft and flew into space. Our cosmonauts circle all around the earth and found nothing. God does not exist."

We listen and take it in. There is a knock on the door and a little girl named Masha walks in. She is tardy.

"Stay here, Masha. You may not go to your seat," our teacher says. "Look at her, children! Her dress is crumpled, her tights are drooping like an accordion! Her braids look like mops!"

Masha smoothes out her hair and pulls up her tights at the knees. Her eyes wander over our heads.

"You are a laughingstock, Masha. Shame on you! Sit down, already."

Another knock on the door and a different teacher walks in, dragging a little tear-stained boy by his sleeve. She says, "Children, this boy is a thief! This morning, he sneaked into our cloakroom and ransacked your raincoats. Come on,

show what you have stolen."

The boy sucks in his breath and takes out a broken toy truck, a tin soldier, four kopeks, and a soft chewy candy called Cow-Moo.

"Does any of this belong to you, children?"

Everyone is quiet.

The bell rings and we file out slowly, one after another, as we have been taught. Our teacher closes the door behind us. The boys check to see if she is out of sight, then run, hell for leather, around the recess room. The girls stand by the windows, fumbling with the corners of our starched aprons, and look out. I think, When will Mama come to take me home?

I don't remember when I heard the word *Jew* for the first time, only that it was at home and I was a small child. I remember Grandma going to the synagogue to buy matzo for Passover. I tasted it and thought, Someone forgot to put in sugar and salt. Our neighbor always brought hot buttery cakes called *Paskha* for Russian Orthodox Easter. I asked Grandma if we can have that cake instead of matzo. She smiled and said, "No, we don't have the recipe."

I know that Jews are different from others. Grandma's Jewish friends have unusual names—Moisey, Naum, Simka, or Tzilya—which none of my classmates have. At my home the word *Jew* is said with empathy and in a hushed voice, though no one explains to me why. My mother is a Jew, and so is my grandmother. But not my father. He is a Russian, and that is why I am a Russian too, as it is written on my birth certificate. I have a very Russian name—Alëna,

Alënushka—a girl from Russian fairy tales. I have a shade of blonde hair called *rusaya*, which rhymes with *russkaya*, meaning "the Russian." My mama's eyes are dark like cherries. I want her eyes. I am sorry I am not like my mother. I did not get her reckless freckles. She can make funny jokes and write poetry. She is good at math. She can start a conversation with strangers in a street, and they will invite her to their home as if she were an old friend. She says, with a measure of pride, that she inherited her father's quick temper.

"And what did I inherit, Mama?"

"You are your father's carbon copy," she says emphatically. "Consider it your good luck that you took nothing from me."

My schoolteacher tells our class that the Russians are a strong and courageous people. That Russia is the big brother for the other small friendly nations and the Russians give them their freedom.

"Gúlnara, please stand up," she says to my classmate. "Children, look at our Gúlnara. She is Tatar. Her people have an autonomous territory in our Soviet Union."

When we study the Tatar and Mongolian conquests that subjugated Russia for two hundred years, I feel bad for that girl, but she is not ashamed of her people. Conquests or not, she is the best student in our class. We all admire her, and the boys beg her to let them copy her homework.

"Now, Masha," says our teacher. "Look at her, children. Our Masha comes from Buryato-Mongolian tribes all the way on the other side of our great republic."

When we go over the Tatar and Mongolian conquests, I feel bad for her too. But Masha couldn't care less. She stopped listening to the teacher on the first day of

school, and probably missed all about the conquests.

And yet when it comes to Jews, the teacher says nothing. No one does. The Jews have an autonomous region, called Birobidzhan, in the far East, near the North Korean border. Stalin created that outpost in the early '30s. You can take the Trans-Siberian train there and find 36,000 square kilometers of rugged earth. Few Jews moved there. We live everywhere else, but no one mentions us. Jews fought in the war, served in combat, rode tanks into battle. My grandfather led horse-drawn supply wagons under fire into a besieged Leningrad. Jews fought against the Nazis with partisan troops during the occupation. They went all the way to Berlin. When they earned their medals of valor, they became valiant Soviet men. Never Jews, the courageous nation of heroes.

Our school curriculum of ancient history begins with Egypt, Greece, and Rome. We learn that these were great civilizations. They had pyramids, Tutankhamun, Queen Nefertiti. They had Zeus, Hera, and the Acropolis in distant Athens, where I cannot go because our Soviet borders are closed. But there is no mention of Jerusalem or ancient Judea in the Soviet textbooks.

"What does anti-Semite mean, Grandma?"

"Oh, Alënushka . . . There were people called Semites in ancient Mesopotamia."

"And the anti-Semites? Did they live across the street?"

"Perhaps. Don't repeat this word."

Grandma says that there is a wonderful writer, Sholem Aleichem, whose name means "peace be with you." He wrote witty stories, and I must read them someday, but our public libraries don't circulate his books.

Grandma tells me that she grew up in a town called Balta that once was a part of Bessarabia, then Moldova, now a nameless suburb of Odessa.

Balta-Bessarabia, with a double *s*, where fearless, reckless, homeless youth run the streets. Where gypsies come at night on a creaky wagon. They sing songs of love and play the cimbalom, tambourine, and seven-string guitar. There are vineyards in Balta, and its wine has the scent of acacia flowers. There are wild dragon flowers with the folk name "lions' jowls." Roses grow there, but not cranberries. Noisy young men with dark tousled hair flicked over their black almond eyes smile and squint under the relentless sun.

Balta.

People there say *zhmenya* instead of "handful." *Tzibele* instead of "onion." They say *bikitzer, yente,* and *mischugas.* They don't sigh but *kvetch* and *krekhzen.* Children run barefoot, with pigeon feathers tucked into their matted locks, dreaming about America. Balta . . . where my grandma is young and her beloved, Syomushka Roshkovan, is waiting for her on a street corner. There, she and her best friends, Bélochka, Ánna, and Olenka, play street theater and dress up her little brother, Lév, Lévushka, as a princess. Later, all of them will move away to settle in big cities, or vanish during the war.

Balta, Bessarabia.

Grandma never took me to the place where her town used to be, even when we were near there in Odessa. There is nothing left. A new neighborhood has been built over it. Balta is no longer on the map, only in her stories and my daydreaming.

My grandfather's Babi Yar paintings are stored in our home. When friends come to see his work, they ask for that painting. *Babi* means "women" in Russian and *yar* is a high riverbank. It sounds like *yarko*, bright. I think that this painting should be bright, showing women doing laundry by the river. But it's black and brown. People stand together, some are fallen, there are soldiers with rifles and dogs. It makes me queasy.

"What is Babi Yar, Grandma?" I ask, and see that her eyes grow wide.

She walks back to the painting quickly and turns it around to face to the wall. The painting is dark, and has a secret. Why Babi Yar? Why women? I don't want to ask again.

The word *Holocaust* has not yet entered Russian speech in the 1970s. The words *pogrom* and *occupation* have, but Grandma never mentions them. Auschwitz, Treblinka, and Dachau do not exist in our home. When the newsreel of the liberation of Buchenwald is aired, she turns off the TV. Her silence does not make things light. It leaves a cold, dark pit inside me. It stands apart from everything else about the war.

Grandfather's painting called *Building After Bombing* is about Leningrad, the hero-city that resisted the Nazis. Grandma tells me about the Siege even though these are difficult stories. As people died during that horrid winter, their survivors pulled their bodies, wrapped in blankets, by children's sleds to the Neva and laid them on the ice for the snow to cover them. No burials or tombstones. She told me how she had to get water from the Neva for the Academy. She would go when the Nazis bombed, but never during artillery fire. Her reasoning was that the bomb would kill on the spot, but a bullet would bring long suffering. People died

from bombs and gunfire, from starvation, and later, on trains during the first days of evacuation, having traversed the Road of Life out of the besieged city, when after months of hunger they ate too much all at once. "Willpower is everything," Grandma says.

Yet in her oral chronicles of war, revised for the peace of mind of my mother and me, her younger brother Lévushka did not perish during the occupation, but was killed on the northern front. My grandfather's parents were not murdered by the Nazis in the shooting fields, along with thousands of other Jews in Ukraine. No! They were killed in a bombing as they tried to evacuate, en route to safety. They died quickly and without suffering, so we don't have to carry the heavy load of shame for our good life.

"Don't look there," Grandma says when she sees a dead bird on the ground or when a drunk sleeps on the bench, knees to his chest like a baby. She takes me by the hand and we cross the street. "Cherish joy. Ward off sad thoughts, have them bounce off your coat's buttons."

The truth is dark and history is whitewashed. White sheets are dropped over dark places. And here are my grandfather's canvases, the rope bridges I can take to find my way to what cannot be put in words.

A Time to Uproot

I DON'T KNOW PRECISELY when the thought of emigration enters our home. It seeps in slowly, hiding in the shadows of our daily life. In the mid '70s, I begin to hear the word *ot'ézd*, the departure, spoken with evasive, weighty overtones. It starts with Grandfather's paintings that are stored away in our walk-in closet. "Under house arrest," Mama says.

Works on paper are tucked away on a shelf below the ceiling. Small sketches are in handmade paper folders in boxes under Grandma's bed. A roll of Grandfather's unstretched canvas, wrapped in a sheet, leans on an armoire. His Japanese oils with Italian names, his easel knife, his wooden palette with ridges of dried paint, his portable easel, and his old brushes sit on top of our bookshelves. People keep coming to look at his work and some of them want to buy it, but Mama doesn't sell because Grandfather did not want to divide his oeuvre. His dream was to give it to a museum for everyone to see it.

"But it's not Socialist Realism. Soviet museums will never show it," a collector says.

"Time will tell."

Mama puts the paintings back in the closet.

Then we learn that Grandfather's old friend Mikhaíl

Raikhel, an artist, is emigrating. He and his family applied for a visa soon after it became legal for Jews to leave after the 1974 signing of the Jackson-Vanik amendment, tying United States–Soviet trade to the repatriation of Soviet Jewry to Israel. Mikhaíl is leaving despite having defended the Soviet Union from the Nazis and losing his leg in World War II. He is going to Israel a year after the Yom Kippur War, and the possibility of living through another war does not stop him. His daughter, Zhanna, wears a necklace with the Star of David, a courageous act during the anti-Semitic years of the Khrushchev and Brezhnev administrations. Her parents never kept the horrors of Nazi occupation and Stalinism secret from her. Now she is expecting a child and wants to give birth in Israel.

Their family is going together. The day before their departure, they stay overnight with us. Mikhaíl walks peacefully back and forth with his wooden crutches, soft flannel padding folded over the hard arm supports. He packs his pipe with tobacco that he keeps in a tin box labeled *Marmalade*. He takes two puffs at a time, and in between the pipe rests on a little wooden stand that he carved and polished with oil. He stops and looks at a thin stalk of smoke and the quiet embers that flare and fade in the bowl of his pipe.

"Won't you be homesick, Mikhaíl?" Mama asks.

"I am going home. And you should too. I can send you an invitation from Israel."

On the morning of their departure, I watch from our balcony as they get into a cab—Mikhaíl and his wife settling into the back seat, Zhanna sitting in front, protecting her growing belly, her husband loading four leather suitcases into the trunk. Soon after they've left, we receive our first

international letter with color photos from Beer-Sheva—
Mikhaíl sitting in a folding armchair in the shade of jujube
trees, Zhanna smiling and holding her newborn baby.

Some time passes. Then Lyda calls to say that Édik was
offered a job at a university in Ann Arbor, they are emigrating
to the United States. "How can he say no? What prospects
does he have here?"

"And what are *you* going to do there?" Mama asks.

"I don't know. We're doing this for Édik and Élichka."

"And does your son know?"

"We told him we'll be traveling. It's easier that way."

Mama, Yuri, and Big Sergéy help them pack. Mama
and Lyda comb through department stores looking for things
indispensable in America—Russian nesting dolls and crafts,
Gzhel porcelain, and deliriously floral tin trays from Zhos-
tovo. They also buy military binoculars since, rumor has it,
Soviet optics are in high demand at the flea markets in Rome.

Before they leave, we all go to Lyda and Édik's dacha on
the Gulf of Finland. I have just learned the Soviet anthem
at school and, as we drive down, it keeps bubbling up and
bursting out in loud, unkempt verses:

> *Unbreakable Union of freeborn Republics,*
> *Great Russia has welded forever to stand.*
> *Created in struggle by the will of the people,*
> *United and mighty, our Soviet land!*

Élichka enthusiastically joins in.

> *Sing to the Motherland, home of the free,*
> *Bulwark of peoples in brotherhood strong.*
> *Oh Party of Lenin, the strength of the people,*
> *To Communism's triumph lead us on!*

"Switch the channel," Édik snaps at us.

Mama nods. "You are off key."

Lyda and her family leave for Ann Arbor, and their departure somehow ignites a spark. A small flame at first. Mama begins to think about Grandfather's paintings that now stand in rows locked away in the closet, awaiting an uncertain future. About friends who have left. About every "cannot" and "not allowed" that she has always heard but never questioned. She has taken them as plausible truth. Until now.

And then, I hear again that word, *ot'ezd*, the departure, and now it means . . . us.

"We need to talk, Alëna. I don't want any secrets between us," Mama says, and I know from experience, expect nothing good. "We are going to emigrate. Do you know what emigration means?"

"No."

"Migrate is to "move." *E*-migrate—to move out. *Im*-migrate—to move in."

"Are we *E* or *Im*?"

"It depends on where we are."

"How long will we be there?"

"We are going away for good. We will move to America. On the way there, we'll travel to Vienna, then we'll go to Rome! Do you want to see the catacombs? The Colosseum? The Mediterranean Sea?! We'll go to Florence and Venice where people get around by boat. And then to America."

"I want to see New York skyscrapers with neon lights."

"We will go there and show Grandfather's paintings in museums."

"Where will we live?"

"In Ann Arbor."

"Who is going?"

"All of us—Grandma, you, and me. We are going together. Keep studying English. But don't talk about any of it at school."

"If someone asks?"

"They won't ask if you don't talk."

"I won't talk."

"Good! Come here, I want to kiss your sweet face!"

I let this new information sink in. It feels unsettling. Then I think, If Mama is in the mood for hugs and kisses, everything is going to be all right.

"Emigration is treason," my schoolteacher tells our class. "Only traitors leave our motherland."

When she says it, I feel that she is looking straight at me. I know that nothing is worse than being a traitor, they collaborated with the Nazis and innocent people died.

My teacher says, "Emigrants are spineless drifters who run away when things get hard. We are building communism, it has never been done before, and our enemies want us to fail. But Soviet patriots will persevere and get it done, we will have the best country on earth."

I listen to her and think, I want to build communism. But I also want to be with my mama.

And so it begins for my family. First, Mama needs money. Emigration has substantial costs, and we barely make it from paycheck to paycheck. She decides to swap our apartment on Lenya Golikov Street for a smaller one in the Khrushchev housing projects, which are older and poorly built. She finds a family who wants to swap with us and would pay us for a better apartment. They sign the agreement and now we need an approval from the state residential trust because all housing is owned by state. Weeks go by, Mama is growing more worried with each day of waiting.

"I swear, I will hang myself if this swap falls through," she tells Grandma.

I overhear this and am terrified. I stop thinking about how much I love the boy Leónya Gólikov, and our home that looks like a lighthouse after the rain, the elevator with its sinister cables, the homeless mutts, the crows on an oak branch, the cat on our poplar. And how much I will miss Slávka. And Sahnya the plumber, and our forest. I blot out the corner store with its potato chute, milkshakes, and sugar-glazed buns. And the cinema down the street where I cried my eyes out over *The Little Mermaid*. Our swings and the sandbox, where I still play even though I am eight and all grown up. I want to move to this new place in a different neighborhood, where I know no one. I want to move now, I do.

Finally, the swap goes through and movers come to load our furniture into a truck. Our friends take away the things that won't fit in our new home. Gone is our red couch and Grandma's antique armchair with lion paws, the bookcases with a desk that folds out like a medieval bridge. And the creaky old piano, Red October, that Aunt Kira lent me to

learn to play. Yuri comes with a car and carries down heavy boxes of things that can't be trusted to movers. Neighbors knock to say goodbye. There is a hubbub in our hallway.

Slávka wants to give me one last ride on his new bicycle with big wheels that he just got for his ninth birthday. He tells me to sit on the rack behind him and hold on to him tight. We push off and start riding down the street. The wind whips at my hair, I can't see anything and start feeling queasy. The road ripples under me. I lean sideways. The bicycle tilts. Slávka pumps harder. I lean some more. The bike heaves, wobbles, and tips over. We drag on the asphalt for a stretch. The bicycle, with a jumped chain, lies behind us. Our knees and forearms start to bleed. We walk back and don't not look at each other. We won't cry.

Mama and Grandma begin to prepare documents to apply for state permission to take Grandfather's paintings with us abroad. In the Soviet Union, paintings are not the property of their holders the way a vacuum cleaner might be. Art is considered a national treasure, even if it is willed to an artist's widow and kept in her home, even if it is not Socialist Realism and cannot, for ideological reasons, be exhibited. To take it out of the country, Grandma needs special permission from the Ministry of Culture. She has to make the case that her late husband's art has no cultural value, and the Ministry will then decide.

Mama begins to gather documents. Grandfather's birth and death certificates, his diplomas, and curriculum vitae. An official at the Artists Union writes a letter stating that he knew the artist, saw his work, and has no objections to their

removal from the country. Grandma prepares lists of his artwork. We need to take photos of the oils and the folders with works on paper. Yuri brings his camera, tripod, and floodlights. I watch him set up the lights aimed at the length of tartan fabric on the floor, climb up onto the table, and put a telephoto zoom on his black-and-white Zenit. I think how elegant he looks in a new pair of blue jeans. Grandma puts one of Grandfather's canvases on the tartan. Mama nods. Yuri shoots. I take the artwork away, Grandma puts down the next. Roll after roll until a hundred pieces are photographed. Then Yuri takes the film to his friend's apartment where they set up a darkroom in a bathroom. They bathe the film in chemical solutions procured from some state-owned photography studio, shine light through the film onto sheets of coated paper, and fix the image on the paper with more chemicals. He comes back to us with a pack of shiny photographs, still sticky from being damp. We lay them out on the floor to dry out.

Now everything is gathered, and Mama takes the application to the Leningrad Commission for Cultural Valuables. They review the materials and conclude that this is a prominent artist, and his art is a cultural phenomenon—removal from the USSR is denied.

"With whom do you propose that I leave them?" Mama asks.

"That's not a concern of ours. You may appeal to the All-State Ministry in Moscow if you wish."

"Baloney! They have done nothing for these paintings for the last decade," Mama fumes to Grandma when she gets home. "Fine! You *will* go to Moscow. These are your paintings too. There wouldn't be *his* art without you."

Mama writes out the arguments for Grandma to present to the Moscow ministry:

1. The two of you created these paintings together, you primed every canvas and were with him as he worked.
2. The works have not been exhibited in years.
3. They need constant conservation. The paint is showing stress marks. There will be no one to take care of them after we leave.

Grandma takes an overnight train to Moscow. She stays there for several days waiting for a meeting. Finally, she calls to say that she is coming home. Mama meets her at the train station. Yes, the Ministry in Moscow signed the declaration "Export from the USSR Allowed."

Mama wants to know every detail of how it went, but Grandma is quiet. She looks tired and deflated.

Now we can apply to OVIR, the Department of Visas and Registration. Before submitting her documents, Mama withdraws from her post-graduate program and leaves the job at the computing center at the Railway.

"Never build your happiness on the unhappiness of others," she always says.

Her emigration would bring troubles to her professors and supervisors because they are responsible for the ideological compliance of subordinates. She takes a temporary job at a small cross-country ski rental outside Leningrad, where no one will be hurt by her emigrating. It pays a pittance and is far from home.

Finally, Mama meets with her ex-husband. When she spoke with him before, he agreed to my leaving the country.

Now he has to sign a formal letter of consent. She asks him again about how he feels about my leaving. He is fine with it. He has remarried and doesn't visit me very often. She asks if he is concerned that our moving abroad might affect his job. He is not worried. She asks if he would be willing to sign a letter of consent for me to emigrate, since his name is on my birth certificate. He signs the letter.

At last, she takes our application to OVIR. An officer says that everything looks in order and we will get our permission in several weeks. In a few days she gets a call. I hear her gasp. "What do you mean, no consent?! It's on file, I brought it with my . . ." She hangs up and stares at me. "Your pápochka . . . took back his consent! They won't let you go."

She calls him. He says he began to worry about my future in a foreign country. She meets with him. They talk. He signs another letter of consent. Mama takes it to OVIR. The agent calls back a few days later to say that her ex-hus-band has again withdrawn his consent, and adds that Mama and Grandma are free to leave, as long as the child stays with her father.

"Morons!" Mama says when she hangs up.

She calls Pápohka again. "Tell me the truth this time."

He finally admits that his supervisor told him that if he were to sign this letter, he would never be allowed to travel on international routes. Mama asks him, "Would you be willing to give up legal paternity of Alëna? If you do, we wouldn't need your consent."

He thinks this over and agrees.

Mama talks to Grandma at our kitchen table. "I will have to file a lawsuit to terminate his paternity. The trial will take some time. You and I have our exit visas. I'll stay with Alëna and work this out. But you—you—should go with the paintings now."

"Are you out of your loving mind?"

"You *have* to go now before the permission for the paintings expires. If you don't, we might never get them out again."

"I won't go alone."

"We have this one chance."

"I can't go. I don't know English," says Grandma.

"Learn it."

"How will I carry these paintings?"

"I'll pack and ship them. They will go with long-term luggage and arrive after you get to Ann Arbor. Lyda will help you there."

"What will I do with them there?"

"Wait for me."

"I don't want to wait. I want to be with you and my granddaughter."

"We will come to you."

"I don't want to leave at all. My cousin Kira is here, my Bélochka . . . all my friends. My Academy. The Symphony Hall. The grave of my Felix . . ."

"The grave? Do you think that Felix needs you at his grave? He needs people to see his paintings! Do you want them to rot away in a closet? I am telling you, take the paintings and go, while you can."

I don't know if Grandma is persuaded or simply surrenders. She begins to study English. Every night, she reads an

English-language textbook and listens to the BBC when it isn't jammed. Every morning, Mama gaily says to her, "Just you wait! You'll find a dashing beau there."

"Don't speak skittles, Galia. I have you and my grand-daughter. That's all I need."

She begins to pack her things for the move to Ann Arbor. There is not much to take, and she is only allowed two suitcases. She copies down the addresses of her friends and family in a small telephone book with orange leather jacket that Mama bought for her:

> Cousin Kíra, and my nieces Rina and Lena, Volodya
> Yarmak Street, Leningrad . . .
> Bélochka, Leningrad . . .
> Anna, Deribásovskaya Street, Odessa . . .
> Ólenka, Léninsky Prospect, Moscow . . .

"I will send them all gifts and clothes from America."

"You do that but keep in mind that half of it will be stolen at the customs. And they'll be charged a border tax."

The day before Grandma's departure, Bélochka comes to say goodbye. They talk quietly and their eyes turn red.

"What can we do . . . that's life. We'll write letters." Bélochka says.

Some other friend comes and loudly sobs, "Good god, Lucia! How can you go there? They will never let you back."

"The melodrama," Mama says under her breath.

Grandma is silent.

On the day of Grandma's flight, we get up so early it wasn't worth going to bed. Yuri comes with a car, and we ride to Pulkovo Airport. It is February, dark and snowing. Grandma wears her new felt coat and a turban hat that

Mama custom-ordered from a hat-maker friend. Mama says to Grandma, "You can thank me for being dressed like a Western woman. A looker! Just you wait, an American beau will be after you a week after you arrive in America. Why d'ya laugh?"

"I have you and Alëna. I don't need anyone else."

We stand at the doorway to a secured area where customs agents search luggage and pat down departing passengers. I kiss Grandma's warm cheeks that feel like baked apples. A uniformed man motions for her to go in.

Mama quickly repeats the instructions they went over the night before: "Call me as soon as you land in Vienna. If you can't call, send a telegram. If you can't call from Vienna, call from Italy. If you can't connect to our home number, set up a call to our central post office and send a telegram when to go there. I wrote down their number in your notebook. But don't give your real name. Say 'Maria,' and I'll know it is you. All right, go! The morons are waiting to search your suitcase."

Grandma walks away briskly, then stops and turns to us for a second, waves, and smiles. I follow her with my eyes through the thick bulletproof glass. And then she is gone.

We drive home through the snowed-in Leningrad countryside. It is still dark except for the edge of the sky, turning lavender above the forest. It is cold and empty at home. Mama watches the clock and counts down the hours. Now Grandma must be landing in Vienna. There is no call. Now she has arrived at her refugee hostel. We wait. No call. A day goes by. Still nothing. Mama is desperate. To calm her I say, "If something bad happened, they would have called us."

"Like hell they would."

Six days later we get a telegram instructing us to go to the central post office. An international call. Italy. Maria. The post office is crowded, and the telephone booths are all taken. An hour goes by after our appointed time, then two. There is no place to sit, we swelter in our winter coats. I make blots on postal forms with a steel stylus and liquid ink. Suddenly, Mama hears a voice on the intercom calling her. "Come on, Alëna! Let's go. Quick, before they drop it. And remember, it's 'Aunt Maria.' Guard your tongue, the phones are tapped."

We cram into a little booth. Mama clamps her hand on the receiver as if there were gales of wind. I hear Grandma's faint, distant voice. "Galia?"

"Yes! Yes! Are you all right? Did you get there? . . . You saw Rome? And the weather is warm and sunny? . . . Your room is clean? . . . Yes, she is all right. Do you want to talk to Alëna?"

I take the receiver.

"Alënushka, hello, my darling," says a soft, faraway voice. "I am fine. I am doing well. How are you, my love?"

"We are well here too, Aunt Maria."

I close my eyes. I can feel Grandmother's warm face, see the wrinkles at her temples, the two depressions on her nose where her eyeglasses have just slipped off. I can reach my hand for her. She is not here. I feel I am drowning. I hand the phone back to Mama and walk out of the goddamn booth.

A few weeks after Grandma's departure, Mama takes me, for the first time, to a synagogue on Lermontov Avenue, the only place that has remained open for Jewish services. Now, as I look back on that first visit, the image I retained is of

a stairway with old wooden steps that creaked. I remember them being wide, dark and unfinished, made of silvery aspen, or perhaps it was oak. We walk up tentatively and I feel anxious, not knowing the rules of this strange place. I worry about my posture—am I too prideful, too timid, my footsteps too loud, should I wear a head cover? Two American women stop us to ask something in English, which I don't understand. They leave disappointed and I am abashed for having failed some unclear test, the ritual of initiation by my future compatriots.

We arrive at the balcony where women must sit. An old rabbi in a black silk frock sings out prayers that sound muffled up on the balcony. There are only a few men down below and rows of empty seats. I watch black round circles of their ritual head covering moving back and forth to the rhythm of the prayers and whisper to Mama, Why can't we also sit there? After a while we go downstairs and out to the courtyard. There Mama sees a young man and strikes up a conversation. She asks if he comes here often. He does. She tells him that her mother just left for the US, while we were refused our exit visa. They talk for a long time. After a while, the man, Lev Furman, invites her to his Hebrew study group. He says that she shouldn't talk to anyone about these lessons. She asks if she looks like a fool. They both laugh. He tells her to be careful, they are being watched by the police. After we leave, I ask Mama, "How come these lessons are a crime?" She tells me, "Watch what you say to others, this secret does not belong to you."

She goes to Lev Furman's study group one night, and I stay at home alone worrying if she is being followed. When she comes back, she takes out a folder and hands me a page

with words written in Hebrew letters. She says, "This is a sacred language, you should learn it too." The letters are nothing like Cyrillic or English. They look husky and well-built, like little weightlifters. I especially like Alef, that looks like someone's running and waving "Hello" with their arms. And Bet looks like an eye under a thick eyebrow. I try to make sense of why a language should have only consonants. In Hebrew, vowels are small markings below the line, and are often omitted. Then I think that these vowels are like women on the temple's balcony or Jews in the streets of our neighborhood. We are all here. The words can't be said without our voices, and yet we are unseen.

The Moscow 1980 Olympic Games are about to start, and our school prepares us for foreign visitors. "Be proud, don't ask them for gifts. Don't take anything from those capitalist exploiters. They hide razor blades in the chewing gum they give you."

"Why would they do that?" someone asks.

"Because they hate our way of life and want us to die."

Ach, who cares. Everyone can't wait for the games to start. Leningrad is getting ready to showcase its beauty. The main streets are scrubbed, potholes repaired, lawns reseeded, and faded stucco gets a fresh coat of paint. Window washers with squeegees hang in flimsy baskets, suspended by ropes from cornices several floors above ground, holding on for dear life in gusts of Leningrad wind.

We count down the days before the games. And then suddenly the newspapers announce that the United States and the NATO countries have decided to boycott our games.

The news anchorman says that the decision is an egregious act of aggression against the Soviet Union by the capitalist Western world. Nevertheless, the games will go on with our friends in the Eastern bloc.

Then rumors spread about the war in Afghanistan. During our GTO class (*Gotov k Trudu i Oborone*, or "Get ready for Toil and Defense"), we learn how to put on a gas mask, the stinky rubber nauseates me. The GTO teacher says, "Don't pull on the ring for oxygen. Not yet. You'll do it in the event of a nuclear attack and then hide in a closet."

There is a compulsory military draft for all boys after high school. Now their parents will do anything to keep sons from this useless war. They will pay off doctors to get medical exclusions, bribe college admissions to get them in, which will delay the draft, forge birthdates on their birth certificates to gain one more year. Youths who can't get out of the army any other way deliberately injure themselves—better to limp all your life than to come home in a bag. People who apply for emigration begin to say that soon OVIR will stop issuing exit visas. Mama grows more worried about Grandma being alone in Ann Arbor. We must speed up the paternity trial before it's too late.

Pápochka

THE MAN FROM MAMA'S WEDDING photo is never named in our home. Talking to me, Mama calls him "your so-called pápochka," in conversations with Grandma "an alcoholic," with a shudder. Never *kisúlechka*, a little kitten, or a fair and honest working man. Not even "my ex-husband," he is mine, never hers. He, on the other hand, always looks at her with quiet astonishment and a hint of regret, as one might at a winning ticket that is past due and cannot be redeemed.

Mama is ten years younger than he is and has substantially more education. The bright, witty, and beautiful daughter of a prominent artist, a trophy wife for a Russian man. But who was he in that mismatched marriage? Perhaps an accidental bystander. He was not without good qualities, but she was never able to fully grasp them.

She met him at work, he was a technician for refrigerated trains and she a young engineer at a new computing center, a trail-blazing project of the State October Railway. At that time, she was enamored of the working class through the poetic images of Vladimir Mayakovsky, the art of the early Soviet avant-garde, and her father's paintings. Despite the odds, he summoned the courage to ask her for a date, and surprisingly she said yes. When much later she

got pregnant by a handsome architect, her father's former student, Pápochka offered to marry her and put his name on my birth certificate. And then, given the Russian prejudice against unmarried mothers and against children out of wedlock, she had no choice but to say yes.

At the beginning of their brief marriage, Pápochka traveled on refrigerated trains on domestic routes. But toward its chaotic, crumbling end, he was transferred to an international line, Leningrad–Helsinki. This was a tremendous change in his situation and a stroke of luck, another winning ticket, but one he could make full use of. For a Soviet man, Finland is not a quiet place in eastern Scandinavia, known for good schools, saunas, and environmentally conscious modernism. Oh, no. Finland is the free world, entirely apart from Bulgaria, Poland, Yugoslavia, and our other friends of the Eastern bloc. Finland is a window to capitalism, closed to all Soviet citizens except for the lucky few who are allowed to travel there, and those who watch them. The vigilant eyes of the Motherland are never shut.

Also, on Helsinki–Leningrad trains, enterprising Finns and Soviet black marketeers import Finnish mohair, nylon, and used jeans to sell on the corners of Nevsky Avenue. On returning home, they export vodka, fur, and Russian icons, packed inside the interior casing of a train car. All of this is illegal. Nothing can be done without the help of the train crew. And oh yes, the crew do help planting the seeds of the free international commerce. At other times they squash it by reporting it to the KGB. It all depends on who is in on that game and whose eyes they serve. Now, years later, I doubt that my pápochka was an informant or a player in illegal transactions. He was too timid. I believe he was one

of those lucky honest people with indispensable technical skills.

I barely remember Pápochka living with us. Mama divorced him so soon that our life together did not find its way into my memory. I seem to remember that he wore a white sleeveless undershirt at home, and his pale shoulders were made of dough. He had graying stubble and a tattoo of an anchor. He showed me a photograph of a smiling young man with dimples on his cheeks and a headful of blond hair, wearing a striped sailor's shirt. "This is Papa when he served in the navy," he said, speaking about himself in the third person.

I wish I had known him when he was that young man. I never met his parents. His mother died and his father lived in a remote village in Central Russia, where Pápochka grew up. The old man never came to Leningrad and Pápochka never took me there. He had no brothers or sisters, no friends.

He had a taste for elegant clothes and wore a Victorian-style coat with a short cape and a felt fedora with two small feathers tucked into its ribbon. And since a gentleman is recognized by his footwear, he bought expensive leather shoes with elevator heels to raise his stature.

After the divorce, he continued to visit me, unlike many Russian fathers of the 1970s who systematically disappeared after marital separation. When I was small, he brought surprises from Finland—chocolate eggs with toys inside, greenhouse tomatoes in the winter, canned pineapple, a pink snowsuit, and chewing gum, no hidden blades. None of that was sold in Leningrad stores. One New Year's Eve when I was five, Father Frost showed up at the door, he had

Pápochka's voice. He came with a bag of gifts—little plastic animals, which I remember in detail—a spotted giraffe, a yellow tiger, a hippopotamus with a sharp horn, a brown monkey with textured coat, and a black panther. They didn't look like any toys we could buy in Leningrad. I loved that menagerie and kept it on a stool by my bed.

He offered to bring gifts for Mama too, but she said, "No, I have what I need."

A few years later, she refused his alimony.

When he called, she said a terse hello and gave me the phone with "Guard your tongue." It was easy, because Pápochka was not chatty. When he visited, we walked up and down the street. Sometimes he would say, "Look how grown-up you are, too big for me to put you on my shoulders," or "Look at you, your hair is so light, just like Papa's."

Then he would take me to the corner store for a glass of juice.

Oh, that juice! It was magic, dispensed from conical glass jars with chrome faucets at the bottom. Apple, pear, peach, and my favorite, the juice of a birch tree that always made me hum a Soviet hit song, "Belovezhskaya Woodland":

> *I will warm my heart by your tall birches,*
> *I will carry your sacred, wondrous melody,*
> *To bring solace to the living,*
> *Belovezhskaya woodland, Belovezhskaya woodland.*

A saleswoman poured the nectar into a thick, faceted tumbler with a chipped edge and a smudge of lipstick, which she rinsed under cold water between customers. In the days of tuberculosis and other infectious illnesses of the 1970s, Mama and Grandma would never let me drink juice from

that glass. But Pápochka did. And while I savored it, he slipped out to a liquor stall, where men with swollen faces and no day jobs gathered in the mornings. He returned with a golden pint and a foaming smile. "Papa bought himself some juice too," he would say with a tinge of guilt.

Pápochka drank. Oh yes, he did. He drank blissfully, without anguish, strain, fury, or bitterness. He drank with the innocence of a child, meekly and with the reverence of a devout believer. He drank discreetly. When he was drunk, he was calm as a lake on a windless day. His drinking began in the morning when the liquor stalls opened, and he returned in the afternoon with a sour stench. Wibble-wobble, he walked down the corridor swaying from side to side like a sailor on deck in rough waters, his arms spread out grabbing at the flowers on the wallpaper.

"You inebriated creep! Don't you ever come home drunk again," Mama told him.

"Galia? Why'd you say this in front of our daughter? I'm not drunk, I'm just tired."

Grandma would bring him his slippers and take me to my room. "Let's go, Alënushka, Papa has to rest."

Sometimes the police picked him up on the street and took him to the drunkards' ward for the night. He was rarely alone there. There were plenty of men and a few women, gathered from garden benches, back alleys, and the subway trains. Life as usual in the Leningrad of the '70s. Later he remarried and I saw him less and less. Back then, and in my years growing up, I thought he meant nothing to me, that our meetings were a required formality. I felt little more than pity for this doughy, unremarkable man. He was a lie we all agreed to keep secret. But now, remembering him, I think

I was glad for his presence and affection. Whatever he was, flawed and weak, he was mine.

The year of the civil lawsuit for paternity dissolution is a blur. I go through the motions. I walk to school and write letters to Grandma-Aunt-Maria. I miss her. I guard my tongue with everyone and stay away from my friends. No one knows about our plans to emigrate, or my grandmother being abroad. A nagging, dull, relentless loneliness takes hold of me.

Our lives change. Our phone is tapped, the Secret Service listens in. "Don't give them anything interesting," Mama tells me. We no longer host dinner parties and Mama doesn't laugh for hours with her friends. On the phone, she speaks briefly and in code. She quits her job at the skiing club and takes another one closer to home—at a super-market. I remember visiting her there and waiting for her in the back room that smells of damp vegetables, sour milk, and wet cardboard. A saleswoman, Mama's coworker, comes up to me smiling, when Mama is not there, and hands me two packed canvas bags, covered with fabric to hide what's in them. She tells me to carry these bags out through a back door and to meet her down the street. I can't say no to an adult, so I carry these bags for her. I feel my lips and the roof of my mouth turning dry. I imagine a policeman stopping me and asking why I stole these things, and me, unwilling to rat, going to jail. Mama quits her supermarket job soon after that. She takes another position at a hair salon at a state-run beauty network called Kosmétika (Cosmetics). She wants to learn to cut hair so she can start working while she learns

English in America. It's a temporary job, but something clicks and she starts putting in long hours, coming home late, getting lost in the work. She works as a director of two salons, then as a manager of a district branch. I spend my time at home alone and doing chores, shopping, cooking, and laundry, everything that Grandma and I used to do together.

Grandma sends letters from Ann Arbor. "Everything is fine . . . The paintings arrived . . . I went to Greece . . . I visited London."

She sends us clothes and we have to pay a modest tax for every garment and a huge tax, a quarter of Mama's monthly paycheck, for a small blue scarf. The wink of the Soviet customs, their irony. Still, these clothes are the latest fashion of the '80s, unique and valuable here. We marvel at everything she sends—jeans, pullovers, denim jumpsuits, knitted ankle warmers, and striped loop scarves, oversized sweaters with bold patterns, dresses with shoulder pads that will double as floaters. Velour and velvet. And nylon nighties that someone will wear as an evening gown in Leningrad.

Mama takes nothing for herself and wears her old green sweater with a repaired tear. She takes some things to Aunt Kira and Rina, and to Grandma's friends. She asks me what I want and lets me keep it. I pick out a few pretty things, they hold a touch of my grandmother. But I don't need much. Everyone wears the same things every day—less laundry that way. And you don't want to stand out. If you do, kids will call you *módnitsa*, candy girl, fashion-monger, nose-in-the-air, and a stuck-up, and ask where you got all of that. Mama sells the rest of what Grandma sends to neighbors through word of mouth. It's not quite legal, but it is not a black market

either. A gray market of sorts. She sets the money aside for
when we need it.

Sometimes, Yuri, Mama, and I gather at the home of Big
Sergéy, the jokester friend who came to our dinner parties,
and his son, Seryózha. They live in two rooms in a communal
flat. Seryózha's mother defected to America several years ago
when Seryózha was a young boy. She went to New York
as a tourist and did not come back. Now every six months
she sends them her formal invitation to reunite with her in
America. Sergéy takes it to OVIR and each time gets refused
with "not in the interests of the state."

What interest does the state have in him living here?

After she defected, he lost his job as an architect at the
LenProyekt, the prestigious state-run Leningrad building
design services. Now he takes odd jobs for the record, or else
he would go to prison for "parasitism." Every able-bodied
Soviet citizen must work. These jobs pay very little, and to
supplement, he makes money on the side by sewing jeans
and selling them on the black market. He stitches the Levi
or Adidas logo onto the back pockets and sews on brand
labels he cuts off the clothes his wife sends for his son. The
counterfeit pays well on the streets of Leningrad.

Little Seryózha has clothes and toys from America
unimaginable to a regular kid in our city. Parkas, wind-
breakers, reversible jackets with Velcro, zippers, and pockets
in uncanny spots and in colors seen only on an artist's
palette. These are brand names, L.L.Bean, Lacoste, and
Patagonia, which I never heard of before, despite my grand-
mother's parcels from Ann Arbor. He has a model railway

with true-to-life signals, stations, trains, and cars with radio controls that he rams into walls and furniture to make me laugh. He is not worried when something gets broken. There is more. He always lets me play with everything he has. Seryózha is kind, as happens sometimes with people who have lost something important. He has everything except his mother. Just her voice on the phone.

He writes "U.S.A." in big letters on the dusty screen of their TV. He plays an Elvis record that his mother sent him. "Listen to this! It's *kaif*, it's groovy," he tells me.

Big Sergéy says to Mama after having a drink, "To hell with it! I'm tired of living out of a suitcase. I'll get divorced and start my life over." But for now, the shades in their rooms are always drawn, because the two of them are being watched. They are *refuseniks*, dissidents, without having intended it, living out of a suitcase, but trapped.

The calendar turns to 1981. The district civil court sets a date to hear our paternity dissolution case. Years later as I write these pages, I have no vivid memories of that trial. I can vaguely visualize the Kirovsky district court building, where the trial was held, as a grand and foreboding building, meant to stir awe and reverence for the people's justice. But years later, "walking" around it now on Google Earth, I see a modest concrete structure, weathered and stained, a touching tribute to the aspirations of early Soviet modernism. I don't remember the rooms and the people who were there. I seem to recall a wood-paneled space where I was taken to speak to the judge about my preferences. But the wood paneling may have been transplanted into those memories from courtroom

scenes in American movies. I don't remember any complex feelings toward my pápochka, my father. I wasn't hurt or sad for his giving me up. I didn't consider his feelings about his losing his daughter. I wanted to be done with what felt like a charade. Above all, I wanted *my* family, the three us, the girls, to be together.

The limp clumps of memory that resurface are of my mother and me sitting in the waiting room, Aunt Rina walking in to testify in support of our case. Other people are there too. But not my father. A large woman in a tight skirt takes me, alone, to a small windowless room. A pleasant, friendly man in a suit asks me, "Who do you live with now?"

"With my mama."

"Which of your parents do you want to stay with?"

"With Mama."

"How often do you see your father?"

"Not often."

I am led back to the warm and stuffy waiting room. Then I remember Mama being called in. She turns pale and walks as if she is stepping on melting ice. I wait by the door. She comes back with her eyes shining. "We won the case! The court ruled to dissolve the paternity. We can go to Grandma!"

My heart skips. I am so happy. Thrilled. Ecstatic. I could bounce to the ceiling. I hug Mama. Of course, I am happy. For sure . . . Then a small shy voice in my head asks, What about Pápochka? I feel my armor being breached and a slow drip of sadness setting in. I think back to the last time he took me to a zoo; for some reason he talked about the colors red and black; fine colors they are individually, but put them together and they turn into the colors of a mourning

procession. So they are, in Russian tradition—a red flag with black crepe, a black casket with a red ribbon. That was the last time I saw him.

To Fairyland

MAMA BEGINS TO SORT our belongings. She needs to get special permission for the remainder of Grandfather's sketches and a roll of dark Babi Yar paintings that Grandma didn't want to take with her when she left. We have to give away much of what we own because it is banned from being taken abroad—old books, cut glass, amber, antique objects, rugs, and archival documents. Every day, friends come to say goodbye and they leave with a piece of my childhood. Aunt Kira takes away Grandma's hand-cranked Singer that we used together, I cranking the wheel, Grandma guiding the seam. Someone takes our pot-bellied black-and-white TV. The pressure cooker is heading off to a neighbor, good riddance. Our cookbook, with food stains and Grandma's handwritten notes, goes to Bélochka. All of my picture books and Grandfather's art catalogues, which he collected by saving money on food and clothes, end up in the used bookstore. Mama's favorite white-and-blue vase goes to Kiera Ivanovna, a ceramic artist, who had designed it for my grandparents back in the '60s. It held every rose and carnation ever brought to our home, and Grandfather painted it in Mama's portrait.

By and by, our home becomes empty. Suitcases huddle

in the corner. Dust bunnies gather along the walls and when the draft prods at them, they slowly float from place to place. Every day, Mama goes downtown to shop for gifts for people she will meet in America—Russian wooden crafts, tins, trays, enamel brooches, and shawls with bright flowers and mottled fringes, which Russians wear on cold winter days and Americans don't, but might drape over cupboards holding some forsaken old country *samovar* they will have purchased at a yard sale in Brooklyn or, years later, on eBay from immigrants' descendants. She brings souvenir playing cards with pictures of harlequins, theater binoculars that are mostly useless, but she can't find, let alone afford, the military ones so valued in Rome. And a brown teddy bear, a mascot of the Moscow 1980 Olympic Games. "These are collectibles," she says emphatically. "You may get top dollar for them one day." Then she brings home a spear gun, an accident in the making.

"Going fishing, Mama? There is no sea in Ann Arbor."

"There are five lakes nearby—learn your geography. And the Mediterranean Sea in Italy. Okay? Fine. A saleswoman set it aside for me at Gostinniy Dvor, I couldn't say no. Maybe we'll sell it at a flea market and have some money to travel. Do you want to see Venice? Can you believe we will soon see the world?"

I don't know why Mama puts off our departure and why she goes to the center of Leningrad every day.

"Look what I found, Alëna," she says as she puts down a painted rooster and a horse on the table. "See here, this is the year of the Rooster and it's our sign in the Chinese horoscope! You take this happy guy with flowers, and I'll take that sad little horse."

"Why are you sad, Mama?"

"Who said I am sad? I am just joking, Alën'. Why do you take everything for a silver coin?"

May arrives. I want to go to the May Day parade. Mama says no. The day after, there is a trail of ripped balloons, flags, and candy wrappers trampled in the mud, where the parade had passed.

"I don't like May," Mama says. "May is unlucky. We won't travel in May."

A subpoena arrives in the mail, a request to make a witness statement for some ongoing and unspecified investigation. No signature required. Sent by the OBKhSS, the state law-enforcement agency for combating economic crimes.

"What should I do?" Mama asks Yuri.

"Get on the next flight out of the country."

"What should I be afraid of? I have never broken the law. No, I'll go and answer their questions. This might be about Kosmétika, and maybe help exonerate someone."

I remember coming home from school on the day she went there, to find three men scouring our nearly empty apartment, flipping over what's left of our things—our bedsheets, pillows, our clothes, bedding, books, crafts, and suitcases. Mama stood in our tiny hallway, leaning against a door jamb, looking as if she were not present in the moment. *Movers?* But these men were not picking up but scattering. *Burglars?*

"Who are these people, Mama?"

"Go for a walk, Alëna."

One of the men overheard her and said to his crew, "We are almost done here. Let's go."

Another man walks out of the bedroom, carrying a dusty bottle of rubbing alcohol and a couple of small manicure sets that I used to trim my Olympic teddy bear's toes.

"Mama, are these men from your work?"

The men leave. She sits down, lights a cigarette, and stays silent.

"Mama! Mam'. . . Mam! Mama!"

"They took our visas."

The Mediterranean. Rome. Ann Arbor. Grandma. A cold feeling of collapse sets in. An ugly double extracts herself from my chest, turns toward me, and points her finger, cackling, "You thought you could dream of all that? A loser! You deserve nothing."

Our empty kitchen shimmers, the walls pixelate and dissolve into white. Mama stays as still as an ancient sphinx, swaddled in a quivering smoke. Her lungs contract and expand, contract and expand, taking in the poison. I keep my eyes, wide open, unblinking, fixed on her. She is safe while she stays in the frame of my view. In my eyes, she grows large, the curve of her nape and shoulders become the ridge of a mountain. Then she contracts—a child, whom I failed to protect. My child-Mama. I don't yet know what is happening, except that disaster is coming. This feeling will never leave me. It will grow with the years and take over my happiest moments—our family holidays, the birth of my children.

"When will they give back our visas, Mama? Let's go right away."

"They've brought criminal charges against me. We can't leave, Alëna."

Within and Without

UNLUCKY MAY ENDED AND the summer slowly trickled out, leaving murky stains of hopelessness. There were new words in our home—criminal court, penal statutes, prosecutor, defense attorney. The date of the criminal trial was set for September 15, 1981. Mama left in the morning. Zhenia came in the afternoon and took me to her home.

We shall overcome!
We shall overco-oooome!
We shall overcome, some daaaay!

This is the song my class sings when foreign visitors tour our school. Groups from East Germany, Hungary, Czechoslovakia, and occasionally from the United States come here because my school, with its intensive English curriculum, is a showcase of our district. They come to meet the exemplary Soviet children, the young pioneers. And here I am, a refusenik and the daughter of a convict, singing.

The foreigners, shy and curious, shuffle into our classroom. "Hello, children!"

We stand tall at our desks and answer in flawless unison, "Good mooorrrnin'! How do you do?" We stand with Angela Davis, who we see on TV in faraway America, where human

rights are breached and where police break up riots with water hoses.

My school principal, Rimma Pavlovna, allowed Zhenia to transfer her son, Maxik, to my school. Zhenia had told her that she couldn't take care of two children studying in different places. After school, Maxik and I walk home together. We stop at the ice-cream parlor on the ground floor of Zhenia's residential high-rise. A roly-poly saleswoman in a white smock and baker hat asks, "What do you want?"

We want everything, but meekly ask for a scoop of chocolate and a scoop of blueberry ice-cream to share. She looks at us stone-faced, without any sign she has heard us. We stand still. She glumly takes out a metal scoop, dips it into warm milky water, and carves out flawless, glistening, perfectly round, bliss-infused scoopfuls. Yes, she heard us. She puts them into a stainless-steel chalice. Pours fluorescent, honey-colored syrup. Plants two spoons. Then, suddenly, she melts into a smile. "Here you are, *sladkoéshki*, you sweet-tooth darlings. Don't you drop it, eat for your health!"

We come home, high on sugar. We prance in the corridor and spray each other with water guns. Zhenia's parents, Maxik's grandparents, beg us to please be very careful on the wet floor! We have our lunch in the kitchen while they stand by the stove, asking Maxik about his day at school. After lunch they invite us to their room for chocolates. We go in and sit for a while in their soft, wide, brightly upholstered armchair warmed by the sun.

When Zhenia comes home in the evening, she tells us that she wants to get a puppy—a boxer or a bulldog, a protective friend. She says, "Then no one would dare touch you." Maxik and I dream about the puppy, how it will walk

with us to school, carrying our backpacks, while our class-mates, green with envy, will ask us to let them pet it.

Grandma sends parcels from Ann Arbor for Zhenia and her family, Aunt Kira, Aunt Rina, and me. She sends coats, winter jackets, dresses, shoes, boots, blue jeans, turtle-neck sweaters, knitted scarfs in bright colors, and hats with pom-poms, nylon pantyhose, lacy underwear and bras, and canned ground coffee. Some things are set aside to be sold. Trading foreign goods in a socialist economy is illegal and you have to be careful. Yuri handles this and sells to the people he knows. The money goes to Zhenia for my food and upkeep, and some on top for Zhenia's own spending. One day Yuri comes with a new sleeper ottoman, which he bought for me on the money from some of these sales. Now I have a bed of my own, and neither Maxik nor I have to sleep on the squeaky aluminum cot. He sets it up in Maxik's room, and I glow with pride when I find it there after school. The ottoman is as elegant as the man who chose it, light brown, with soft pillows and a firm mattress that is good for my back. It turns into a couch during the day, and when I sit on it I think of Yuri and my grandma.

In the evenings, when I want to be left alone, I pick out a book from Zhenia's vast library of world classics. Here is Dumas, Conan Doyle, Dickens, and shelves full of the nineteenth-century Russian writers, Lev Tolstoy, Anton Chekhov, Aleksandr Pushkin, Ivan Turgenev, and more. I start reading *War and Peace* and get lost in it. I imagine myself as Countess Natasha Rostova and fall in love with Prince Andrei Bolkonsky. Natasha breaks my heart when she runs off with another, and then marries clumsy Count Pierre Bezukhov.

"Why awkward Pierre?" I ask Zhenia when she comes home from work.

Zhenia trained to be a teacher of Russian literature, but after applying for emigration she couldn't get a job at school. She says, "Pierre is awkward but kind, while Prince Bolkonsky is principled and unforgiving. Life, I'm afraid, needs heart and compromise." Then she smiles and adds, "I am so glad that you are staying with us and we are friends, Alëna. I can talk with you, girl to girl."

I suddenly notice that I have gotten used to Zhenia, her lipless smile and sharp elbows, her slouching and skidding down the corridor. Something sinks inside me. I *do not want* to get used to anyone. I don't need friends. I am waiting for Mama.

I buy a map of Leningrad and go to Krestí Prison. They won't let me in, I know. I know! I just want to be near where she is. Perhaps I can stand by the wall and shout, "Mama!" She will recognize my voice and look out the window. I walk up to Krestí. It is a massive compound behind a blind red-brick wall and its windows are covered with metal louvers. No one will hear me shouting or look out. I go away. There is a zoo nearby. The animals are behind bars just like the prisoners, but at least I can see their eyes.

Life goes on. Winter comes. Days become short. Nights eat away at the daylight. There are breakfasts of fried toast and sunny-side-up eggs, the grandparents' borscht after school, and Zhenia's hot dogs and mash in the evenings. Long months drag on. I go to school. I go to my forest. I read. I wait. Winter brings the flu season but now I can't see a

doctor at my pediatric clinic. They serve only children who live in that neighborhood, and I do not. I don't have an address and so, no clinic. Mama once took me to her friend Rita's hospital, where Rita helped arrange a visit with a lung doctor. Yuri puts me in touch with her. She agrees to meet with me. When I come to her hospital, a nurse meets me in a hallway and takes me to a back room that looks like a closet. I sit there for a long time. Then I hear a knock and Rita opens the door just a sliver. She looks up and down the corridor, then slides in and sits stiffly on the edge of a chair some distance away. None of her usual hugs and kisses. She is wearing a white mask and stays quiet for a while. Then she takes off her mask. "Alëna, please don't come here again." Her face turns red and becomes darker than her teased, bleached-blond hair. She says something about her son Sasha . . . applying to medical school . . . the involved risks . . . Afghanistan. Her words clang and scrape, like pebbles on a metal roof. She gets up and says, "I am so sorry."

There are tears in her eyes. She is afraid.

And I am afraid that everyone will turn away from me if they find out what had happened. My music teacher, for example. Zhenia says that I must tell him about Mama. I can't. He will stop teaching me. She insists. She accompanies me to my next music lesson, struts into his small studio at the House of Culture, and, in a dramatic speech with pointed pauses, tells him about our failed emigration, my grandmother in America, my mother in prison. I want to melt and seep away through the cracks in the floor. She throws back her head, her voice ringing, "Will you keep teaching Alëna?" Victor Ivanovich replies quietly, "I don't see why not. She can come to my home. It would be closer for her."

Every Sunday morning, I walk, humming a tune, with my guitar in my hand, to my music teacher. I knock on his door. He opens wearing his plaid house shoes. His home smells of oatmeal. His wife waves to me from the kitchen. We go to his music room where he has set up two chairs and two small footrests for him and me. There is a new score on his music stand, which he copied for me in longhand the night before. He tunes my guitar. "Shall we start?"

He is lanky, with crimpled lips and a wide forehead. Not handsome, but I like his looks. He takes his guitar and shows me how to hold my left hand on the fretboard. "The wrist must be round, like it's holding an apple. The fingers must look like little hammers on the strings."

Metal strings are harsh on my fingers, high E cuts into flesh.

"The little hammers are hurting," I tell him.

"The pain will go away once you grow calluses."

He takes out a new set of nylon strings from his credenza. You can't find this type of strings in stores, only professional musicians get them. He takes off my metal strings and puts these precious ones on my guitar.

"They will be gentler on your fingers, but music begins with your heart. If you listen and feel, your fingers will follow. If you don't, your hands will stay cold, and so will your listeners."

I play Villa-Lobos, Scarlatti, Fernando Sor, and Baroque music written for the lute, which my teacher transcribed for guitar. He plays Bach for me. There is no music more sacred, he says. He talks about polyphony and counterpoint. "Here are two, even three voices. Can you hear them talk?"

I listen. His guitar is gentle. I hear his fingers sliding

along the strings. They sound like doors opening, it's another voice.

He gives me a Bible, a thick volume with a dark, worn, leather binding and silver-rimmed pages. He says, "Read it so you can better understand Bach's music."

Bibles are not sold in Soviet bookstores. They have been taken out of library circulation. None are offered at our schools. Churches, except for a few, have been torn down or converted to other uses. The Kazan Cathedral in the center of Leningrad has become the Museum of Inquisition. I think back to my old first-grade teacher who taught us, There is no god. Believe in communism! She did as she was told. But not my music teacher. Another person would not give his Bible to the daughter of a convict in a police state that hunts down its dissenters. He offers it to me without hesitation. His three-part polyphony is courage, kindness, and faith. Years later, I still think of him as a remarkable man.

At night, when everyone is asleep, I read the Old Testament. In Jacob's dream:

> *A stairway was set on the ground and its top reached to the sky, and angels of the Lord were going up and down on it.*

I keep reading about the patience of Job, and the story of Jonah and the whale. I read all five books of Moses, the Judges, the Prophets, and the Kings, then the New Testament. All of it is new and difficult and I have no one to talk to about it. Why is there a stairwell in the sky if angels can fly? Why, when the army captures a city, it has to save the trees but kill all of its residents? Why is Tamar a righteous woman? Why should Yael kill a man to whom she has offered refuge? Why, when struck on the cheek, must one

turn the other? I read Ecclesiastes, and it gives shape to my feelings:

> *That which is crooked cannot be made straight: and that which is wanting cannot be numbered.*

After New Year, Zhenia asks me to move out. Yuri comes when I am at school to take my suitcase and my brown woven sleeper ottoman. He brings Zhenia the last payment and takes my belongings to my aunts. They don't ask questions, and I am grateful. Together we decide not to tell Mama about this change. Why add to her worries? Nor do we inform the authorities—my aunts have too little space for me to reside there legally. A small voice in my head asks, Why won't Yuri take me to live with him? I could help him cook and clean. But as I sure know, he has no place of his own.

From Mama's letters I know that she was transferred to the Sáblino penal labor camp. From there she can send letters to me and I to her. In February, she writes that she will be allowed to have one overnight visit from family and asks if I want to come. I have not seen her for six months. Oh! We will be together for three days and two nights—three magical, blissful days with my mama.

How we prepare for this visit! I shop for nutritious foods, whatever I can find this time of year—black bread, butter and tea, oranges, green scallions and garlic. Yuri buys two blocks of Opal cigarettes, ten packs per block, twenty cigarettes per pack, four hundred smokes, as Mama asked. Aunt Rina scouts all over town looking for sweets. She finds *petit fours* that are new to Leningrad, shaped like Japanese

netsuke. One of them has a tiny schooner set in a sea of cream, a replica of the Admiralty's weathervane.

"Leningrad's landmark is a touching memento," I say with irony.

"Let it be our joke," Aunt Rina replies.

Early one morning in March, on the day of the visit, Yuri and Aunt Rina take me by train to a desolate, snow-bound place. The bus from the station to the Sáblino labor camp does not come, so we start walking down the narrow strip between the highway and the forest. Limp, flaccid snow melts underfoot. Steam, slime, and rotting grass rise inside our footstep caverns. Dark green water trickles in little springs and pools up on the highway. A third of the way there, our belated bus comes wheezing up behind us. Aunt Rina and I turn around and wave for it to stop. It comes closer and slows down, then, when it's right next to us, speeds up. Its wheels throw up black slosh that hangs in the air for a moment, like a Jolly Roger, then plummets onto our heads. We keep walking.

In the waiting hall of the *zóna*'s administration building the ceilings are low, and Leonid Brezhnev looks sternly from the wall down at visitors. A military officer searches my bags, a woman officer checks my documents and then does a pat-down. A guard leads me to a door to the visitation wing. I go down a narrow corridor and there I see Mama. She is walking toward me, youthful and slim, wearing a dark-blue cotton prison dress. Everything looks good on her, I think, and tears squirt out like a shameful spasm of vomit.

"Here, quick. Why should they see us like that?" she says to me quietly and steps into a small room. I follow her, the warden closes the door behind us.

"*Dóchenka*, my love," she says and kisses me. I see her lips. Then I see her teeth. And the reality of prison hits me. I think with horror, How will a man ever kiss her again?!

The teeth. These horrible inmate teeth, the branding of Soviet incarceration. Not the smooth white pearls of the free, but crumpled bits that look like chewed-up gum, thinned at the roots and wobbling, with wide gaps in between. They are set in the gums, red and swollen from chain-smoking, a vitamin deficiency, and a touch of scurvy. I will see these teeth on every man and woman who has spent time in a Soviet prison. No matter how long their sentences are, all convicts come out with those teeth. Dental disease starts the first day and keeps progressing. Infection settles into the gums and eats away the enamel, it reaches the roots, then the bone. It brings chronic pain. It hurts to chew or drink. The teeth ache from both cold and hot foods. Shame comes along. Too much shame to smile, kiss, or fall in love. The teeth keep deteriorating, their alignment shifts, bringing the dreaded TMD disease with headaches and radiating pain in the arms and shoulders. It hurts to walk and to lie down. One can never be free of this pain. It burns like a memorial candle, a reminder of the abuse and violence of the law in a place of lawlessness.

I am silent. Mama is silent. Small talk seems absurd, serious talk feels trite. In these first minutes of our time together, food comes in handy.

"Mama, look at these *petit fours*."

"Open them up, Alёna, let's go for it!"

I open the pastry. She picks up a pack of cigarettes and a box of matches, walks to a window and strikes a match on the side of the box. It doesn't light up. She strikes again, and

again, angrily, losing patience with each dull, unproductive stroke.

"Motherfucker!"

Never have I heard her use these words before. She had her colorful set of swears—*parazít* (parasite), *zaráza* (infection), and *nakhal* (saucebox). Here they have turned into word-monsters: motherfuckers, cunts, dicks, and whores. She says them without malice, but as tired breaths, the punctuation of a penal life.

I repeat after her, "Asshole!"

She looks at me mournfully. "Don't you ever repeat these words! Good girls do not speak like that."

"And you, my good Mama?"

She strikes another match and I make a wish: Let this one light up—for good luck. It does. She bites into the filter, clutching the cigarette in her fist, leaning over it. She sucks in the smoke and exhales. She smokes it to the edge of the filter, then coughs and reaches for the next one. "I know it's bad. I will quit, Alëna, I promise."

I think, I will swing my arm and a magic carpet will appear. I will swing it again and the wall will warp and open. We will put on our see-me-not hats, climb on the carpet and hold onto its fringes. Fliff! Off we go! Fly! Fly away! We will fly above the clouds, and everything down below will look like toys.

Mama, what happened? Tell me about yourself . . .

PART TWO

Galia

The Rain You Accidentally Saw

ALËNA, DÓCHENKA, MY LOVE, you have asked me to tell you what happened. It has been something I've been unwilling or unable to do . . . Years have gone by. You became a mother, your children are growing up. And still I can't fully speak about my life.

I wanted to forget the past, to let go of it. But I couldn't. I was constantly steeped in it. I felt terrible guilt for having hurt my mother and you. The feeling grew stronger as my mother became frail toward the end of her life. The guilt was unbearable. I felt anger at those who perpetuated injustice against the two of you. I also felt rage at myself for allowing it to happen.

Remembering the past is living it over again. My past became my present. It would suddenly appear in the midst of my day. Certain situations would throw me back toward it. When it burst, my life stopped being mine, I lost control over it. My past warped my reality; I saw everything through its lens. New events did not start with a clean slate but in the shadows of pain from long ago. It felt like watching a harrowing, looped film—about myself. My past snowballed inside me. I became trapped within it. I kept waiting for the scabs to form, for the pain to subside.

I want to tell you about my trial and incarceration. But before I can find my way there, I need to anchor myself in my childhood and youth, in the memory of my parents, and their work that formed my worldview. Be patient with me as I unravel it.

My Childhood

I LOVED COMING BACK to Leningrad. The best journeys anywhere could not surpass the joy of my return. Here is the darkened entrance to the platform at the Moskóvsky train station. The train slowly pulls in; I wait for it to halt. Iron roof arches open their lacy arms to embrace the train and me. We are quiet in its warmth. Home.

In the early 1950s, when my friends and I were old enough to cross streets on our own, we broke free from our dark and crowded *kommunálka* (communal apartments) and went to Nevsky Avenue, open and light, crisscrossed by sparkling canals. Everything there was a surprise: lazy trollies floating down Nevsky like catfish, gulping in and spewing out passengers; palaces, with stucco molding and bas-reliefs, that looked to us like holiday ornaments. Their serpentine fretwork and stone caryatids bedazzled us. The House of Books, with a globe on top of its conical roof, looked like a Christmas tree. The statues of Field Marshal Kutuzov and Barclay de Tolly by Kazansky Cathedral greeted us with a salute from the days of Russian victories in the Napoleonic Wars. We peeked in the windows of restaurants and pastry shops, the few that had opened after the war. Even though none of us had money to shop, their window displays gave

us joy. People and cars flowed toward Palace Square and the Neva; we were taken up by this current.

The city was ours.

We read the Russian novels whose scenes took place on these very streets. Our city and our friendships nurtured our love for our way of life. Back then we thought that it was the best way to live. It was the best for Nadya, whose father was a director of a canteen and always had food on the table. And for Mila, who lived in a spacious home and had a nanny. And for Inga, whose family of five lived in a cramped room in a communal apartment. All of it seemed fine after the war. My family barely had any food or clothes, but my father was an artist. I saw his paintings in museums. They, too, were part of this city. I belonged here. We children thought that our Soviet life was good. We knew nothing else. And would we have liked it had it been different?

My earliest childhood memory is of our first communal apartment on Bolsháya Podyácheskaya Street. Fifth floor, no elevator. It had a long dark corridor with doors to our neighbors' rooms, then to the two rooms that Father, Mother, Grandmother, and I shared. Father was gruff, which frightened me. Grandmother, my mother's mother, adored and pampered me, serving me chicken broth with a spoon. I loved her and felt sorry for her, so frail, walking with a cane.

Another memory was of a drunk in our neighbor's room, her husband or a boyfriend. When she wasn't there, he called me in and put me on the bed next to him, trapping me between his body and the wall. I was four or five. I remember the curved metal tubing of the headboard, the

stench on his breath, and his repulsive half-naked body. I think I was bewildered more than frightened. It happened once or twice, perhaps a few times. I told Mother. She spoke with his wife right away. The man vanished. Soon after that, Mother exchanged our two rooms for one at 8 Marat Street, a block from Nevsky Avenue. It was on the first floor—only one flight of stairs for Grandmother to climb. She moved there, while the three of us stayed on at Father's studio. When Grandmother died in 1954, we moved to that room.

The corridor at the Marat kommunálka was even longer and darker than at our previous home; there were eight rooms and some twenty-two neighbors. Its many doors were always shut. The toilet was always occupied, and the one room with a bathtub was used only for laundry. To bathe, we went to a bathhouse across the street, built to replace a beautiful church demolished by the Soviets. At the end of the corridor was a small kitchen with two ranges and six tables, one for each family. Only two women cooked there—the wife of a gourmet-store manager and the head of a residential trust, an agency that oversaw all living space in the neighborhood. The manager's wife cooked chunks of meat, a rarity in postwar Leningrad, taken from her husband's store. I remember the crackling of fried butter and the powerful smell of burgers as it coalesced with the stuffy air of our corridor. My family never had money for meat. For breakfast we shared a single egg, a slice of Doktorskaya kielbasa (a bologna), and a small slice of bread. For dinner, a bowl of cabbage soup. Sometimes the manager's wife offered Mother a burger, not out of pity but because she liked her and called her Lucinka. Mother accepted it, not because she wanted to accept stolen food but because it would be an insult to refuse.

The kommunálka was the melting pot of Soviet society, a Petri dish for the communist experiment. An industrial worker lived here with his daughter, an artist. A nuclear physicist, Gennadiy Tarvid, lived in another room with his mother. Two sisters shared a room by the kitchen; one of them had lost her husband and twin babies during the Siege, her mouth was doleful and hard. Her sister, always cheerful, carried blades in her bra and eventually committed suicide. The trauma of war had a long reach.

I remember too an elderly *knyaginya*, a princess. She lay in the dusk of her room, sunken into a down bed, propped up high by pillows. To me, she appeared to have no mass, a mysterious, semi-transparent entity, a fog. Father was the only one to visit her in her room. He gently knocked and vanished in there, their soft voices rising in the air. I tiptoed by the door trying to catch fragments of their conversation. And then the knyaginya was gone.

Her room was assumed by the head of the residential trust, who cooked liberally in our shared kitchen. Her husband worked as an electrician at an elite hospital. Everyone in the apartment, except me, knew that the duo were *stukachi*, Secret Service informants. An unavoidable evil in Stalin's Russia. The gourmet-store manager's wife kept giving her burgers, but it didn't help—her husband was soon arrested and imprisoned. My parents told me none of this when I was young. They never shared things that might compromise our safety. How hard is it to get a child to chat? My parents just kept repeating, "Speak less! Words are silver, silence is gold!" Loose lips sink ships, as they say in America. In Soviet Russia, loose words ended in disaster. I remember mistrusting those two neighbors, without knowing why. When I grew up

and Mother finally told me, I felt repulsed by them.

The Stalin era left its scar. I knew about the show trials, the gulag, innocent people disappearing in secret police vans on anonymous tips and, later, in psychiatric institutions during the Khruschev years. I knew this no matter how much Mother tried to give me a cloudless sky. Back then, I thought that those were despicable acts committed by isolated rogue individuals, by Stalin and his assistants. I didn't see it as systemic crime.

Another story kept secret was the life of Mother's uncle, Mikhail Ksendzovsky. I knew that he was a famous singer, we had his recordings, which we couldn't play because we didn't have a gramophone. I didn't know when I was a child that he had been a prisoner. When I grew up, Mother told me that it had been for refusing to hand over his theater during Stalin's nationalization in the late 1920s. I remember him, Uncle Mikhail, in the 1950s and '60s, dressed in a three-piece suit, sitting regally in his big armchair with its carved lion paws. He wore a small gold watch in his pocket, attached to his vest by a chain. When I came in, he took the watch off the chain and gave it to me. "Would you kindly wind this timepiece with your delicate fingers? Mine are too big for such a fine job." He was grand, magnetic, and unpredictably witty. He made the room more expansive, Mother and me brighter and happier. Having no children of his own, he loved Mother as his daughter. She adored him and took care of him at the end of his life.

Years later, after both Uncle and Mother were gone, I learned about his life from old newspaper clippings. Mikhail Ksendzovsky was born in Balta, studied voice in Russia and Italy; after coming to Petrograd he joined the opera, then a

small troupe that he grew into the Theater of Musical Comedy. It was the most popular place among young theater-goers during NEP. He and his brother, Aleksandr, produced musicals, toured Europe, and made recordings of Ksendzovsky's vocals. They expanded to perform at the Summer Theater at the Garden of Leisure. When nationalization of private property began, the head of Leningrad's Communist Party, Sergéy Kirov, told them to hand over their two theaters and everything they owned. They refused. In prison, they were beaten and tortured to extract a confession they never gave. Mikhail cut his throat with a metal ruler he found on the investigator's desk. The investigator, in a panic, summoned a surgeon to save the famous man's life. GPU, the Unified State Political Directorate, tried to keep this from being leaked to the press, but the news escaped. The two brothers and Mikhail's wife were put on trial. Mikhail was sentenced to five years of hard labor, his brother to ten, at the notorious Solovki Gulag in the far north. Aleksandr died there. They were not tried for a political crime. Oh no! Kirov knew that it would make them martyrs, and their resistance would inspire others. Instead, they were charged with embezzlement and corruption, like small-time crooks, destroying their lives and marring their reputation. To this day, researchers visiting archives are faced with the lies embalmed in the records of their trial.

Mother shared none of this with me. Perhaps Uncle hid these details from her, wanting to only bring joy—the show must go on. Or maybe Mother did not want me to carry this burden. When I had you, Alëna, I didn't want any secrets between us. For that I had to trust you and taught you to keep quiet about what you heard. This saved us time and time again.

Being Jewish was never discussed in my childhood. I knew that we were Jews, but only vaguely understood what it meant. There was no Yiddish or Hebrew, no Shabbat, no candle-lighting, no High Holidays. I didn't know that Mother's grandfather was a rabbi. It came as a shock, years later, to learn that she remembered prayers from her youth. When she finally could go to a synagogue, she attended services weekly. Later, when Mother was gone, I learned all those prayers and began to lead an observant life.

When I was a young child, Stalin began to ramp up anti-Semitic campaigns. Having closed synagogues before the war, he was now shutting down Jewish theaters, publishing houses, and schools, murdering Jewish leaders and cultural figures. Jewish doctors were falsely accused of treason and murder. Anti-Semitism became a patriotic cry in the streets. Mother would see thugs beating up old men who looked Jewish. On a bus, a drunk would yell at her, "What are you doing here, Yid-face? Go to Israel!" Absurd as it was, given that all borders were closed and she couldn't leave. She wore a shawl and began covering her face before going outside. She never told me about it; I would find these stories in her memoir that she wrote in America.

My first memory of anti-Semitism was a girl, my classmate, yelling a slur at me. We were in first grade. I remember picking up a little bottle of ink from my desk and, without thinking, hurling it at her. A splat appeared on her face, narrow blue lines flowing down to vanish in the folds of her brown dress; blue drops forming an island on the floor. I seem to remember my teacher kindly asking what had happened, my tight-lipped stand, and the girl's tearful denials.

Growing up, I had an overwhelming need to defend

Mother and every Jew who was ever insulted, at the same time not wanting to be one myself. There were hurtful nicknames and ugly caricatures in national newspapers. Jews were portrayed as weak at a time when physical strength meant survival. Inner spiritual strength was devalued. My parents had that strength in abundance, but I was too young to understand its merit. I didn't know enough about my history and traditions to neutralize those demeaning images. I wanted to be strong, to separate myself from tribal identities, to be a broad-minded cosmopolite at ease with all kinds of people, blind to their class, ethnicity, or level of education. These were Soviet ideals, which we absorbed at school and in the streets. I thought that my father also lived by these principles. More than anything, I wanted to be just like him. But he had little time for me. He spent most of his time at his studio, painting.

My father's studio. Most happy and important events in my life happened in it. I lived there as a small child. I walked to school from there. My friends came there to visit, and so did my first love. It was there that I wrote my college thesis and brought you, Alëna, as my newborn daughter from the maternity ward. So many homes and cities came afterwards, but only the studio comes back in my dreams.

The building was erected before the Revolution. Along with the adjacent buildings, it formed a street block and enclosed a backyard, mossy and dark, that served as a playground even without a slide or sandbox. Children from workers' families played there. They were brave, nimble, strong, rough, and unforgiving of weakness. I was shy, clumsy,

proud, and afraid to play their fast, aggressive games. Up the steep stairs to the top of the sixth-floor building there were two entryways, one to the attic, the other to the studio. The front door was finished with a black oiled fabric, yellow padding bursting out of its many rips. A narrow hallway led to another doorway, which opened onto an enormous space with soaring ceilings. Perhaps it was not large but only seemed so when I was small. One wall was all glass. Innumerable squares of glass of different tints that looked like a watercolor collage. I walked in and the vast, luminous Leningrad sky spread before me. It would take my breath away.

The entire studio was a mural. The walls were painted dark green, their plaster chipped away to leave pale, sandy hollows. The wooden floor was covered with drips of paint from Father's palettes and brushes. While he worked, he wore a blue robe and wiped his brushes on his sides and sleeves. The robe and floor around his easel were forever changing colors, like a three-dimensional painting.

Father propped his paintings along the walls. His bare pine stretchers stood in stacks, waiting for canvases. Brushes, paints, charcoals, pencils, glue, books, and his many sketches sprawled out over an old piece of plywood with wooden planks as its legs. There was a wicker chair with a leg missing, like one from a Van Gogh painting, and a rusted kerosene lamp left by the previous tenant when the space was still an unfinished storage space. And there was dust, but wiping it off or touching anything here was forbidden. When Father worked, I had to stay away or walk quietly, without lingering or intruding on his strange order.

When we lived in Father's studio before moving to Marat Street, the three of us stayed in a tiny room next to

his workspace. That room had a spicy smell of burned wood coming from a black iron potbelly stove, called *bourgiuyka* (bourgeoisie), the only source of heat for the entire studio. In the winter, we wore coats indoors, and Father, when he worked, a sheepskin vest over his multicolored robe.

When I close my eyes, I see our tiny room with its squat window set into the mansard roof. Feral cats wandered in front of this window along the eaves of the roof. They stopped and stared at me through the glass. I stared back. At night, their dark-gray coats blurred into the black sky. Their eyes glowed and drifted, like flashlights.

My father worked constantly, everywhere, without days off. He sketched in the streets, on the bus, when he visited friends, and even on a boat while I rowed, taking us across the river for him to paint in Old Ladoga. Materials were expensive, so he drew and painted on discarded posters, wrapping paper, and the backs of his old drawings. Often he painted over earlier works that he dismissed as his style changed. Mother sewed together scraps of canvas, mounted canvas on stretchers and primed it for his new paintings.

She was part of everything he created, and I believe that he wouldn't have achieved what he did without her. She understood his mission. He asked her opinion about his paintings and always considered her advice. He wanted her always by his side and did not want her to work. But she did, because it allowed him to work freely, without having to take state commissions and create propaganda.

We lived frugally. For as long as I can remember, Father wore the same pair of pants, darned and patched like a whaleman's shirt. I had the same school dress for years; Mother repaired the rips and repositioned the skirt to hide

the patches under my apron. Father would say, "Why waste money on anything but art?" When money ran out, Mother borrowed from friends or took her gold necklace, her only heirloom, to a pawn shop.

Occasionally, Father took small commissions, art projects, jobs designing theater sets, city decorations, or posters for New Year celebrations. They were meant to be minor responsibilities, but always the perfectionist, he pored over them, making many beautiful versions. Finally, when he got paid, we stretched the money to last for months so he could be free to paint.

I learned from my parents that art comes before anything else. It forms culture, memory, history, and philosophy that will last for centuries. As I was growing up, I saw others share these ideals. At Father's retrospective exhibition, people poured in and called his work a breath of fresh air. This was in 1960, during Khrushchev's Thaw, a brief period when artists were allowed a bit of creative freedom. Father's art kept changing, but Soviet art policies reversed, and for political reasons his paintings could no longer be exhibited.

Father respected artistic talent and always helped students and other artists in their work. His talent was his only treasure and he shared it generously with others, offering his gift to anyone who came to drink from its wondrous well. He had a gift as a teacher. When he talked to me, when he took me to an art exhibition or to the symphony, or taught me poetry, these experiences would remain with me forever. When he spoke, I felt that he lifted a curtain to some hidden riches. I wanted to be a part that world! I wanted to earn his approval. But I also wanted to carve my own path.

As a girl, I dreamed of becoming an actress. I took

lessons at the performing arts studio, recited poetry on stage, and read every Russian play. What heroine did I not see myself as? Then my parents asked for advice from their friend, a famous actress at the Bolshoi Drama Theatre. She watched me perform and told me that I wouldn't do well on stage. She said that I had a voice for dramatic roles but the figure of a comedic actress, plump and short. I accepted her verdict and turned to writing. I dreamed of becoming a journalist or a poet. But Mother said, "Don't go there, it's nothing but trouble." I did not ask her why and accepted her advice.

I started to draw, hoping that Father would teach me. He praised my work but said, "It is better to be a mediocre engineer than a good artist." I did not argue. I took his words as the absolute truth. Or perhaps I took it as a rejection. I stopped drawing.

I did not understand my parents' reasoning then as I do now. They wanted to protect me from a conflict they knew firsthand. Artists and writers had to choose to either conform to Soviet ideology and produce state-mandated work, which was well paid, or to follow their own creative vision and become an enemy of the state. My father made his choice but wanted to protect me from making the same one myself. I never questioned my parents. I understood and accepted that I would hear "No, you cannot" much more often than "Yes, you can." These were the terms of the Soviet reality.

So I studied engineering. After graduating from the Institute of Cooling and Refrigeration Technologies, I was assigned to work at the computing center at the State October Railway. The center was brand-new, one of the first in the country. The entire computer field was in its infancy. The people who worked at our center were young. Our

supervisors were also young, in their thirties, although they seemed old and seasoned to me then. There was a spirit of youth and novelty; we were trailblazers and felt that everything was possible. One day I would meet a deputy minister in Moscow, the next day negotiate with a manufacturer in Ukraine. We worked around the clock, on weekends and at night, taking turns napping on chairs with our coats as blankets.

The temporary office was at the railyard, and to get there I had to walk along the tracks, listening to the rumble of train wheels. Engines slowly rolled back and forth, like lost sleepwalkers. Freight cars stood idle for long stretches of time, waiting to be unloaded or for the lines to clear. Workers stood at the switches with flags and flashlights. Father painted railway workers in the Urals. When I walked down these tracks in the snow, I thought of him.

My Marriage

I WAS NOT MARRIED when I became pregnant with you. In the 1960s, women tried to become liberated. We wanted to be like those gorgeous, emancipated women we saw in French and Italian movies played by Sophia Loren and Brigitte Bardot. In the West, women had feminism and contraception. Not in Russia. When we got pregnant, men were free to leave, while the responsibility for a child fell fully on the shoulders of a mother. Birth out of wedlock brought unspeakable shame. I was in a relationship only once before I got pregnant. I didn't care what people might say about me, but I couldn't let you, my daughter, bear the burden of my decisions. Then this quiet man came along. He asked me to marry him. He would put his name on your birth certificate. I felt I had no choice. He was a technician at the October Railway. A working-class man. It was enticing. I grew up watching Father paint miners and blast-furnace workers in the Urals, whom he had met during the war. He always spoke of them with respect.

Did I love my ex-husband? We had nothing in common. He did not inspire me, there was no romance. But I was

grateful, and at the beginning of our marriage, I thought we could make it work. I remember one day that we spent together. It was sunny and warm in the late summer. We went for a walk along the Neva, then came back home. We made love. He said, "I will never leave you or let you go." I felt anchored, attached. The next day, he came home dead drunk, sloshed, barely conscious. The drunk on the bed with curved metal tubing floated out of my suppressed memories. It was revolting. I told him to leave. He did, then came back, sober. Then drunk again. He promised to stop drinking, but continued. Then he accepted a job traveling on international routes. This was a promotion that give him access to Western stores with products rare and coveted in Soviet Russia. He may have taken that job to win me back. But I knew that this meant that he was a state informant. He confirmed it. He did not think of it as despicable. He may have regarded it patriotic. I cut all ties with him, and we barely spoke after that.

I developed an overwhelming fear that, somehow, he would influence you. I was afraid that his drinking would seem normal to you or that you also would start drinking. I was also worried that he would sell us out and we would live under the watch of the Secret Service. One way or the other, we would be spun into that horrible web. This was my first reason for us to emigrate. The other was Father's paintings.

The Decision to Emigrate

I TURNED TWENTY WHEN Father grew ill and was twenty-five when he died. People kept coming to our home to see his paintings, and agreed that his art defined the generation. I felt that I was failing my duty by not doing more for his legacy. During the 1960s and early '70s, nonconformist artists began to fight for freedom of expression. Just as Soviet Jews fought for their right to practice Judaism and to repatriate, artists demanded to create freely outside the canon of Socialist Realism. The government did not allow their art to be exhibited. Artists began to show their work outside, in open fields. Police took it down with water hoses and bulldozers. These shows became known as "bulldozer exhibitions." Artists reached out to foreign collectors—Garig Basmadjian, Norton Dodge, and others—in the hopes of having their work shown in the West. Then their studios were set on fire by the police.

Father's paintings were not Socialist Realism. I couldn't exhibit them. I didn't have the right to risk their destruction. I couldn't sell his work to foreign collectors because Father hoped for it to eventually find a home in an art museum.

I thought, I didn't spend time with him when he was alive. I would make it up by devoting myself to his art. His

legacy took over my life. It became more important than my own career or marriage. I knew that his paintings had no future in the Soviet Union. There was growing interest in Soviet art in the United States. I decided to emigrate to present his paintings there.

I won't recount the details of our applying to OVIR. I did what had to be done, one piece of paper, signature, and stamp at a time. I put away thoughts about leaving home or having to cut my roots. I knew I was carrying out Father's life mission. Or so I imagined it. I almost succeeded when I applied in 1979. But after every piece of paper was signed, my failed marriage caught up with me. I couldn't leave without my daughter.

The war in Afghanistan had started and tensions between the Soviet Union and the United States were building. OVIR officers warned me that soon only those with immediate relatives abroad would be permitted to emigrate. I decided that Mother would leave with the paintings. She didn't want to go alone. I convinced her. How I regretted it. How I still do.

I remember the day Mother left. It was hectic at the airport. She went in and out of the customs office, taking in her papers and luggage to be searched, coming back to the waiting room. Finally, she was led to a secure area behind bulletproof glass. I could still see her, but there was a physical separation between us. During the weeks up to that moment I was busy with the bureaucracy, with getting her visa and permissions for the paintings, and packing. I was on autopilot. My emotions, my capacity to analyze what was happening,

were turned off. I did not think that she would not be with me—until that moment when she walked behind that glass. And only then did I feel a harrowing anxiety and loss.

The Supermarket

BEFORE APPLYING TO OVIR, I decided to quit my job at the railway so I wouldn't have to mention it on my application. I didn't want to cause problems for my supervisors, who were responsible for their subordinates' ideological conformity. My emigration would be their failure, and they would be punished for it. So I left. After briefly working as a coatroom attendant at a cross-country ski club outside Leningrad, I found a job at a supermarket near our home. Here, I thought, was a place without worries or high stakes. At the beginning it was.

When I came in, my team captain took me to a bin of vegetables. "Sort these." Sure, why not. But after a few weeks, I was promoted to cashiers' controller. I had no idea what to do. My team captain said, "Stand next to a cashier and check every bag and every receipt. No customer will leave the store without paying."

I had never worked in sales before and knew supermarkets only as a shopper. That is to say, I had seen *cashiers* stealing from their customers. Now I had to catch "thieves" whom the store itself was robbing daily. I stood there and watched our saleswomen putting less on the scale than what they charged. I saw the evening shift workers taking bags

of food out through the back door without paying. I could never have imagined such brazen theft.

The store usually sold the same basic foods. When delicacies arrived, they never made it to the shelves and counters. The employees scooped them up or sold them under the counter, with a big surcharge, and pocketed the profit. On rare occasions the delicacies were put out, they were bundled with slow-moving overstock. On those days, sellers tipped off their friends and neighbors, who lined up early in the morning, elbowing one another to get to the counters; saleswomen took their friends out of the queue, and the others yelled. Regular customers never got those delicacies, but the profit from sales kept pouring into the hands of the supermarket's director and accountant.

The supermarket customers stole too, but much less. Sometimes they hid wine at the bottom of their sweatpants or under the lining of their jackets. It was the Masterpiece Theater of stealing. The art of theft, a happening! A young man would walk toward me in oversized pants tied with elastic at the ankles, something bulging at his calves. As he passed me, I would gently tap my toe at his shins. Bottles clinked. He pushed me aside and ran. I caught him by his jacket, but he tore away. Other customers grabbed him, took away the bottles, and let him go. The store recovered two rubles to be added to the thousands they stole.

After a couple of months of working there, the director called me to his office. "I want you to manage our special orders department."

I was shocked. By then, I had worked there long enough to know that "special orders" was a front for money laundering, major-league theft that churned food into money. All

hard-to-find delicacies went through that department and straight to the director. He sold them for a good profit and funneled the money to the state agencies that protected him. I knew that refusing this offer would amount to an affront to him. Accepting it, on the other hand, would be an affront to me. I thanked him and quit.

The Beauty Salon

I LOVED STYLING HAIR, and coiffure was high fashion in the 1970s. It took great skill and it made women look beautiful. I also knew that unemployment was a problem in America and wanted to have work as soon as we arrived. I thought I might cut hair while I looked for a professional job. I went to Kosmétika, a state-run beauty services network, to find a position as a hairdresser. Seeing that I had a graduate degree, they offered me the job of director at a hairdressing and a beauty salon. I always loved working with people and had management experience from my computing center. I had never worked in the beauty services and could not have predicted the scale of corruption there. I thought it would be an interesting job where no one would be harmed by my emigration. So I agreed.

On my first day, I walked through an industrial area, past a factory and a railway terminal, to the noisy street where my two salons were located. I stopped at a glum residential high-rise. Brown brick. Dark windows. A rickety front door with peeling paint. I checked the address. Correct. I spotted a small sign by the door: *Parikmákherskaya* (Hairdresser's). I entered a dim corridor that led to another closed door. This one led into a hallway lined with battered chairs. Empty.

Farther down, a larger room with mirrors and styling chairs. Empty. At a smaller room off the hallway, a sign on the door read "Cashier." The door was locked.

I stood there, listening to flapping curtains and the street din. Then I heard faint voices and followed them to the kitchen in the back. I first saw two greasy stoves with chipped enamel, then a big round table with a bottle of vodka in the middle. Three women dressed in dirty uniforms sat around it. No one turned her head when I walked in. They kept talking.

I said, "Hello, I am your new director."

"Sit down and join us."

"No, I would like to see the hair salon."

One of them got up. She had bleached hair, dried out from hydrogen peroxide. I thought, Why wouldn't hairdressers have a beautiful haircut? We went back to the styling room. Zina said, "This is where we work." We walked a few more steps. She pointed toward a room in the corner. "Here's your office."

I opened the door. It was a long, narrow, dark tunnel of a room with a skinny window squeezed between a table and an empty glass cabinet.

"Well, I'll be going then," she said and went back to the kitchen.

I stood by the window staring at the brick wall of another high-rise, with no idea where to start.

At noon, a man and young woman arrived at the hair salon and asked for me. The man said, "I am the outgoing director. Welcome! We need to sign an official form transferring the two salons from me to you."

The younger woman was an accountant at Kosméti-ka's headquarters. She was there to oversee the transfer. She said, "We will need to cosign the *materiálnaya otvétstvennost* (personal liability) certificate. You are taking legal guardian-ship and personal liability for the salons' tangible and finan-cial assets, which are the property of the state."

I thought, Oh, the wretched bureaucracy. The words *materiálnaya otvétstvennost* meant nothing to me. White noise.

The outgoing director took me across the street to the beauty salon. He showed me the treatment chairs. "Let's count them and write down the number."

He said he received them recently as a set, bundled with some defective tools and equipment. The chairs were glossy, upholstered with maroon leather, foreign-made, and of good quality. Then he showed me a closet with old rugs, mops, and broken hair dryers. There were also several small, dusty boxes. "All of this was written off."

I wondered, What is "written off"? More white noise. Fine, I'll find it out later. I opened one of the small, dusty boxes. It had scissors, nail clippers, tweezers—a manicure kit you could buy at a household store for a few rubles. The former director said again, "These sets came bundled with the treatment chairs. They are defective. We couldn't use them, so we wrote them off. You can throw them out or do whatever you want with them. Now, please sign this certificate of transfer of state property from me to you. And sign this form too, under the list of assets you've received."

I signed it. The accountant took one copy. I took the other and filed it away in my desk. The boring part was done.

The former director and accountant wished me good luck and were gone.

I was alone with my two salons and in shock. I kept crossing the street, back and forth, from one place to the other. The beauty salon, with its new furniture, looked sturdy and lustrous. Its cosmetologists were friendly and neat, dressed in colorful, clean uniforms. They had customers, not too many, but enough to fulfill the state plan.

The hair salon was a disaster. Almost no clients. A few came to Zina, she gave them five-minute haircuts, then quickly colored their hair and pocketed their money. Good grief! I was dumbstruck when I first saw it. But that was only part of the problem.

The hairdressers got drunk at work. They drank in the kitchen, in plain sight, with no effort to hide it. They began in the morning and kept at it all day. Zina looked inebriated most of the time, staggering and grabbing at a styling chair to keep upright. Being drunk, the hairdressers made mistakes. Sometimes they forgot to wash hydrogen peroxide out of their client's hair in time. It burned the scalp and could lead to hair loss. When this happened, the hairdresser would shrug and say, "I told you that your hair is too thin. You shouldn't have colored it at all."

And the client would apologize to her.

The salon, it turned out, was notorious for never delivering on its planned earnings. The state set the plan. Each salon had to fulfill it. The money from haircuts had to be handed to the cashier, who sent it to Kosmétika's headquarters, which then had to transfer it to the state treasury.

This was how businesses worked in the socialist economy. In theory. But in reality, the money got dispersed along the way.

I thought to myself, I can improve this place. First, I asked my hairdressers to stop drinking. They ignored me. I asked them to stop pocketing money. They ignored me on that too. I decided to find a cashier, someone honest who would back me up. I called a friend, a retired accountant from my computing center, and persuaded her to work with me at the hair salon.

And so it began. Zina's client was heading out the door. My cashier stopped her. "Please pay for the haircut."

"I already paid the hairdresser."

The cashier went to Zina. "Put the money in the cash drawer."

The hairdressers hated us. They lied to us. They argued with us. They laughed at us behind our backs. They stopped talking to us.

I realized I couldn't root out theft completely. The entire beauty service industry was based on it. Hairdressers earned a tiny salary, not enough to support themselves. They compensated by pocketing money for their services. A tip of sorts, except it was illegal. I could not change this. I had to find a compromise. Give-and-take.

"Please put in enough money to meet your state plan. I won't ask what you do with the rest."

After that, they started to hand over more money to the cashier. Our relationship improved. Then, one after another, they began to come to my office and give me cash, kickbacks. Five rubles, ten rubles. I told them, "Put this away! I won't take it."

They brought wine glasses and porcelain figurines. I would insult them if I rejected their gifts, so I placed everything in the empty glass cabinet in my office and told them, "This is for all of us. We will use these glasses together to celebrate holidays."

One morning, I found shattered glass at the front window of my salon. Ispolkom, the district government offices, called and ordered me to replace the glass immediately.

I phoned the Kosmétika headquarters. They said, "No, deal with it yourself."

I called the building-trust office that was responsible for the upkeep of our building. They said they had a backlog of several days. Then one of my hairdressers said, "Find any carpenter and he will install the glass for you right away if you pay him with alcohol."

We always had grain alcohol at the salon because we used it to disinfect our tools. I thought, How odd that I should fight drinking at my salon but encourage it in a carpenter. But that's how things got done. I found a handyman, gave him his bottle, and he replaced the glass right away.

A couple of hairdressers quit, and I hired new ones. Maya was a virtuoso. She created unimaginable coiffures. Teased hair, French and Dutch braids, rope twists, swirl buns, sleek topknots. Anything you could imagine. She was an artist with scissors. She molded hair into bold curves, cut it at sharp, dramatic angles. Every woman got up from her chair transformed. When Maya worked, other hairdressers stood behind her and watched. Bit by bit, our services began to improve.

The second hire was Sasha, a reliable worker, a single mom who needed the money. After a few weeks of her working with us, a detective came to the salon. He walked into my office and closed the door. It was about Sasha. "Do you know that her husband is a convicted criminal?"

"No."

"He's also a fugitive. Just escaped from prison. If he comes here, call me right away."

I said nothing. After he left, I told Sasha about that conversation and said, "If you talk to your husband, please tell him not to come here."

I felt more empathy for her than for the detective. Stalin's terror had left its mark. I knew enough not to become an informant.

The salon interior was in bad shape. Everything in it was falling apart. The styling chairs were threadbare, their leather ripped, veneer delaminated. The curtains were tattered, the dryers broken. There was no shampoo or hair dye. We were supposed to get equipment, tools, and supplies from Kosmétika's headquarters, which collected all our income. But in reality, the best of everything went to the leading salons of the city, which served the government staff and elites. Not my unremarkable hair parlor in a blue-collar neighborhood in the shadow of a factory and a railway terminal. We got what was left, which wasn't much.

At headquarters, they sent me to accounting. A woman in her late twenties introduced herself as the deputy chief accountant. I told her, "We serve workers from the plants nearby. The salon has been neglected for years. How am I supposed to meet the state plan?"

I kept talking and the deputy chief accountant, Nína,

kept listening, not saying a word. But several days later I received a batch of new hair dryers. I brought her a gift, a handbag that my mother had sent from Ann Arbor. She took it. More things arrived at our salon—shampoo, professional scissors, new hair dyes, and new window drapes. Then we received new fabric for our uniforms. Regular neighborhood parlors, like ours, usually got white cotton smocks that turned gray after a couple of washes. This fabric was bright red nylon with beautiful white daisies, a luxury reserved for the elite establishments. My hairdressers sewed their new uniforms, each to her own pattern, and our salon blossomed.

Then I started to think how to bring in more clients. The city held a competition for beauticians, and we had an excellent team at our beauty salon. I suggested that they enter it, and one of them won second place. There were no official TV commercials in Leningrad, but I found a filmmaker. He came to the beauty salon, interviewed our beauticians, and made a clip that ran several times on Leningrad's city-wide television. New clients started to come for facials and stopped by across the street for a haircut. After that, our two salons were never empty.

None of this makes sense to me now. I was gradually losing myself to this work. My life was in upheaval. We were moving. I was giving away the belongings that were part of my childhood. My mother's departure had left a hollow space in our lives. I worried about her living alone in a foreign country and knew that I was responsible for sending her away alone. And there was no certainty of what would happen to us. When would they let us out? When would I be with my mother? I was afraid to think about it; I felt volatile and could not count on the day after tomorrow. Yet

improving my two salons *was* within my reach. There I was at the steering wheel. We had challenges, but I knew how to solve them. I had worked on more complex projects at the Railway. I thought, Here at Kosmétika our work was about beauty. Styling hair is a form of art, and art had been a part of my life since childhood. I felt up to the task, without realizing that I was going down a rabbit hole.

Soon I was invited to a meeting with Kosmétika's CEO, Vladimir Stasov, who told me, "We saw your beauty salon in the news, and your hair salon has begun to meet our financial goals. What are your plans for the future?"

To this day I don't know why I said, "To make my two salons the best in the district."

Absurd as it seems, it was the truth. The satisfaction of growing a business had caught me by surprise. A few days later I got a call from Valentína Volkova, the head of human resources. "We want to promote you to the position of district branch manager. You and the head of the branch will co-manage all the beauty establishments in the Kirovsky district."

I felt a chill to the bone. A day before, my mother had called me from Ann Arbor, and I hadn't slept all night thinking about her.

Valentína Volkova continued, "We need quality service. Discipline. High sanitary and hygiene standards. And a state plan delivery. You will work directly with us at the head-quarters. This job does not have *materiálnaya otvétstvennost* (personal liability). What do you say?"

I wanted to say that I was trying to emigrate and didn't want a promotion. But she would have fired me. I felt that I couldn't say no. I accepted the job. When I was leaving the

salons, I threw away the certificate of transfer and the list of assets that we signed with the previous director, a mistake I would understand in several months. I cleaned out the closet and threw away broken things. The defective manicure sets were still there, and I thought maybe I could fix them or my daughter might play with them. It all seemed harmless then.

Kosmétika's District Branch

AT THE DISTRICT BRANCH, I soon realized that I had almost no power to bring about change. It didn't stop me from trying. During the first week, I visited every salon and met with every director at my new district branch. I watched hairdressers and stylists at work, checked the conditions of their salons, and asked directors about their problems. Then I invited the directors to a meeting and set out our new goals to improve our services and work conditions for our hairdressers, and to bring in more clients. The directors listened to me with blank stares. I added, "And you need to start meeting your earning targets." No reaction. I made a last attempt. "We can also organize a hairdressers' competition in our district."

A heavyset woman with décolletage and a bleached mutton perm got up, fist to her hip. "What's this baloney, hah? What do we need this competition for?"

"To inspire our staff. They will prepare for the competition and try new things. Your clients will be there to watch them. It will be a celebration. We will showcase our craft."

"Drivel! We don't need it. And we can't meet your state plan either."

"Why not?"

"Do you know that we buy tools and supplies with our own money? We've worked here for years and know how to run our businesses."

It was clear that larger forces were at work here. Salon directors and their staff earned tiny salaries, barely a living wage, and, at the same time, they handled large sums of money, often without a paper trail. Those who worked in the services industry for many years could not resist the seduction of cash.

Beauticians, hairdressers, and directors pocketed only a fraction of the income generated by their salons, nothing next to the staggering payoffs that flowed up to Kosméti-ka's headquarters, its accounting department, and the state agencies. First of all, salon directors needed to protect their businesses. Each establishment depended on various state agencies that could potentially close it down. A hair salon could be shut down because of a failed state inspection—public health, sanitation and hygiene, fire inspection, and others. Inspectors could easily find fault even in a flawless place. Often directors could not satisfy official norms because they never had enough money for upkeep and repairs. It was cheaper to bribe an inspector. And inspectors took the bribes, oh, did they! Each agency required a different bribe. Public health inspectors demanded high payoffs because they had more power to close down a salon for noncompliance. The same went for fire inspectors. Building-trust managers had fewer ways to harm us; they were responsible for servicing our tenant spaces, and if we didn't give them bribes, they could get back at us by not repairing a smashed window, a

broken pipe, or a blown fuse. But the salon directors could hire their own repairmen and pay out of pocket. So the building-trust managers had to settle for smaller favors: a free haircut or small gifts.

Secondly, there was the question of protection. To steal and not get caught, the industry needed protection from law enforcement and government agencies who could easily find *kompromat* on anyone, they could blow a small mistake into a criminal offense and bring charges against the most innocent people. Everyone depended on connections and patronage. A hairdresser needed protection from the cashier. The salon director needed a district branch and headquarters. Kosmétika's headquarters had the KGB, OBKhSS, Ispolkom, and the leaders of the Communist party. No one wanted penalties or investigations. And everyone needed money.

Beauty services traveled along two separate orbits: the socialist state-run structure and the system of corruption and bribes. The free market with a Soviet slant evolved somewhere in between.

Before going to Kosmétika, I could not have imagined the turnover of dirty money as substantial and the web between the industry, state bureaucracies, and law enforcement as complex. Having worked at the Railway, I thought I could manage two salons with the skills I learned both there and at Father's art studio. I had taken this temporary job, a stopover in a quiet harbor, a detour on my road to emigration. But I also believed in doing my job well and building relationships with my coworkers and supervisors that would grow into friendships without monetary ties. The communal above the individual. This may have been true among engineers and artists. But at Kosmétika the business was built on

the idea of everyone for themselves. I couldn't foresee how this job would ricochet against my family and me.

The next step in the trail of errors was my trip to a farm. Kosmétika maintained the patronage of a state farm near Leningrad and sent its employees there every summer to help with their harvest season. This was common practice, students and employees from the big cities went to state farms to help in the summer. Kosmétika's CEO, Vladimir Stasov, put me in charge of that venture and asked me to go there in early spring to meet with the farm administration. "Go to plan your work and take some drinks on behalf of Kosmétika, the farmers will want to celebrate the beginning of the new season."

At my district branch, someone suggested taking grain alcohol from Kosmétika's warehouse. At the warehouse they told me, "We will give it to you but you'll need to file a request on behalf of the salon."

That day I had a meeting with Tatyana Lavrova, a director of one the salons in my district. I asked if she had grain alcohol that I could take to the farm. She said, "No, but you can file the request on my behalf at the warehouse."

The warehouse gave me a bottle holding three liters of grain alcohol. I was ready to go to the farm but began to have second thoughts. How disrespectful to bring disinfecting alcohol to the farmers! I bought wine with my own money and left the alcohol at home. When I returned, I called Tatyana Lavrova about getting it back to her. She said that she would come with her car and pick it up at my house.

Then suddenly I received a call from the head of human resources. She did not sound friendly. I went to her office. She asked, "Did we treat you badly?"

"Of course not."

"Then why are you doing *this* to us?"

"Doing *what*?"

"Why did you apply for emigration?"

I thought, How could she have found out? Kosmétika wasn't listed in my OVIR papers, because I went to work there after I applied. I explained that I had filed my application a year before and my case had been on hold because of family matters. She said, "Submit your resignation immediately."

I wrote a letter stating that I was quitting of my own volition and left Kosmétika that same day. I called Tatyana Lavrova to remind her to pick up the bottle of alcohol and put it in the back room.

The Unplanned

IT WAS EARLY SPRING 1981. OVIR issued our exit visa, valid for a year and a half. I thought we should wait for my daughter to finish her school year. Our residential trust informed me that I had to give up our apartment, but they allowed us to stay there until we were to leave. I also had to give up my right to residency in Leningrad, the city where I was born. It was unsettling. I began to prepare for our departure.

Nína, Kosmétika's deputy chief accountant who had helped me with my salon, started to visit me at my house. She brought news from work and once told me that she had a fight with Tatyana Lavrova. She said, "Oh, I will cut her to size. I will get the OBKhSS to investigate her salon."

I said, "Nína, don't do that. It will be nothing but trouble. Tatyana is still new to Kosmétika, give her time."

She picked up a pack of cards. "Do you want to see your future?" She spread the cards out on the table. "It shows *kazeniy dom* for you."

"What does that mean?" I asked.

"A courthouse or jail."

"Why a courthouse, if I am leaving?"

"Who knows."

The subpoena arrived May 7, 1981. A small piece of paper, a third of a standard school notebook page. It came by regular mail, and I didn't have to sign for it. How easy it would have been to throw it away. And to buy two airline tickets out of the country right away. The subpoena demanded that I appear as a witness at the OBKhSS on May 15.

The day I received it I was meeting a friend who had ties to the refusenik and dissident community. She said, "Get out of the country immediately."

I called my friend Yuri. He said, "Get two one-way tickets to Vienna, take your daughter, and leave now."

I thought, Yuri's making a mountain out of a molehill. What do I have to be afraid of? Did I do anything wrong? No. So why should I run? And if I were to buy those tickets, the police could come after me and drag me off the plane. Then they could charge me with evasion. This had happened to other dissidents in Leningrad. I thought about Kosmétika and Nína's rage against Tatyana Lavrova. I suspected the subpoena had something to do with it. If the OBKhSS investigated my colleagues, I would want to clear their names. So I went.

It was a drab, overcast day, a typical May in Leningrad. The OBKhSS office was housed in windowless rooms of a government building made of concrete that looked stained and bruised. Three agents met me there. One was short and skinny, with sagging pants and a drooping moustache. The second was tall and beefy, a brute that made me think of a medium-rare steak. The third was a shadow behind them, I barely remember him. The skinny man said he was a chief and the head of the investigation. "We were alerted to problems

at the salon under Tatyana Lavrova's management. Do you know who she is?"

"Of course I do."

"Lavrova had accounting gaps. Missing supplies and furnishings. In particular, we want to ask you about a three-liter bottle of disinfecting grain alcohol. She told us that you signed the request for it at the warehouse?"

"Yes, I did."

"Did you collect it? Why did you need it?"

I told him that we needed it for the farm. He nodded. I didn't want to drag the farmers into this so I didn't mention the party or the wine. I simply said that we did not use the alcohol.

"Where is it?"

"At my home."

He dialed a number and handed me the receiver. "Tatyana Lavrova's on the line."

Her stifled voice pleaded, "Galia, tell them that it was not your decision. Say that Stasov ordered you to take this alcohol for the farm. The Kosmétika CEO did it."

Why Stasov? Why alcohol? This didn't feel like clearing anyone's name. I was in a room of warped mirrors. I said, "No, it was my decision."

The medium-rare said, "We know that you applied to emigrate to Israel."

Anyone in my place with a drop of common sense would have kept their mouth shut. Not me. "Yes! And I already have my visa."

Dead silence. The chunk of beef walked out. Then the skinny chief said, "Galia, you can give us payment for the alcohol right now."

I heard a twitch of empathy in his voice. I had ninety rubles in my handbag. Three liters of grain alcohol cost about thirty. I began to reach for my wallet. Then I stopped. If I were to give them money now, he could book me for bribery. As if reading my mind, the chief added, "I will give you an official receipt for your payment."

Like hell he will. "I don't have the money," I said.

He got up. "Then let's go."

He led me outside, his two men followed. We got into a military van and drove to my home. I stared out the window and saw nothing. Only one thought was throbbing in my mind: Don't let Alëna come home while these men are there.

The agents roamed the rooms of our flat holding little wands with balls at the tips. You see similar gadgets in America, beachgoers looking for treasure. They touched their wands to our clothes and pillows. They found nothing but dust. I stood there thinking, They will plant drugs, as they do with dissidents, and put me away. The chief asked where the alcohol was. I showed him the bottle. He took it.

Then I saw you at the door, Alëna. You came home from school and I felt a cold swirl inside me. I said, "Go outside."

You said, "No."

The chief must have heard us. He snapped at his men, "Enough! The search is done, let's go."

But the brute lingered. He went back to a bedroom and brought out a stack of boxes. The defective manicure sets that had been "written off" by my predecessor at the beauty salon. Why did I take these sets home? A habit leftover from an impoverished childhood—don't waste and throw nothing away. The brute said, "Look what I found here."

The chief muttered, "Take them and let's go."

They left, carrying away the bottle of alcohol, the manicure sets, and my visa. I was without citizenship, a passport, or the right of residence. I sat down in the kitchen, my mind sinking into a black hole.

Materiálnaya otvétstvennost—personal liability for tangible assets of state property. I now fully understood what it meant. The director of a hairdressing or beauty salon, or any other state-owned business (and they all belonged to the state) was liable for its assets—furniture, equipment, tools, supplies, and money. He or she could be criminally charged for any unexplained gaps in accounting or missing property. Tools or supplies that were defective or used up could be removed from the list of tangible assets. But there had to be a paper trail. The director had to file a formal report, an *act*, which certified the cessation of use. Money and property could not just disappear.

I finally realized that Yuri was right when he hadn't wanted me to take a job with personal liability. He knew that the OBKhSS could find accounting gaps or something missing even with the most diligent paperwork. They could always fabricate evidence and frame a case.

The OBKhSS started their investigation against me. Misappropriation of state property—grain alcohol and manicure sets. I was sure that I would be cleared of these charges. The cost of these items was very small even for a Soviet budget. People at Kosmétika knew that I had taken the alcohol for our state farm. The manicure sets were not on the list of property that I signed with the outgoing director at my two salons. From a legal point of view, the sets were

not the state property of the salon and therefore could not be stolen. I had signed two copies of the certified *act* and that list. The young accountant who oversaw the transfer had filed one copy at Kosmétika's archives. I kept the other but threw it away when I was leaving that job. I didn't understand its legal implications.

There was a larger backdrop to my story. Little was known about it by the public at that time. Years later, the press began to report about nationwide anticorruption operations the KGB and OBKhSS had conducted ever since Yuri Andropov took over the KGB in the late 1960s. There was a method to their work. They focused mostly on the sales and services industries. The investigations usually began with charges against lower-ranking employees who were coerced into pointing at their superiors. In the end, everyone, from the lowest to the topmost echelons, went on trial as an organized criminal network. They received much higher sentences as a group than they would have as individuals. The best known are the "Fish Case" of seafood stores and Gastronom No. 1, an elite Moscow delicatessen, investigated in the late 1970s, and the "Uzbek Case" in the cotton industry in the early 1980s. There were many others.

Those investigations were a show of force by the KGB and the Ministry of Internal Affairs, MVD, which oversaw the OBKhSS and the police. There may have been a simmering feud between the KGB and MVD, and a power struggle between their leaders, Andropov, the chairman of the KGB, and Nikoláy Shchelokov, the head of MVD and a Brezhnev appointee. The KGB prevailed. After Brezhnev died, Andropov became the country's leader. Shchelokov was removed from his post and investigated for corruption. Soon

after, he and his wife were found dead, according to the official report a double suicide.

Kosmétika could well have been under the microscope of various law enforcement agencies for some time. Not long before I came to work there, its administration underwent major restructuring. New management had ties to all three competing government agencies: the OBKhSS, the KGB, and the Ispolkom. Nína, the deputy chief accountant, worked with the OBKhSS. Valentina Volkova, the head of human resources, had ties to the KGB through her family, as she once told me. Vladimir Stasov, the CEO, had close associations with the Ispolkom and the Communist Party.

The OBKhSS inquiry into Tatyana Lavrova's salon may have started for two reasons: first, a national anticorruption effort, and second, her personal feud with Nína. Their quarrel may seem trivial, but it reveals fault lines in Soviet society forming during its last decade. While everyone was expected to be equal, they were not. Nína came from a family of factory workers, which may have been the reason she started to help my salon. She was not wealthy and lived with her parents in a small dark apartment in an old part of Leningrad. Tatyana looked like she was part of the Soviet elite. She had a spacious home, wore elegant clothes, and owned a car, a luxury out of reach for most Soviet citizens. She was attractive, married with a child, and had just received a prestigious job. Without prior management experience, she was given the leading salon in that district. This was unusual. When Valentina Volkova hired Tatyana, she asked me to help her, which was also out of the ordinary. Above all, Tatyana carried herself

with the confidence of someone who had strong protection. Nína had none of that. She was a typical Soviet functionary who valued power above all else.

Soon after Nína told me that she planned to report Tatyana to the OBKhSS, they came to inspect her salon and found missing property. To avoid a criminal investigation, she shifted the blame to others. Then the investigation turned to me.

Tatyana called me again after our conversation at the OBKhSS office. "Galia, you have to point to Stasov. My brothers work for the KGB. They told me that you must testify against Kosmétika's CEO."

She was telling me to become an informant. It would have been unconscionable for me. I could never be a snitch, nor could I count on the fairness of the law. I had to choose between shifting blame to Stasov or standing on my own. I did the latter. The investigation into corruption at Kosmétika would stop with me.

I called Mother in Ann Arbor—the most difficult call I ever made. "We are not coming."

I still feel the knife in my chest when I think back to that call. I sat in my empty apartment afterwards, echoes of my thoughts bouncing off the walls, until my mind turned itself off. I was without citizenship, visa, documents, savings, a job, or income. I had given most of our belongings away. I had no residence permit. The residential trust could tell us to leave at any moment. I had a child I could not protect. The ground under me was parting.

Help came from an unexpected place. Valentina Volkova called and invited me to come back to work at Kosmétika. This was illegal. According to Soviet law, a job could be given only to a citizen who had a passport and residence permit. She and Stasov knew about the OBKhSS and my investigation. I still don't know why they offered me that job. I took it. If I didn't, I would be charged with parasitism, evading work. The law required every able-bodied person to be employed in the state-run economy. They gave me a desk in Stasov's deputy's office but nothing to do. I sat there day after day, staring at the wall.

Thinking back to that time, I was surprised but I don't remember feeling anger or hatred. Not toward the three men at the OBKhSS, Tatyana, Nína, or anyone else who came later. I remember being in shock, with a sense of losing control, as one might feel during a stroke. It was a feeling of unreality, of everything happening outside me. The whole world became inanimate, unalive. Even you, Alëna, my daughter, began to feel unreal to me. There was a sense of disintegrating bonds. People around me, my friends and colleagues, turned into windup dolls. They came and interacted with me, but I felt no joy, love, or connection with them. I did not see their faces. They became moving objects, a crowd. Perhaps, this disassociation from my own life helped me survive without explosions or cataclysms.

I remember on one of those days a heavyset woman showed up at the door of my cramped shared office. Décolle-tage and a bleached mutton perm. It was the salon director who had yelled at me at our kickoff meeting at the branch. She looked sheepish now. "I am so sorry, Galia. I never thought it would come to this!"

"There is nothing for you to be sorry about."

"I only wanted to get you fired. You kept meddling in our business. My husband works for the OBKhSS, so I asked him to dig something up. He talked to some people and found out that you were applying to OVIR. We called Human Resources. But I swear, Galia, I have nothing to do with your criminal charge. Everyone knew that you didn't steal. Now everyone says that if they press charges against you, all of us will be put away."

I thought, Don't make enemies when you live in a glass house. From her visit I finally knew how Valentina Volkova found out about my emigration, but it made no difference to me now.

Another time, I was riding the subway on my way home from work. I suddenly noticed a man staring straight at me. Leather jacket, broken nose, cold mocking eyes, the face of a hitman. I got off the train. He followed. The street was dark and there were few people around me. I tried to maintain a steady pace, not speeding up or slowing down. I made a detour. I thought he had gone away. When I reached our house and went up the stairs, he was standing on the half-story landing, leering at me. I walked past him and continued up. I had heard about these men dispatched by the secret police to sow fear . . . if you let them.

Yet another time walking in the street, I recognized the two OBKhSS agents who had raided our home—the skinny one and his beefy partner. The first one looked at me as if he wished he could help me. I asked him, "What can I do now?"

The brute cut in, "Go hang yourself."

Nína now came to my house every day. I couldn't stop her. Her icy calculator-eyes never looked at me, but scanned every corner of my apartment. She kept trying to get me to talk. I had nothing to tell.

I asked her to find the other copy of the transfer certificate and property lists for my salon that were still on file at Kosmétika's accounting archives. These documents proved that the manicure sets were not part of my salon's property at the time of transfer. I thought it exonerated me from that criminal charge. I kept asking her, "Please, submit this certificate as the evidence to the court."

She kept saying, "Yes, I will."

She never did.

Another regular visitor from Kosmétika was Zhenia. She was not a close friend. I had met her just a few months before, after I became a district manager. She worked as a hairdresser in my district and came to me for help with a dispute between her and her director. She had told me then that she was a refusenik, but now I felt burdened by her company. I didn't have the stamina to see anyone. I felt hollowed out by everything happening to me, numb, and not present in my reality. This may be the reason why I never looked for someone to take you, Alëna, in case of the worst outcome of this trial. I wasn't naïve about the possibility of a prison sentence, but I couldn't consciously accept the thought of being taken from my daughter, of you being alone. My mind was protecting itself from madness. But it was also madness not to plan ahead.

While the OBKhSS was looking into my case, people told me, "Don't worry, it will soon end. You will get back your visa."

When the case was handed to a prosecutor, they said, "You will be acquitted."

As the time got closer to the trial, they said, "You might get a fine or probation."

I went through the daily motions—I showed up at work, did something or other, spoke to this person or that. But underneath the monotony of the routine, I felt that a looming catastrophe was heading my way and I could do nothing to avert it.

My friend, L., an attorney, worked in the Leningrad court system. She talked with the prosecutor who was overseeing my case. Through her I learned that the KGB had asked OVIR to revoke my visa and reinstate my citizenship. The OVIR said, no, they wouldn't do that. Then the KGB agent went to the prosecutor and told him to detain me for the duration of my visa, a year and a half, so I wouldn't be able to leave the country.

The prosecutor reportedly explained to him, "By law I cannot ask for probation, because she has no passport, citizenship, or residence. The only way for me to detain her is to incarcerate her."

"Then incarcerate her."

To which the prosecutor replied, "There is no criminal case here. Do your dirty tricks on your own."

"You'll do as you're told."

The prosecutor complied. He transferred the case to the Kirovsky district criminal court to proceed to trial. As my

attorney friend found out, the judges initially refused to hear it. But the district's chief judge pressed them. Then one, Judge Lukyánova, acquiesced.

The hearing was held in a small room that looked like a dingy classroom. There were three or four benches in the back of the room for visitors. The hearing was open to the public, but I had asked close friends to stay away. Why watch this sham trial?

Judge Lukyánova sat in the middle at a big wooden table covered with a thick dark-green cloth. She looked like an onion on a plate of lettuce. An onion head on top of an onion body. Thick cheeks and greasy hair in a bun. Untidy. The two people's jurors sat to either side of her. I, the accused, sat facing the judge. The prosecutor and stenographer sat to the left. My defense attorney, Nikoláy Grigórycvich, sat to the right but at a distance from me. He took my case after L., my attorney friend, had asked him to help me. He reminded me of an old teacher, with his stooped back, thick horn-rimmed glasses, and worn leather briefcase. He was near retirement, and I was grateful that he had the courage and heart to defend me. He was thoughtful, soft-spoken, and astute. He had served as a criminal court judge for many years and knew the mechanics of the Soviet judicial system inside out. If I could choose anyone to defend me, it would still be him.

The prosecutor presented the case—misappropriation of state property on a minor scale. The state property consisted of a bottle of grain alcohol and three defective manicure sets.

Witnesses were called to testify during the first day of the hearing. The young accountant who had overseen the transfer of the two salons to my legal liability came as an

official witness of Kosmétika. She confirmed that all the manicure sets had been formally written off and did not fall under my oversight.

Valentina Volkova and Vladimir Stasov submitted written statements praising my work and recounting how much I had done for Kosmétika. The head of the farm wrote a letter commending me on my leadership during the harvest season a summer before. Every letter and oral deposition was in my favor.

But when Tatyana Lavrova was called to the stand, she testified that I had signed the formal request for the alcohol and taken it on my own. She did not add that I took it with her permission for official business. Nor did she say that I had asked her to take the bottle back to her salon.

On the second day, my attorney addressed the court. He argued that the accusation was baseless from a legal point of view, that the facts and witness testimony proved the lack of *corpus delicti*, a crime as legally defined. He spoke of my honesty and integrity. About the fact that I was a single parent and that full custody of the child was given to me by the civil court of the same Kirovsky district that was now holding this hearing. That the decision was made on consideration of my character. Nikoláy Grigóryevich was transformed from a stooped old man into a warrior. He had force, vigor, eloquence, the power of conviction, logic, and knowledge of the law. The courtroom fell silent. It seemed impossible not to acquit me after his speech.

During the two days of proceedings, the judge kept exiting and reentering the courtroom. She would get up, rush out, come back, flushed, sit for a while, then leave again. After my defense attorney finished his statement, she and

the jurors left the courtroom together. When they returned, the jurors rose for the reading of the verdict. I remember their bowed heads and white, clenched knuckles pressed against the dark green tablecloth. I thought, If they move their hands, they will collapse like rag dolls. Jurors had no real voice in Soviet courts. The judge decided everything. In my case, the judge was a puppet. Someone else was deciding.

Two years later, when I got to read the transcript of the trial in the court archives, I saw that portions of the young accountant's testimony had been crossed out and replaced with a contradictory handwritten text. Fabricated statements supplied "proof" of my supposed misappropriation.

The judge read:

> It is the judgment of this court to find the defendant guilty.
>
> The defendant is sentenced to serve a term of imprisonment at a correctional facility for the duration of one year and six months. The term of the sentencing will begin immediately.
>
> Place the defendant into custody upon the conclusion of this hearing.

I had only one thought—Alëna. I turned toward the visitors' area. Nína was standing right behind me. She looked like a ghost. Zhenia was three rows away. There were no family or close friends in the courtroom. Military men were walking toward me. I said, "Zhenia! Take my daughter."

They led me away.

Krestí Prison

THE GATE—MY FIRST MEMORY of Krestí. Wide and metal, lime green and luminous from the glaring mid-September sun. I thought, Why did they paint everything green?

After the court hearing, I was in a trance. I remember nothing after they read my sentence and I asked Zhenia to take you, Alëna. Not how they put me into a prisoner transport van. Not being driven in it. Not being led out of it. And suddenly—this gate. Not even a gate, but a pale green sheet before my eyes, the color of new grass. And then, as if cut open with a knife, it came apart, slowly, with a roar, in a spell. Then I woke up.

A prison guard was standing in front of me. He had no face. My eyes watched his arms. Freckled, copper-colored, hairy forearms. A military uniform, green. His fingers held my visa. So light and flimsy, just a piece of paper with a delicate emerald pattern. Our visa—in his enormous hairy hands. It all looked beautiful. Mesmerizing. The freckles, the gate, the wall, his uniform, and my visa. Copper and green, like a painting.

And then, his voice from above, "Welcome to Israel."

I fell back into the black hole.

Obezyánnik, the monkey tank. My first prison cell. If it were a room in a house, it could barely fit a couch and small table. This cell had wooden double bunks, wall to wall, against either wall. They looked like wide bookshelves. Two women sat on the top of one, the third woman on the bottom. There was also an open toilet bowl, rusted and stained. Cockroaches everywhere. And an unbearable smell. A pungent reek of unwashed bodies and human waste.

When the door locked behind me, I stood there holding onto its cold metal surface and stared at the words scratched into its paint:

> *No glorious feats, nor heroism,*
> *nor legendary, epic deeds.*
> *There's only the yoke of Communism*
> *in the archipelago of labor camps.*

I read those lines over and over. Once a teacher gives you a mantra it never leaves you. You may not repeat it for years, but as soon as you start your meditation, it comes back. The stardust of Soviet patriotic songs and Mayakovsky's poems—all of it died there. Only that mantra remained.

A few hours later, the guard took me out of the monkey tank and moved me to another cell. It was larger and more crowded. The bunks, called *shkónki*, took up most of it. The space between them was so narrow that when someone was sitting on the lower bunk, you had to turn sideways to pass. I took the empty shkónka above the sink, the first bed as you walked in. I thought, Feet to the door, a bad superstition.

Oh, it was dark. You could barely make out the face of another cellmate on the opposite end of the cell. Dull, dim, sickly yellow light came from a single ceiling fixture, covered

by a grimy metal mesh. The windows were covered with horizontal louvers, bolted from the outside and angled up to block the view of the yard. No view at all. None. You could see only strips of gray sky between the black metal slats. We called them "eyelashes." The legend goes that the man who invented these terrible eyelashes was murdered by prisoners. But inmates managed to hook strings onto the metal slats and somehow constructed a communication path between the male and female cellblocks. They called these letters *malyávi*, scribbles. Malyávi went back and forth constantly, you could hear paper gently graze against the red brick outside. Some were coded messages between crime partners. More often they were love letters between strangers, some were quite vulgar, others tender and sweet.

The bread they gave us . . . It felt like clay. Black and sour. When I tore off a piece, it congealed into black clots. I couldn't eat it. Women shaped it into toys. Little black foxes, wee black bears. I looked at these crafty things and thought, Here women are making toys, and their children are somewhere else without their mothers.

My attorney, Nikoláy Grigóryevich, came to see me. He still looked like the soft-spoken old teacher in horn-rimmed glasses, only more stooped and years older. He wanted to fight the verdict. I told him that he was naïve. He insisted. I agreed, if only to console him. We both wanted to give each other hope. He brought me cigarettes, pens, and notebooks, and offered to take a note for you, Alëna. I wrote my first letter to you during my meeting with him. When I returned to my cell, I wrote a poem to my mother.

Then I started to write down every poem I could remember. I sat on my bunk above the rusty sink and wrote

everything I had ever learned. Pushkin, Esenin, Akhmatova, Pasternak, and all the others.

Prison guards constantly raided our cell. We called these raids *shmóni*. Horrid. Guards searched everywhere, inside pillows and mattresses, behind the toilet and the pipes. They took away anything suspicious or forbidden. And what wasn't? They turned the cell upside down, and after they were gone, we had to clean everything up. During one of these shakedowns, they took away my poems. The poem to my mother and everything else. My entire notebook was gone. It had been my thread to the outside, to my life before, to myself. That too was taken away.

Poem to Mother

It's winter now, and flurries of white snow
come sweeping past my hands and face once more;
once again, I want to soar, a bird
flying free and landing at your door.

In the morning, through a net of twigs,
I catch the rays that shine above your brow,
and wish to breathe in your strength and warmth,
and feel that you are near me again.

—Galina Lemberskaya, 1981–82

I had a feeling of constant anticipation, which swung between hope and hopelessness. We all had that in Kresti. Most people there were awaiting their trial or appeal and counting on a miracle. We were suspended in space and time.

Something was happening to us; we just couldn't quite be sure and couldn't steer it. Everything of consequence to us was taken away. We couldn't work, see our family, have books. Photographs were forbidden.

When people are free, their loved ones are part of them. But in prison those we love slowly morph into an abstraction. Family becomes unreal; every thought and memory of them is a reproach, an unbearable pain—a weakness that we cannot permit ourselves. Some women went to prison with pregnancies that had to be terminated and others gave birth to infants who were taken from them. Women left behind children who were placed in orphanages or taken by strangers. Family members or loved ones sometimes fell ill or died while the women were incarcerated. I had to separate myself from it all—from the worry of what might be happening to you and Mother. I could only carry you and her with me constantly. To feel your presence viscerally yet not be conscious of it. To block my mind from any thoughts.

Galia to Alëna, Krestí, Leningrad, via Nikoláy Grigóryevich, October 1981

Dóchenka, my dearest one!

It happened, as I had expected. But no matter what comes in life, you need to bear it with honor and dignity. One must cope with misfortune.

Most importantly:

1. Study English, study music. Take care of your health. Write poems and stories; make art. In eighth grade, you should take up drawing with seriousness. These should be your goals.

2. Write letters to Grandma regularly, twice a
 month, and show her your love and support.
 Write that you and I are well and that she needs
 to stay healthy.
3. It is paramount that you move to Grandma.
 I wrote out an application, Zhenia should take it
 to the right agency, but I think you should meet
 with them yourself and tell them that you want
 to be with your grandmother.
4. Zhenia should sell both my brown and gray coats
 and my corduroy jeans, and use the money for
 your food and clothes.
5. Always keep in mind to be cautious with others.
 Do not act imprudently.
6. Find the profession that you love and have a good
 family to be happy in life.
7. Be polite and poised. Reach for your goals.

Please, don't be annoyed by my relentless lecturing.
I am fine. I have food, clothes, I am healthy. Don't worry
about me. Just ask Zhenia to bring me warm clothes.
Don't wear yourself out with worry. And most importantly,
protect yourself.

At first, I couldn't talk to anyone in my cell. I lay on my
upper bunk, didn't take meals, and came down only when
ordered to by a guard. But gradually the need to be with
people prevailed and I began to get to know my cellmates.

Katya was nineteen, although she looked even younger.
Her face was round, the way children's faces are, with pudgy
cheeks and big, blue eyes with pale eyelashes. Her sandy
hair had been cut short but now, grown out, fell constantly

over her eyes. She looked like a tween. Her crime was armed robbery with a deadly weapon. She was riding in the back seat of a taxi with her friends. They needed money and one of the boys told the taxi driver to hand over his cash. Another boy had a pocket knife and must have threatened him with it. The driver gave them the money, let them out of the car, and then called the police. The kids were caught almost immediately, charged with a premeditated crime, and sent to prison. Long sentences, many years for each. Katya constantly spoke about her little brother. Silly, tender stories about him, in mismatched socks, blowing bubbles out the window, putting on his father's leather coat, or climbing on top of a bookshelf to hide while everyone looked for him. I imagined this boy, with Katya's pudgy round face, only smaller, full of mischief. It was unnerving to hear these stories in prison.

Another woman, Sveta, found out that she was pregnant. She had terrible, convulsive morning sickness. She couldn't bear the stink of the cell or the rancid food. She became so weak that she could barely climb down from her upper bunk. She worried about having a baby while in prison. She wasn't married. What would happen after birth? There was no place for babies in Krestí and no one to take a child. Abortions were legal for the first twelve weeks of pregnancy, but women in Krestí didn't know if they might be forced to abort or forced to give birth. Sveta worried that the warden was delaying the procedure in order to miss the first trimester. Eventually, she was taken to a hospital off the prison grounds; I don't know what happened to her after that.

Another woman is etched in my memory. Lena. I saw her in the monkey tank on my first day in Krestí. She too had been brought directly from a courtroom. She was glamorous.

She carried herself as if she had just stepped off the pages of a fashion magazine. She wore makeup that was elegant and understated. She still had on her civilian clothes—a wheat-colored woolen coat and leather boots unmarred by the autumn muck. She was peaceful, with no signs of regret at being in that monkey tank. I remember thinking, How do such women end up here?

All of these people—child-Katya, the pregnant woman, and Lena from the fashion plate—seemed out of place, even incongruous, in the prison. Absurd. As if this were a satire, a dystopian joke.

These women did not express any destructive, savage rage. I never saw brawls or fistfights. Katya looked lost. The pregnant woman seemed resigned. A woman who had worked for Ispolkóm, the government executive branch, carried herself as if she had come here on a business trip. She told us that she was sentenced for a bribe. *Mnogokhódki*, jailbirds, seemed to be in their element here. An elite prostitute organized dances in our cell. The daughter of a prison doctor, who was awaiting her trial, recited Ecclesiastes to me.

After a while I started to tell my cellmates about my trial. I told them that I was trying to emigrate, that my mother was living abroad, that I was given a prison sentence because I had an emigration visa and thus had no citizenship. Reckless talk, it's so clear to me now. I knew not to give away information that others had shared with me and had taught *you* to do the same. Yet I kept talking to strangers about myself. It was as if I felt that I owned my own narrative and could take risks. I did not take care to protect myself, knowing well

that I was being watched. Soon after I told them my story, something strange happened. We took our daily walks in a small room. It had brick walls but no roof. It reminded me of an open shoebox like those in which children kept their pet hedgehogs. When you walked there, all you saw was a square of sky. Several roofless boxes were strung one next to the other. A group from each cell walked in its own box. We couldn't see the other inmates but could hear their voices across the wall. Suddenly I heard someone from another box yell out my name and something else that I couldn't make out. When we got back to our cell, my cellmates stopped talking to me. Katya, the pregnant woman, and everyone else. When I spoke to them, they snapped at me or didn't answer at all. I was dumbfounded. I hoped they would explain what had happened. They didn't and I never asked them.

It became unbearable to remain in that cell. Nikoláy Grigóryevich asked the prison warden to let me help at a small print shop on the prison grounds so I might spend a few hours away from my cell. He eventually persuaded the administration to move me to another cell. It was much larger, and had more inmates. Two of them talked to me constantly. It felt as if they were trying to extract something from me. There I kept to myself.

Galia to Alëna, Krestí, Leningrad, October/November 1981

Dóchenka, my love,

I am writing this little letter in case Nikolay Grigorievich comes.

I miss you. I try to put bad thoughts out of my mind and have only good ones.

I hope that everything I have taught you will stay with you during this time that we are forced apart. . . .

As a child and young adult, I always considered Grandma's opinion and, in my mind, I would consult with her before taking any action. It helped me. . . . If you get in trouble, try to talk to me in your thoughts, and you may find answers to your questions.

Write down in your notebook what happens to you, what you imagine, what stirs you. When we meet, give it to me to read. All these experiences will not vanish, they will stay with you . . .

I hope and believe that you won't be without me long. But as you know, anything can happen in life. Despite everything, you must remember—what parents left unfinished, you must do on your own. . . .

How are you out there, my love? Keep an eye on your health. Don't eat ice cream or drink those cold milkshakes lest you catch cold. Dress warmly, perhaps it's time for your winter coat? Aunt Kira has my old coat and boots. Can you wear them? How's Zhenia? She must be exhausted, poor thing. Any word from Grandma? I will only be able to get your answers in a month.

Visits are allowed here only after the appeals court decision comes into effect. . . .

Care packages are allowed once a month. My only craving is for vegetables, fruit, and, of course, sweets, but the weight is limited to five kilos. I won't be allowed to receive a package with clothes for three months. Too bad that G. could not bring me a dress. I wear the same skirt and turtleneck sweater, which I wash and put back on.

Kiss you,

Your mother

Nikoláy Grigóryevich still hoped that I would be acquitted on appeal. I wasn't. As I predicted, our appeal was denied. I was informed that I would be transferred to a penal labor camp. Gulag, the *zóna*. I dreaded it. Krestí was in Leningrad, but a labor camp could be anywhere in the country. I could be sent to a place where no one would find me. Mostly I was afraid that I would be moved to a place where my daughter couldn't visit me.

Nikoláy Grigóryevich was crushed by the outcome of my trial. His health began to fail. He may have felt that he had let me down. I feel differently. Despite the brevity of our meeting, I still think of him with the deepest gratitude. He was the only one to defend me publicly, ignoring risks to himself. Before he became an attorney, he had served as a judge. He had worked for the flawed legal system all his life, but he never betrayed his own moral principles. He died while I was still serving my sentence. Years later, I still consider him one of my closest friends.

The *Zóna*: Sáblino Labor Camp

A DRY PRAIRIE, DUSTED with ash, and a ghost town—
my first impressions of the *zóna*. There were small, squat
barracks and not a soul in sight. It looked like a surrealist
Dalí. Krestí was green and dark. The Sáblino zóna was gray.
Gray padded *vatniki*, bruised gray buildings, gray soil, and
putrid gray oatmeal that we were given at the zóna mess.
Our faces were pewter gray too. And the cats. Nowhere did
I see such cats—large bodies; enormous heads, with muzzles
flat like saucers; and spiteful eyes. None of the silky gloss of
a pet. These cats' fur looked like frayed ropes, like dreadlocks.
They walked slowly, as we inmates did, straining to lift their
feet. No one fed them or played with them. To this day I am
repulsed by the sight of a cat on the street.

The guard took me to one of the barracks, up a narrow
stairway, down a gloomy corridor with closed doors on both
sides, and into a room packed with bunk beds. A thicket of
metal bunks. They stood head to the wall, feet to the center,
with little beaten-up night tables between them. To this day,
I don't like bunk beds—can't stand them. One upper bunk
was free, and the guard told me to settle in there. The silver

lining was that my bunk was out of the way and when I would later feel at the end of my rope, I could climb up there and lie down, face to the wall.

After the guard left, I noticed two women sitting on the lower beds in the corner, eating slices of processed cheese. I was famished. After several months at Krestí, the hunger was relentless. All of us inmates experienced this in prison. I stood by my bunk and watched those two eat the cheese slices. I thought, Why won't they share? Later, after I began working and could buy the processed cheese at the zóna store, I always gave it to women who had just arrived from prison. But after the zóna I could never eat that cheese. I couldn't stand looking at it.

The guard brought my uniform—a short-sleeved blue cotton dress with white flowers, brown slippers with flat soles that looked like the ones that men wore in my communálka, a brown flannel scarf, and a *vatnik*, a padded cotton jacket that was several sizes too large and reached down to my ankles. It was well worn, but not threadbare or dirty, no. Good enough. Putting it on, I remembered the vatnik I wore as a student, during my apprenticeship at a Baltíysky plant. That was a happy memory.

I asked for any job as soon as I got to Sáblino. Most inmates went straight to work at the garment factory, but I had to wait for the factory supervisor to review my case and assign me a place. In the meantime, a warden let me carry mail to the inmates. I took the stacks of letters and went from *séktsiya* to *séktsiya*, room to room. In one of them, I saw a bunk bed in a far corner draped with bedsheets. A tall

white tent. And the shadows of women inside it. I stopped at the doorway and said, "There's a letter for one of the women here. I'm leaving it on the nightstand by the door."

A raspy voice barked from the tent, "Bring it over here."

I repeated, "The letters are on the nightstand."

"D'you hear what I said? Over here!"

I left the letter on the nightstand, and went down the corridor to the next *séktsiya*. Almost immediately, I heard running footsteps and another voice of a younger woman behind me. "Do you have any idea who you were talking to in there?"

I didn't. I stopped, turned around, and looked at her point blank. "And do *you* know who *you* are talking to right now?"

It was a stage act. I had no protection at the zóna. I turned my back to her and kept on walking down the corridor, thinking, When will she hit me? She didn't. And after that encounter no one ever bothered me at Sáblino.

The next morning, I received my job assignment at the garment factory. A guard came early in the morning to take me there. It was still dark outside. She led me across the yard, black and murky against a sky that was just beginning to pale at the edges. To a factory building, up another gloomy stairway, down another glum, dimly lit corridor. The door to the sewing workshop opened, and suddenly there was a gash of light. A luminous downpour. It must have come from the task lamps hanging from the ceiling. After months of darkness in the cells of Krestí, the light here seemed blinding.

The inmates sat in two rows, several dozen seamstresses,

each with her sewing machine. I couldn't see their faces, only their backs and shoulders, bent over their work. And the quiet rattle of their sewing needles.

The shop made cotton boxer shorts—yellow, blue, red, with circles, flowers, and anything you could imagine. I wondered, Why should men's underwear be made at a penal labor camp for women? What a mockery! No one laughed.

The sewing shop's supervisor, a civilian woman, explained my job—to check each finished garment for defects before sending it off for shipping. I had never learned to sew and admired anyone who could make even a simple straight seam. The seamstresses, especially those who had long sentences, did this job day after day for so many years, I felt they were more qualified to check my work. Only rarely did they make mistakes. It usually happened when they had troubles outside of work, a quarrel with another inmate, or bad news from home. Then they couldn't concentrate on sewing. When I found a mistake, I would discreetly ask the seamstress if she could fix it. If not, I would toss the garment in a bin for defective work in such a way that her name would not reach our supervisors. My goal was to cause no harm to these women. We had all had enough.

Sometimes the seamstresses pointed out the defects in the precut fabric, which came to us from a pattern shop downstairs. I began to check the pattern before handing the fabric over for sewing, and our supervisor moved me to the pattern shop full time. It was much smaller with fewer inmates. The jobs there were less monotonous but more dangerous. There, women had to mark the pattern on stacks of fabric, several centimeters thick, and then guide it through a large industrial cutter without getting injured.

Our civilian supervisor kept a bowl of chocolates on her conference table by the door. Children's favorites, "Little Squirrel," "Red Poppy," or "Little Bear in the North," in bright crinkly wrappers. You could hardly find these brands in Leningrad stores, and they were beyond luxury at the zóna. She kept the door to her office open and often invited us to come in. But she never offered these chocolates to anyone. Some inmates took the candy. I never did. Another mockery, I thought. Later, just before leaving the zóna, I asked her, "Why do you bring chocolates here and not offer them to us?"

"Why didn't you take them?"

"How can I take something that is not mine?"

She told me that when she first started to work at Sáblino, she brought sandwiches from home for the inmates who worked at her pattern shop. She knew it was forbidden but did it anyway. She offered food discreetly. Suddenly the warden called her in and almost fired her. One of the inmates, who had enjoyed the food that the civilian supervisor had brought, reported her to the zóna authorities. Why? No logic. None! Perhaps, the warden offered her something more valuable than a sandwich. After that, the young supervisor could not offer food anymore, but she still left chocolates on her table for us to take. Oh, these acts of kindness were preciously rare in the zóna. Informants, on the other hand, were commonplace, and suspicion of one another colored every interaction.

Galia to Alëna from Krestí, ca. December 1981

My precious girl!

Aunt Kira came to visit yesterday, and now I have at least partial clarity about you.

I know that you kept going home to check the mail, but I couldn't write to you. Now my situation has changed, and I will write to you daily, or every other day, and will send the letters as soon as I get envelopes.

Ask Aunt Kira to send me envelopes, standard postcards, notebooks, and replacement ink cartridges for a ballpoint pen by certified mail. All of it can go in the same letter. . . .

I can imagine how difficult it is for you now, I feel it, as if I were walking next to you, but what can I do? I have already "done enough" . . . Oh, please forgive me . . .

Lástochka, my little bird, be prudent, and safeguard everything that is good about you, don't let the resentment or anger drown all the beauty. Let Pushkin, Grin, Chekhov, and other authors as yet unknown to you, but whom you must discover this year, become your friends and nurture you always. . . .

If you need clothes, have Grandma send them to you. I was upset at first, when Aunt Kira said that you asked for new jeans and a jacket, but then I considered your circumstance and realized that if you asked, you must need them. Ask Aunt Kira to let Grandma know and she will send you everything you want and need. But, my sunshine, do consider this—don't let those pretty things that you own become your life's purpose. They are worthless next to creativity, art, love, motherhood, and so much more. Remember that. I understand why you need those jeans, but never try to prove to others your worth. There are better ways to do that. And why bother proving yourself to others? . . . This is not an instruction, but food for thought. Please do write to me what you decide. Agreed? . . .

Dóchenka, my daughter, after three months of

silence, we can now communicate, so let's use this opportunity. Write to me about everything that goes on with you, what interests you or leaves you indifferent, send me your compositions, stories, and poems, and I will give you my opinion. Send your drawings in large envelopes. Let me know what you read and see, what pleases you or doesn't. Where you go, and who you meet. . . .

My lástochka, I will be allowed to have visitation, which means that you and I can spend a full day together, or perhaps even two days. I think that we must see each other and talk about your life. Will you come? . . .

Dóchenka, not living next to each other doesn't mean living apart. I am still with you always—in trouble and joy. No matter what happens, you must remember—children have to be better, wiser, and more pure than their parents, they must accomplish what their parents could not. . . .

Please send my gratitude to Zhenia for everything she does for you. . . .

Be well, my dearest, my only one, my beloved, my smart little girl. Do write to Grandma.

Your mama

Sáblino's zóna was a penal camp for women. It had standard security and compulsory labor. It was forty kilometers from Leningrad and an hour away by train. Its entire campus was no larger than a city block—our sleeping barracks, the mess hall, the small sewing factory where we worked, the administration building with a wing for overnight family visits, and a few auxiliary structures, that's all.

Most women were incarcerated for white-collar

crimes—bribery, fraud, misappropriation of state property, theft. Also robbery and drugs. There was one woman who had killed her husband. She was full-figured and always looked serene, like a matriarch who had just stepped out of the kitchen and hadn't had time to take off her apron.

I never saw violence there. I also remember no laughter. There must have been funny moments, yet they never made us laugh. We didn't talk much. We smoked in the corridors, squatting along the walls after work, in complete silence.

The feeling at Sáblino was different from Krestí. In Krestí, most of us were awaiting a trial or the results of our appeals. We were walled-up inside a brick box, waiting for someone to return us to our normal life. It's like having a taxi meter running inside one's head. All my thoughts were directed at something happening outside in abstraction. Krestí was temporary. So the inmates we met, the bunk we slept on, the rotten food, and the splattered toilet bowl in the open—all of it seemed short-term. But at Sáblino, we had to accept that this was our new life. In Krestí we constantly talked about the people we left on the other side. But at the labor camp, we did not speak about them. In prison, there was hope, but in the zóna there were conditions we could not change.

There were many young women. Katya, my cellmate at Krestí who looked like a child, was also transferred there. She had begun to smoke and was now spending time with a much older woman, a recidivist with a long sentence who showed Katya how to brew *chifír*, a concentrated tea, a stimulant.

I also saw Lena, the woman I first met in the monkey

tank on my first day in Kresti. The zóna was crowded, and when there weren't enough beds for new arrivals, they were given a place on the floor under the bunks. One day I entered my séktsiya and saw a woman getting up from under my bed. She had the same pallid face and dark-blue dress with flowers as the other inmates. But from the way she carried herself, I recognized the woman who had looked like a model from the pages of a fashion magazine. She moved about our séktsiya as if its walls did not exist. Her life continued independently of the floor and that dress. She showed no signs of anger, or any feelings, good or bad, toward other inmates. She walked as if the zóna were a street where we were passing by.

Like me, she had been charged with misappropriation of state property. By and by, we became friends, and she began to tell me about herself. Lena's first marriage had been to a Hungarian, she had lived abroad. It was very rare for a Soviet citizen to marry a foreigner. First of all, secret agents constantly watched international visitors and kept Soviet citizens away from them. If despite every obstacle a foreigner wanted to marry a Soviet citizen, the couple needed special permission from the state, and then another exemption, to leave the country. It would take several years for a couple to get their exit visas, and the effort usually failed. Meanwhile, the Soviet bureaucracy did everything it could to break such unions. Lena succeeded and moved to Hungary. Her marriage then fell apart and she returned to Leningrad.

After a time she married a Russian, tall and broad-shouldered, with green eyes that looked like well water. She was in love with him. He was a manager at a state-run chain of cafés and restaurants, a massive state-run organization. She went to work for him. He supervised a district, and she

became the manager of a smaller café. Like supermarkets and beauty salons, this organization had an enormous flow of cash, and the same scheme of corruption, money laundering, and bribes prevailed. Her husband was an enterprising businessman, but to build a business in the socialist system meant to also take part in corruption. Lena became involved in this game. An investigation began with her husband. If it had proceeded, it would snowball into a large case: many others would be charged with organized crime and her husband, as the ringleader, would receive a very long sentence. Lena took the blame. Her husband pulled in his connections and organized her legal defense. She received a relatively short sentence.

He died almost immediately after her trial. She learned about it when she was still in Krestí. Heart failure. The real reason was unclear. She also found out that everything they owned together was taken away. Their apartment, belongings, and the money they had saved were gone. She was left with nothing.

Despite it all, she remained unbroken. She did not become apprehensive or dejected. She had no regrets for the decisions she had made. Never looked back. Her first marriage, the move to Hungary, her new love, and business . . . She saw the lies of the Soviet system and fought her duel with the regime in her own way. She was a stoic.

Galia to Alëna, Sáblino, February 1982

My little lástochka,

The air outside smells of spring and the sun is so warm, I want to believe that our lives will also have sunshine. For now I see blue sky, sparkling white snow, and amidst

it, wooden cottages, like fluffed chicks, on the other side of the fence. Such a wondrous calm, without movement, stir, or anxiety. I want to immerse myself in that bliss and stay there, but life zigzags along and imposes its own laws and determines the path we follow. There are people who choose their own path, and those who are led by fate. I want you to be in the first group, and for that you must stand firmly on your own two feet. . . .

Alëna, my dearest, are you angry with me? Did I write something wrong? Why are you silent? Are you sick or upset? What happened to you? Is something wrong with Grandma? Does she write you? How is her health? Dóchenka, you have the wisdom to understand what I cannot write, so please read my thoughts. We have always understood each other, so how could this separation, created by others, change that?

I don't write poems at all now, too tired and have no spirit for poetry. And you? . . .

Nothing from Yuri and Aunt Kira. Your collective silence prompts sad reflections, but perhaps the mail service is having its fun. . . . So please dispel my worries, send me a note. Or maybe you are just very busy? How's your school vacation?

Dóchenka, send more envelopes. . . . I'm waiting for your letters.

Kisses,

Your mama

For our work at Sáblino we earned around thirty kopeks a day. It was the cost of a pack of unfiltered cigarettes that

reminded me of the hand-rolled *samokrútki* that soldiers smoked during the war. We did not receive cash, but credit at the camp's commissary. In addition to cigarettes, processed cheese, and soybean candy, we could buy tea and pens there. Tea was used to make chifír, and pens to write letters home. Tea and pens were units of currency that could be exchanged for other coveted things.

Our mess hall was in a separate barrack. There were long tables and benches made of crudely sawn planks, old and dark, rubbed by hundreds of seated bodies. Veteran wood. Food was served in aluminum bowls, dented, stained, and spotted, like the arms of old women. The spoons were aluminum too, bent and twisted. We each had our own spoon and carried it in the inner pocket of our vátniki.

What were we served there? Soup, macaroni, oatmeal. The macaroni looked like hookworms—short, curved, and moldy. The oatmeal was soot-colored and rancid. I couldn't eat it at first. In time I learned to eat what I was given. One bite at a time. It stank, of course, the reek of spoiled grain. But after a while, it didn't seem so musty and smelled like regular oatmeal. People get hardened to anything.

There were handwashing sinks inside our sleeping barrack but no bathrooms. We went to the outhouse built of wooden boards. No door. No heating. Inmates had to get used to the cold. It had a dirt floor and a piece of plywood with round holes for squatting over. It was rarely cleaned. The holes filled up quickly. When the piles rose out of the openings, women used any clear space on the plywood or on the dirt floor itself. In the winter, when the piles froze and were crusted with ice, it was easier not to step in them. But in the summer, we would smear our brown slippers and had

to wash them under cold water in a sink inside the barrack. I don't know why the administration cleaned the toilet only after it was completely filled up. And after cleaning, the cycle resumed its full course. The stench of waste was unbearable and became worse in warmer weather. I got used to that too.

At night, we were locked inside our barrack and had to use a bucket next to the sinks in the washroom. Everyone tried to go before it filled up, and no one poured it out after themselves. Eventually, the unlucky one had to pour out the contents of the overflowing bucket into the sink. I don't understand why each woman wouldn't flush it out after herself.

Galia to Alëna, Sáblino, March 1982

My beloved precious girl,

. . . I don't remember the exact phrase and its context in my previous letter, but I wholeheartedly know . . . that I would never laugh at you, especially when you aren't with me. Always remember this: everything that you find serious, is serious to me a hundredfold, and what you find hurtful is my tragedy. I have little interest in things related to my own person. But each one of your tears is my sobbing, your smile is my laughter. So you must have misunderstood, or I did not express my thoughts clearly. Do not have any doubts in this regard. . . . Agreed?

I don't want to write about myself, but know that I am fine, and my stay here should not inform worries. Understood? Most important to me is your spirit, your mindset, your life. The rest is meaningless. I feel your mood swings even at a distance, and they cause identical swings in me. See what is happening to us! . . .

Dóchenka, my darling, there are only eleven months

and a few days left. We will be together again. . . We must learn to find good in everything bad that happens to us. . . .

What are you like now? I often ask myself this question.

Please write to me, my good little girl.

Your mama

I was working alone at the pattern shop when Katya walked in, put her chin on my workbench, and looked up at me with her big round child's eyes and asked, "Would you forgive me?"

"Forgive you for what?"

"Do you remember how rude we were to you at Krestí?"

"I do."

"I want to tell you what had happened."

She told me that when women from my cell had gone on their walk, someone from another cell had yelled out, "Galia Lembersky is a *cuckoósha*." Everyone knew what it meant except for me, because I was new and haven't learned prison slang. After that, all of them stopped talking to me.

"I am so sorry for that. Now I know that it wasn't true," Katya said.

After she told me this, I finally understood why my cellmates had withdrawn from me. At Krestí, I didn't know the word *cuckoósha*—a cuckoo, snitch, stool pigeon. What I had told my cellmates about my trial and emigration must have reached our wardens. It clearly sounded like anti-government propaganda to them, even if it was all true. The prison administration did not need it to spread among the inmates. So they did what they always did with those who didn't fall

in line—spread rumors and slander their name. This was a common Soviet practice and not only in prisons. After they had their patsy yell out that I was a snitch, my cellmates didn't want anything to do with me. I am still grateful to Katya for telling me or I would never have known.

At Krestí, during the first stage of our incarceration, inmates hated and despised snitches. The values of good and evil carried over from our previous lives. The informants could influence our trial and change our fate. But in the penal labor camp, snitches became an unavoidable part of our new landscape. We tried to be careful around them but did not shut them out entirely.

I didn't know who these snitches were, but I could guess from the way women talked or the perks they were getting. The cukoóshka would pretend to be a friend. She would talk to me and try to provoke me into saying something compromising. Then she would go behind my back and report what she saw or heard to a warden or to the higher-ups. In exchange, she would get a few bags of tea to brew chifír to get high, or linen to hang around her bed, or an extra chunk of fish in her soup, or a coveted job at the kitchen. Their perks were in plain sight. How did she have so much tea? Why was she allowed to skip work and sit in her linen tent? Her victim could be sent to a solitary or lose visitation rights, but the snitch would take her petty rewards with no empathy for anyone else.

There were also "official" informants—troop captains. Inmates were grouped by *séktsiyi*, the rooms where we lived, some twenty women to a room. A female military warden

supervised each *séktsiya* and she appointed a troop captain from among inmates. Her role was to report to the warden, yet her role differed from that of a snitch. She did it in the open, with our understanding that if there were problems in the séktsiya or at the factory, she would have to inform the authorities. These women had a lot of power over us.

The captain of my troop looked like a squat armoire with flapping doors. On my first day at the zóna, she marched up to me. "I expect discipline and hard work. No shenanigans! You step out of line and will go straight to solitary. And then you can forget your family visitation and an early release. I'll be watching."

My cellmates told me that it wasn't about discipline. She expected gifts. Everyone gave her whatever they could. Women bought her pens, tea, packs of cigarettes, or the processed cheese, and soybean candy—whatever we could get on our tiny factory wages. She took everything. It was unfathomable! We were all starving, loosing teeth from malnutrition, while she used her position to take what little we had.

Galia to Alëna, Sáblino, March 8, 1982

My dear beloved girl,

. . . I recently read a remark of Leo Tolstoy's—you will be amazed: "If you do something, do it well. If you can't or don't wish to do it well, don't do it at all." Alëna, it is word for word what I've been telling you daily, when you were sewing a skirt, cross-stitching, or doing anything else. . . . Everyone has to begin their lives from this very principle. . . .

One more day is almost over. On the 15th of March

it will be exactly half a year since we parted, although I was never apart from you, not even for a minute. The hours I had to spend with others, when my thoughts were tied up by other things or people, I consider that time lost because you were not a participant in it. And only those discoveries, which I can relay to you, if only on paper, have meaning for me. . . .

Please write back, my darling . . .

Kisses,

Your mama

Galia to Alëna, Sáblino, March 1982

Lástochka, my little bird,

I received your story about a painting, and I found out the next day that we can meet on the 5th and 6th of April. . . .

About your written story: It is bad, Alëna, really bad. It is bad not for lack of interesting ideas, but because you ruined the magnificent description of the sand and the sea with the absence of any interest in your protagonists. You took the easy route out and did not take time to think, you did it *ad hoc*, ship and pray, once again. . . If you didn't like the painting, you would be better off writing a basic story that would take you one minute. But since you conjured up a brilliant idea about the dog, his feelings and emotions, his love for the girls and his owner, and about things that rouse him, you should have written about that. But in your writing—the father was good, the girls were good, they wore their blouses, they sat in the boat—drivel,

pure shame. Your pooch got lost in the heap of hollow, meaningless phrases, and, by the way, it is up to your reader and not you, the author, to draw conclusions about his young owners. Their thoughts and feelings must be refracted through the prism of your dog, the protagonist. In your story, they are torn apart from everything else. Sure, it is the description of a painting, but if you took a risk, you must carry it through to the end. Everything got lost. Sit down and rewrite everything except for the description of nature and the idea of a pooch—those pieces are excellent. I'm so sorry we can't talk face-to-face, or I'd tell you so much more. But you can see for yourself that it is bad, and I don't give you a B, but a D. How could you ruin such a thing? . . . No, my love, foster self-criticism toward everything you do, or you will never improve.

And one more thing. Keep an eye on your spelling. I wrote to you once already that "original" is written with *i* and not an *e*, as you have it, remember this. Neighbors— with an *h*. My little kitten, you are so illiterate—it's frightening. Your writing skills speak about you. Sorrow— with double *r*. Copy these three words and send them back to me.

You are my intelligent wonder girl, and I scold you so you don't decide that you are at the summit. Those peaks are still ahead of you, and your path there is through persistent, hard work.

My love, can you imagine that we will see each other in two weeks? I can't even believe that I will see your adorable face. . . . Why don't you write about music— how's Victor Ivanovich? . . .

And one more thing: You are upset that you are not as grown-up as your classmate Lena P. What nonsense!

Being eighteen is still ahead of you, but you can only be a child once. Don't rush to grow up—there'll be time.

Why doesn't Zhenia write to me?

Kisses for my beloved daughter,

Your mama

P.S. Until our meeting on April 5th. Are you glad?

There was a library at the colony—one room with a table for six and a few shelves. It was usually empty when I went. I would go there after work and write to you. During the day, when I was working at the factory, fragments of my letters formed. And in the evening, I would come to the library and put them down on paper. After bedtime curfew, I would continue writing on my bunk. If I couldn't sleep, I would keep writing until early in the morning. Sometimes, I didn't send them. The wardens read all our correspondence—everything we sent and received. If they didn't approve of something, they threw the letter out without letting us know. And if they found anything compromising, there could be serious repercussions for me. Or for you. I had to be careful with everything that I wrote.

I also had to be careful with how my written words would sound to you, without the benefit of my voice or intonation. Something I might mean as a joke could come across as an insult. Or I would reply to something in your letter, but it would be irrelevant by the time it got to you. Knowing how anxious you were about me, I tried to alleviate your

worries and keep anything negative from seeping into my text. And, as much as I could, I tried to keep being a parent to you, to anticipate what might arise in your life and guide you through it.

I waited constantly for your letters. I was living from one letter to another. When they didn't come, I felt the rising doom inside me, like a bell pealing between my temples. I had to fight to calm it. But when a letter arrived, I had an even sharper pain. And a terrible sense of guilt would come with it. A physical pain and the fear, the uncanny dread that something awful could happen. I tried to suppress that feeling.

I remember once an inmate put a letter on my workbench and said, "It's from your daughter!"

I kept working. Only after she left did I pick it up and take it to read it where no one would see me. It included a poem you wrote about spring. I stood there and wept.

Another time an inmate team leader of the pattern shop came with the news, "You have permission for a visit with your daughter."

She said this cheerfully. People did not smile much at the zóna, yet this time she was smiling. But I was at a loss. No happiness. No joy of anticipation. I was afraid of our meeting. That visit . . . No, I will not talk about it.

Dóchenka! My daughter,

Forgive me for the rain you accidentally saw;
forgive me for the bitterness of my offenses
and for the ones of which you never learned,
and for the oddity of woodland fairy tales.

Forgive me for the world, so fabulously dreamy
which I flung open but did not disclose;
forgive me for the false sense of well-being,
and for the fact that I am not with you

and for the pain of tears you have not shed,
for all the troubles that befell you, so absurdly,
and for the reveries that didn't come true,
and for my love—so blind—of those who don't deserve it.

Forgive me for the harshness of sharp words
that I let slip and that I've long forgotten,
and for my waking you from childhood dreams,
for all, all, all you have discovered without me . . .

—Galia Lemberskaya, Sáblino, July 1982

Toward the end of the summer my warden filed a request
for my release to *khímiya*. I hoped—I was counting on it—
that they would let me stay in Leningrad, where I could see
you, my daughter, on the weekends. Instead, they sent me a
thousand kilometers away to Gorky, an industrial city closed
to foreign visitors. It was where Andrey Sakharov was exiled
at the time.

The day before my departure, inmates gathered at the
pattern-cutting shop. Our civilian shop supervisor said to
me, "Look out the window! Everything is warm and green.
How good it is now."

But I felt nothing. I said, "I don't feel it . . . This does
not belong to me."

The next morning a guard led me off the Sáblino

grounds. I stepped outside the gate and saw a woman in the street coming toward me. I recognized her right away—she was my friend from the labor camp, the lawyer convicted for a bribe. She had been released a few days earlier. It was unexpected. There was an incongruity—my inmate friend and the space outside the fence. She was tall and her hair was black and frizzy, like foam, it swayed when she walked. She had African blood and was a descendant of Aleksandr Pushkin. She came to say goodbye. I saw her for a brief moment. She picked a raspberry off a raspberry bush and reached out to give it to me. The red berry on her dark palm . . . freedom.

Then the guard took me to a prison van and we drove away.

The City of Bitter

Galia to Kira, Rina, and Alëna, Gorky, August 21–23, 1982

My dearest people,

It took me the entire month to get to Gorky. The name of the city fits with what I experience. Upon arrival I went straight to a post office to call you but there was no answer. I am worried. . . . I called Zhenia but was told that she went away for vacation.

How's my mother? I feel so anxious about her and Alëna. My staying in Leningrad fell through. Human callousness is unlimited. . . .

I walk around the regional center like a hopeless drunk in torn slippers and a bedraggled vatnik. They give us one ruble a day—live as you can. I don't even have a bar of soap. What a fairytale! I would be better off staying in Sáblino. At least, there was a set routine and a tolerable job. Here they shoved me in a machine-assembly shop, in front of a lathe. It's a comedy.

I asked to go to Leningrad for five days. They answered, "You must earn your compensatory leave first."

On Saturday and Sunday I have to work at a state farm—there's nowhere to go to avoid running into agricultural duties. I don't know when I can earn

my compensatory leave. I will have to work two shifts, fourteen hours in a row, never mind that I stagger and sway in the breeze like a birch tree . . .

Alëna, my girl, I so want to see you, but you shouldn't come here until I get back on my feet. A mother in moments of weakness is a bad deal. I will try to come to you in September. I don't know if it will work out, but I will definitely come for your birthday in October and will stay for ten days. It's our tentative plan. . . . But if you want to see me sooner, come here. Have Yuri or someone in the family put you on a train to Gorky, give you food for half a day, and send me a telegram. I will pick you up. . . . Then we could spend time together. Agreed?

Galia

No, Alëna, I don't want to talk about khímiya. I don't want to go back to that memory. It was horrid. Repulsive. I would have preferred to stay in Sáblino. When I first heard the word *khímiya*, chemistry, my only association was with a science course in high school. Then I thought that convicts were being sent to work at a chemical plant, where I would be exposed to chemical agents. That's what had happened to them in the past. Then someone explained that khímiya was an intermediate step between the zóna and freedom. Gorky was an industrial city with one of the largest automobile plants in the country, GAZ. I would have to work there.

From Sáblino, I was taken to a holding prison. I was put in solitary there. I don't know why. Perhaps they didn't have space in a regular cell. No one explained. It was a box with a bench, so small that if I were to get up, my face would

smash against the door. Everything was metal—the walls, the door, and the built-in seat. A sealed and airtight cage. It was dead quiet and hard to breathe. Almost impossible. The air was stale, stagnant, and very hot. It must have been a hot summer. I thought, That's it, I won't make it out of here. An older person would perish in hours.

Then I and other inmates were taken to a train. We sat in locked compartments with metal grating instead of doors, and guards walked back and forth along the corridor. They brought us bread and herring wrapped in newspaper, but no water. Women were thirsty and asked for water. The guards kept walking. We asked to let us use the bathroom. They ignored us.

We were brought to another transit prison—Vladímirsky Central. There were many women inmates and many guards. Back in Sáblino, our guards were all women, but here they were all men. We were taken to a large cell with holes in the floor along the wall instead of a bathroom. Everything out in the open. Women squatted, and guards stood in front of us, leering and laughing.

After that I remember nothing for the rest of my trip to Gorky. No memories, a blank. We arrived. I expected Gorky to be a colorful medieval city. Instead, it was dark and gray—stone and concrete. I was taken to a dormitory for incarcerated women. It was also gray, three or four floors, with long corridors that reminded me of Krestí. The ceiling was so low I could touch it. And doors, one after another, looked like a patched sleeve. A male warden met me there. He was beefy and fat, like the brute from the OBKhSS or the copper-haired guard from Krestí. The same type, a hitman. He explained the rules.

"You have to be at the dorm before curfew. Nine (or ten) o'clock in the evening. Any infraction inside or outside the dorm or at the workplace will send you back to a labor camp."

He took me to my room. There were two women staying there, one convicted for grand larceny, another for racketeering, both with long sentences. I went outside and walked to the nearest food joint. I was not hungry. Cigarettes suppress the appetite. But I had a little bit of money from Sáblino and bought a chicken wing with mashed potato— the cheapest thing on the menu. It was gray too. And just like us convicts, it had no meat. I sucked on the bone. Was it tasty? I don't remember. I felt nothing, no emotions. No joy, or fear, or disdain. My mind told me to be concerned about my safety, but I did not feel it in my heart. Only detachment and stupor. The sensation of not recognizing anything. These streets? I didn't know what to do with them. The whole of Gorky was like that chicken wing to me. Freedom . . .

The next morning I was at the auto-manufacturing plant. My knowledge of industrial plants was limited to the movies and my internship at a Baltiysky plant in Leningrad when I was a student. There we had built tankers that were painted crimson and orange. We worked inside them. It was a good memory. But the Gorky plant was black and massive. People looked like ants. Everything was metal, and there was grime, dirt, and a horrible din. And although it was summer, my memory of the plant was of perpetual darkness.

I was brought to a grinding machine, and someone showed me how to operate it. I never liked machines, and

here I was, standing and grinding metal rings and gears all day long. The head of the shop came to talk to me. He asked where I lived, what my crime was, and how long my sentence was. I told him. When I returned the next morning, I saw another woman working at my metal grinder. I went to the shop head. He said that he had reassigned me to oiling the equipment. He gave me a cart and an oil can and showed me how to do it. That's what I did my entire time in Gorky.

The shop head continued to stop by and ask about my work. Sometimes he asked me what I did after work. Once he suggested that we meet on a weekend. He did it kindly, without vulgarity, even though he had complete power over me. I was taken aback. I wondered what to do with that. I had forgotten how to be with a man. I didn't go. He did not pressure me. He seemed to understand what I was going through. I walked with my cart and my oil can around the plant in a trance.

I felt a strange longing for the zóna—for the austerity of its living conditions, our movements and thoughts. I felt more freedom at the zóna than at khímiya. It is easier to live in an isolated place than in the open world with restrictions. In Sáblino I could go from one barrack to another, and those constraints tempered anxiety. We were like automatons, robots with the switch flipped on or off, executing assigned tasks. But in Gorky, everything was open. Our reach widened, but our hands were still tied. The constraints were no longer physical. I lived in the open but was aware of the fact that I would be punished for the least infraction. I wouldn't even know that I was doing something "wrong."

At the labor camp, we were equally deprived, but at the khímiya we became outcasts. When I stepped out of the

dorm, passers-by kept away, because they knew what kind of dorm it was. I didn't make friends or get close to anyone.

At Sáblino, I was separated from the world. I had to take what was given. My only choice was to accept what was offered. But at khímiya, my cage had been opened, and I constantly had to choose. I had to decide between a chicken wing and something else, and those choices gave a hint of freedom. Automation yielded to desires.

To survive you have to let go of feelings and memories, to separate yourself from your past, from the yearning for comfort, food, prestige, reputation, influence, power, or money. If you succeed, you become free. Freedom is elusive. You feel that it is almost within reach, you see it, you grasp for it, but it moves away. You think, When I am released from incarceration, when I return from khímiya, after I leave the Soviet Union—I will have my freedom. But it never comes. Toward the end of your life, you find yourself in another cage—a prison of your ailments. No freedom there either. It is like fishing, you think you are about to catch it, but it keeps escaping. Something is always whirling inside you. You constantly need to run somewhere. But freedom is peace.

Every person has to find their own purpose. For some it is art, for others their family or the happiness of those around them. If the choices you make are not authentic to you, if you haven't found your own truth—you will remain in a cage that you have created. You need to find your connection with your inner self. Not an artificial connection that you invented and imposed on yourself, but the one that arises naturally within you.

When I was young, I thought my life's purpose was to carry my father's legacy. I put those fetters upon myself. But

when I was sent to prison, my father's art rested on one side of the scale, and my daughter and my mother on the other. Then I realized that my child and my mother were more important to me than anything else. My father may have made a different choice. His parents were murdered during the war, and he gave them voice through his paintings. Growing up, I didn't know what lay behind his paintings. To protect me, my parents did not share their truth with me.

When I was a child and visited the homes of my school friends, they had photographs of their grandparents on the walls. Old photographs taken before the Revolution. I never saw such photographs of my father's parents and never asked, Who were they? Where did they come from? My father's lineage did not exist in my mind.

When Mother was emigrating, I found photographs of pencil drawings my father had made of an old man and an old woman. My mother said that they were his parents. I never met them, they died at the beginning of the war and my parents never talked about them when I was growing up. I never asked. Another silence that I accepted. Much later, after both of my parents had died, I began to learn what had happened during World War II. The images of the Holocaust, the shooting grounds of Ukraine that I found in books and archival documents became real to me. These two people, my grandparents, sprang to life. I began to feel my grandmother's presence, as if I could touch her. I wanted to know about their lives, what they loved, what they read, where they traveled, what they believed in. I needed to learn about their faith. I thought about Father's paintings, his parents living in his art. Did he practice painting as a religious ritual, giving form to his, to their, prayer? I finally understood the gravity

of his task and the urgency with which he painted, cutting off everything that stood in its way. Then I wanted to ask him, "Did you see *me* as their new life?" Years later, I had a dream that I was hiding under a dark stairway waiting for the Nazis to take me away. After that, I hung the drawings of my grandparents on the wall. When my granddaughter came to visit me, she pointed at the drawing of the old woman and said, "Grandma, it's you!"

PART THREE

Alëna

Adolescence

I AM ALMOST THIRTEEN and want to read serious books: philosophy, Hegel, Immanuel Kant. Masha's mother, a university professor, lends me a volume. "Be my guest," she says not without irony.

Transcendental idealism. The critique of pure reason. Observed entities, space and time, as phenomena of consciousness and constructs of one's mind, sensibility, and intuition.

"Let's get a manicure," Masha says.

We go to a local beauty salon. A manicurist greets us, "Ah, our young pioneers are here!" She puts out two tubs with warm soapy water. "Here, soak your hands and pick your colors—crimson, like your neckerchiefs, or pearl, like this cloudy day."

Masha picks crimson to stand out. I choose pearl to dissolve into the universe. Afterward, we walk down the street and swing our arms, fingers splayed out so everyone notices them.

"You know, Mash', this street is *a priori*, it does not exist outside our consciousness."

"Yeah? And does that pastry shop exist?"

The pastry shop does indeed, but not money in our

pockets. We go back outside and nag passersby for spare change. They kindly give us two kopeks at a time, until there is enough for a milkshake and a shortbread cookie.

"Yum," Masha says, "I can't wait to start making money."

"Money is only a signifier within a semiotic system of signs," I observe.

Summer begins, and my aunts send me to an overnight summer camp for young pioneers. I don't want to go. I don't like life ordered by a shrill megaphone, rowdy kids, sunshine, and sleeping barracks with no quiet place of my own.

At the camp, a bugle cuts into my sleep like a rusty machete. I creep out of bed into a misty morning. Kids I've barely met begin to slowly take shape in my post-dream fog. We fuss with our bedding to recreate the assemblage our troop leader taught us on the first day of camp—sheets taut like the skin of a baby, woolen blankets folded in quarters, pillows fluffed and set on their corners like a full sail at the head of a regatta. Then we slouch, waiting for our troop leader to inspect our work. She walks in perkily, all five feet of her, black curly hair, cropped short to make her look like a middle-schooler. She walks up and down each row. "Yes. Yes. Yes. Oh no! Lenka! Is this your blanket or oatmeal on rocks?"

Lenka has to start over.

Done with inspection, we totter outside to splash our faces with ice-cold water from the manual water dispenser. My teeth clatter. We do jumping jacks to warm up. The bugle screeches again, we line up and walk in formation to all-camp assembly.

"Left, right, left right . . . left . . . left."

I slowly begin to wake up.

"Fa-a-all in! Eyes rrrright! Aaaa-tten-tion . . . Who will be raising the flag?"

A captain of the fourth-grade troop is called up. The tiny girl marches down to the center of the formation, military-style, knees lifted high, bony elbows swinging wide. A recording of the national anthem grates the air. She pulls together all her might and all her weight against the rope, but sadly it's not enough. The flag barely budges. Red fabric meekly flaps with a gust of wind. There's a dead silence. The girl yanks at the rope, scraping her hands. I hold my breath. Children in the back begin to chuckle.

"Atten-tion!" the camp director howls.

Suddenly the flag jerks up and begins to slowly climb up. I exhale. Then I think, I wish this flag would rip off and fly to hell. The camp director begins his long, unbearable speech, scrambled by megaphone.

"*Brakha-ha-ha, za-mi-kah-kha.*"

My knees buckle from boredom, my back begins to itch. Shit on a stick, I think. Girls should not think rude words, I know. But they crawl into my head like maggots. *Dickhead. Asshole. Motherfucker.* Other kids are starting to get antsy. Lenka jabs a stick at the boys' behinds. They hiss back at her, "Get lost, you clingy idiot."

She cackles. Time passes faster. Finally, the assembly is done. Kids disperse and reassemble in amorphous patches all over the common.

"There will be crafts and activities after breakfast. Doll-making, embroidery, and repoussé," my troop leader tells me chirpily. "Do join!"

"Maybe," I reply. To hell with your repoussé, I think.

Nothing is more sacred at the young pioneers' summer camp than a hot meal. There are many. They punctuate the day like a Morse alphabet. In the morning we are served flapjacks with jam and milk, and bread. Soup, chicken, and rice, with bread, at noon. A midday snack of a thickened sweet berry drink, called *kissel*, that tastes like slime, or hot chocolate with sweet buns, follows an afternoon nap, a compulsory torment. I am still full at dinnertime, but to no avail. Meat and potatoes, with bread and butter, for dinner. And because no food is ever thrown away, in honor of the Siege of Leningrad, the cafeteria lady walks up and down between our long dining tables, as if we were taking a quiz. She is looking for cheaters.

At the end of the day, the bugle rounds us up into our sleeping barrack. No one is tired. The troop leader comes to turn off the lights. We beg her to stay. She asks if we want to hear scary stories in the dark. Yes, please! Every one of her stories begins with "One night, when it was pitch dark . . ." and ends with a murder. We scream and beg for more. "Tell the gross one about Vovochka!"

She does. Then she tells another. And one more. Each time she says sternly, "That'll be the last one."

And keeps going. I think she might be afraid to be alone in the dark. Finally, she turns off the lights and leaves. The minute the door shuts behind her, the lights come back on. We pull our suitcases out from under our beds. Out come combs and mirrors, pins, hair ties, and makeup "borrowed" from mothers without their consent. The troop leader strolls back in. Lights off. She leaves. We are back to our makeover in the dark. Then someone says, "Time for treats!"

The girls take out care packages their mothers lovingly packed for them—yumsters with a long shelf life—chocolates,

candy, dried fruit, spice cakes, dried sweet bagels called *sushki*, and marmalade in little tubes. I have neither makeup, nor yumsters. Nothing in my suitcase but a change of clothes and socks that needs darning. Nothing in Lenka's suitcase either. She takes out her toothpaste and squeezes a drop into her mouth. "Mmm, cherry!"

"Are you nuts? You'll get a stomachache!" someone says.

"I won't. I do it all the time."

I try mine. It's called Zhemchug, the Pearl, and tastes like fermented sawdust.

"Don't waste it," another girl says. "Let's go and spray boys with toothpaste." Everyone is elated. We'll go at midnight, when they are asleep.

"Who will wake *us* up?"

"I will," Lenka says weightily.

At midnight, it's dead quiet on our side of the barrack. Some twenty girls are sleeping. Then I hear Lenka's husky whisper, "Hey, *bratvá*, bros! Git up! Let's roll!"

We crawl out from under our warm covers. We fumble for our toothpaste in the dark. We creep down the corridor, shivering from adrenaline and the cold, our tubes opened and cocked. We open the door to the boy's room. It hits us with the smell of sweaty socks and glue. We move fast. Toothpaste squirts onto their hands and foreheads. They groan and turn in their sleep. We run like the wind. Out of their room and back to ours. We jump under the covers. No more talking. Only muffled giggles come in shudders until the last of us falls asleep.

In the morning, the groggy boys walk out with a swagger, as white as ghosts. Our small squirts of toothpaste gained ground. Their faces, ears, arms, and hair are chalk-white, like

they've never been in the sun. The boys scrub themselves with sponges in frigid water from a manual water dispenser and jokingly wave their fists at us: "You've got it coming tonight!"

But a few boys give us glum stares and say nothing. The next night at midnight, there is a soft swish in the corridor. Our door bursts open. The gang rushes in with their paste and pillows. The scrimmage is on. We moon-jump from bed to bed, propelled by the rusty springs of our mattresses, swinging back at the boys with our pillows. Everyone screeches and laughs. Then one by one, the boys run back to their room. Except for the glum ones who keep hitting the girls—three on one, then, like a pack of wolves, all on one. She is not laughing anymore, but lies curled up on her bed, with her elbows up over her face. The blows keep coming.

"Stop it," Lenka shouts.

"Shut up, you bitch, or you'll get it," one of them barks back.

"*Shookher*! Cops!" another boy yells.

There are footsteps in the corridor. Our petite troop leader, sleepy and uncombed, runs in and turn on the lights. "Oh, you are in so much trouble, children!"

"They did it first!"

"But only cowards would hit a girl!"

The wolves growl and leave. The girls lie in bed silently, with their eyes wide open.

And yet . . . even though boys are mean and unruly, and smell bad, I have fallen in love with one of them. He is not a glum wolf, but a popular boy, nimble-footed, with mocking eyes

and a swarm of followers. I am not glad that I like him. But I have to do something about this feeling. And this time, I will not press it down and stay numb. I decide to write him a poem. Yes, that would be romantic! Just as Tatyana Larina did for Eugene Onegin in the great Pushkin verse novel. I must have forgotten how it turned out for her. I labor over the poem for hours, matching rhymes—love . . . mangrove . . . from above . . . I write it down in my best calligraphy, that is to say, barely readable, fold it into a paper crane, and hand it to him after supper. The next morning, he and his buddies stare at me in the dining hall and laugh.

I am done! It's over. I am leaving. I will not stay another minute at this camp. I will live in a mud hut in the forest, with a pet hedgehog. I will wear a dress made of grass, and shoes of woven birch bark. I walk the full length of a fence around the camp looking for a route out. Dacha owners on the other side eye me with mistrust, suspecting a strawberry thief. Who wants their feeble, asthmatic crops! Soon I will have wild raspberries, wild herbs, wild mushrooms. I will stay in the dense forest of spruce and pine, where wild animals live, and possibly poisonous snakes. There! I will take off at midnight under moonlight, slip through the slots in the fence, and run. Into the wild! Go look for me. But it rains the next day and thunders the day after, I sleep through the following night, and there is a concert on Sunday. My escape has lost its momentum.

Parents' Day is coming, and I dread it. Oh, those nauseating hugs and kisses. Those fresh loads of care packages with a long shelf life that would barely last a day. I lie on top of my

bed and focus on the ceiling. It'll be over soon. But it isn't. Girls keep running in to hide their waffle cakes and chocolates, their parents' shy grins hover in the doorway. They are on their way to the crafts room to look at their treasures' masterpieces. I walk outside and roam the campgrounds, kicking gravel. Suddenly my troop leader yells, "Hey, Alëna, someone's waiting for you!"

"Not me."

"They said your name."

"Someone else with the same name!"

I turn the corner, and there is my Aunt Rina, flushed from a long walk from the train station, carrying two heavy bags. She sees me, flings open her arms, her bags flying out like the carousel swings, and I am in her damp, hot embrace. "Oh, dearie, how are you? Take the bags. Waffle cakes. Chocolates—all for you! Show me! Show me! What have you been doing here?"

I take her to the crafts room. Here are my crooked one-eared bunnies, and a lopsided bear with no stuffing.

"Look at that! What skill!" Aunt Rina raves.

August comes. And then, just like that, the summer is over. On the last evening at camp, Lenka and a few others climb through the broken fence and walk across a yellowing meadow. The grass has been mowed and raked into low haystacks. And even though all of this is against the rules, our petite, storytelling troop leader comes along. She walks next to a boy from the eldest troop. He leans over and whispers something in her ear, she laughs, he takes her hand. We sit down on the dry grass and watch the sunset. The sky becomes cobalt blue,

then ultramarine. Flies settle down, crickets start their endless trill. Farther down, beyond the meadow and the forest, the rim of the sky turns pink, then gray. We lie in the grass and look at the clouds until everything is drowned in blackness.

I return to Aunt Kira and Rina's apartment where I find the best surprise. Mama's letter. She has been released from Sáblino and transferred to Gorky. She says she might come to visit me in a few weeks. I feel a piercing joy and start crying. Aunt Kira sets up an aluminum cot next to my brown ottoman. Mama comes in early October. Every day she is here, we take a long walk along the Griboyedov Canal. I tell her everything that happened in her absence. She tells me little about herself, but keeps asking, "Why did everything happen as it did?"

The question is not directed at me but at the city, with its heavy damp air, mansard roofs, wrought-iron fences, and the bleak canal bound in granite. What *was* the reason? Her credulity? Ignorance? Misplaced priorities? Unchecked optimism? In the chain of events that had led up to our disaster, she tries to find the pivotal one. Was it something she said or did at the OBKhSS office or at her trial? Was it wrong to take a job at Kosmétika? Or to send her mother alone abroad without planning for the possibility of us being trapped here? Or maybe there is a different reason. Did we become cut off from ourselves? Our past? Or something invisible?

The weather gets misty, and we turn from the canal onto Lermontov Prospect. We walk silently for a while until we come to the synagogue that we had visited several years earlier. I can see now how beautiful it is, with its alternating

white and terracotta stripes and spiraling, fluted cupola that looks like a twirling dancer. It is set behind a tall garden wall, and I can only see a bit of its vaulted entryway, shaped like a horseshoe for good luck, and the crowns of trees that have begun to turn color. It all looks festive in the rain. But the gate is locked, and we walk on.

"Do you think G-d exists, Mama?"

"I don't know. We have to keep looking."

The day before leaving for Gorky, Mama calls an old friend of her parents. "Kiera Ivanovna . . . Hello! . . . Where am I calling from? No . . . Not from America . . . Did leave but did not get there . . . Krestí . . . Aha . . . Just imagine . . . A year ago."

I can hear Kiera Ivanovna roar, "Why didn't you call me right away? Come over immediately."

We take a cab. I walk into a small one-bedroom apartment in a typical drab multistory housing unit, and I am entranced. Porcelain vases, hand-blown glass, exotic rugs, and wood carvings cover every shelf, windowsill, table and nightstand and any surface that might protect these fragile treasures from the peril of gravity. Hand-painted plates hang on the wall of her living room. She takes one down and hands it to me. I am scared to touch it.

"Don't be silly! Take it."

The plate has mythical creatures set against an intricate pattern. Kiera points out one and calls it Sirin, half-woman, half-bird from the Russian legends.

"You live in a museum, Kiera Ivanovna," Mama notes.

"You are a funny girl, Galia," Kiera Ivanovna replies.

She tells us about the ancient Chinese craft of under-glaze painting. You start with a fainting-heart pale lilac paint that is almost invisible when you are making your image. After the porcelain is painted and glazed, it goes into a kiln at an extremely high temperature, above 1,000°C. Few colors can stand such heat, but that lilac turns into bold blue. That's why so much of ancient porcelain painting that has survived until now is blue on white. This painting takes skill, preci-sion, and the gumption to accept failure. The slightest care-less touch of a brush, invisible during painting, will show up as a blot after the firing.

"See these wild creatures?" Kiera Ivanovna asks. "They are all my imaginings. When I was young, I had to paint what others told me—pretty flowers. These days I do as I please, I'm a free bird now."

She points to a bird, carved of wood, hanging on a string above her dining table. With its wings and tail, made of fanning strips, it looks as if it were gliding about this mystical place. "I got one of these from a friend, a wood carver. They bring me good luck. Do you want me to order one for you, Galia?"

"Where would I put it, Kiera Ivanovna? I have no place to tuck Alëna and me."

"I want to talk to you about that. Would Alëna like to stay with me until you come back?"

I stare at her like she is a headless horseman. I try to place myself on this dazzling mythical island. She smiles at me with her radiant silver-blue eyes. She is tall and majestic, her honey-colored hair is cut in a wavy bob. The Jazz Age in retirement. She wears her brightly striped, long linen robe loose at her waist. She has no family. She shows us

slides of her recent trip to India. Here she is in Delhi, here
in Chennai, here she is riding on the back of an elephant.
She picks up little elephants made of wood, bone, ceramics,
and embroidered fabric, set around her house, their trunks
pointed toward the window to catch that mercurial good
luck.

"Pick one, Alëna! I want you to have it."

Her tiny Pekingese puppy, Sunshine, with the same
honey-colored curls, sizes me up from the folds of a divan.
At dessert time, Sunshine jumps onto Kiera Ivanovna's lush
bosom, breathing rapidly into her face. The two of them sway
peacefully together for a while. Then Kiera Ivanovna brings
out crème brûlée ice-cream, and serves it to us, to Sunshine
first.

"Move in with us, Alëna, until your mama comes back!
I will teach you painting on ceramics. Sunshine and I will be
so happy for the company."

Mama leaves for Gorky and Yuri moves my suitcase to
Kiera Ivanovna's. She relinquishes part of her living room for
me. I will sleep on her divan. She brings an antique chest of
drawers out of her bedroom for my clothes and points to a
bookcase filled with art catalogues. They too are mine to read.

On the weekends, she goes to a farmers' market to buy
a large vat with fresh cottage cheese and another larger one
with sour cream. Rich foods are sacred here too. Its fat content
is tenfold higher than the food she could get at the corner
store, and it costs five times more. She flatly refuses Mama's
money. On school days, she wakes up before me to set out
my breakfast in the kitchen. She brews Ceylon tea and puts
out a porcelain tea set, a starched handloomed napkin, fresh
flowers in a small glass vase designed by her, jars of currant

and gooseberry jams, and a plate with thick layers of cottage cheese and sour cream. All for me. Then her majesty retires to her bed chamber for the rest of her beauty sleep.

I drink up my aromatic tea with hand-crafted jam, marvel at the beauty of the setting and the aristocratic taste of my hostess. Then I pat down the sour cream and cheese with a spoon to make it look like I had some. I am watching my figure. In the evening she gently chides me, "Why didn't you finish your breakfast? You will get me in trouble with your mama."

Kiera Ivanovna! Now, years later, how I wish I could have my breakfast and tea with you at your kitchen table. Gratitude grows bit by bit over time like a coral reef. How grateful I feel for your gentle kindness. Back then, when I lived with you, I felt little more than fear of saying or doing something wrong and hearing "Go away," when there was nowhere to go. My dear friend, you cared for me as if I were your child, but I was only a tenant. I couldn't do any better. Dependence clouds the heart with resentment. The need to survive leaves little room for love. The affection for you that I should have had then I feel now, my soaring free-spirited bird.

On November 10, 1982, our principal interrupts classes and calls an all-school assembly. In the auditorium, black crepe is tied to our crimson flags. The principal announces that Leonid Brezhnev has died. Someone begins to cry. Death, so boundless, so immeasurable, poor old man. The entire country is in mourning. We sit and listen to a long, drawn-out speech—Leonid Ilyich, this and that, dear comrade, our

leader, World War II veteran, peaceful time, virgin lands, developed socialism. After the assembly, upper-classmen tell Brezhnev jokes in the corridor and everyone laughs.

Then the announcement comes that Yuri Andropov has stepped into his place. The former head of the KGB is now the country's leader, our new General Secretary of the Communist Party. Adults quietly ask, will the Terror rise again?

But for us, school kids, life keeps flowing forward. ABBA has taken over the world. Their musical documentary is showing in the movie theaters in Leningrad. My friends and I go to watch again and again until we know every line. At school our young teachers hook up a cassette player to a stereo in the recreation area on the ground floor. The bell rings for recess and we break for the door, down the stairs, skipping four risers at a time. "Knowing Me, Knowing You," "Fernando," "S.O.S." We dance disco and lip-synch to the music. Girls try out Anni-Frid and Agnetha's moves.

Older teachers walk by, sighing, "S.O.S.! Where is your modesty?"

Our school principal smiles and nods. We fall in love with boys from parallel classes and wait for them to ask us to dance. They slum on a bench, gawk at us, and do, infuriatingly, nothing.

A Time to Wait

IN DECEMBER, MAMA RETURNS to Leningrad after having served fifteen months of her eighteen-month sentence. Her term was commuted, the release coinciding with the expiration of our emigration visa. Our old apartment is no longer ours, though it remains vacant. Someone from our residential trust lets us in to get our belongings. The place has been ransacked. A reel-to-reel recording tape with me, at three, reciting a poem, lies on the floor, ripped and mangled. My collectible coins for the Moscow '80 Olympic Games are gone. But my Olympic teddy bear, whose toes I'd trimmed with dull scissors from Mama's blighted manicure sets, is a survivor. I find him tossed in the corner along with my formerly happy, hand-painted wooden rooster and Mama's sad horse. We take them and leave.

Mama submits an application to get back our apartment and to reinstate her permit for residence in Leningrad. The residential trust gives her the green light, but the final decision is made by Ispolkom, the executive district branch. They deny the request. "According to the paperwork, you left fifteen months ago. Get on the waiting list like all other out-of-town residents."

The wait will be several years. We have no place to live. Aunts Kira and Rina let us stay with them. There are four rooms in their apartment with seven of us there: Aunt Kira, Aunt Rina, her son Romik and his cousin, Mama, me, and a quadrupedal gentleman—Tosha, a flaming orange Pomeranian with cataracts in both eyes, who likes to take me on a walk. Each room has a foldout couch and a cot. When they are unfolded, there is no space in the rooms to get by.

There is a small window in the kitchen that opens onto a brick ventilation shaft. It has no light or view but brings in moss-scented air and carries noises from neighbors on different floors. Here's Alla Pugacheva singing "Million Scarlet Roses" on the radio; Alexandr Galich, whose criminal counterculture songs rise from a cassette player on a floor below ours; Vertinsky, crooning suave cabaret songs from upstairs; and Utesov, playing turn-of-the-century jazz, from somewhere else. Adding to the cacophony, Aunt Rina teaches Romik to play piano on the Red October upright that had once made a stop at our home. Romik and the October are not in tune. Glinka's overture thumps like a pack of wild horses. Rina shouts, "One and . . . two and . . . stop dangling your feet . . . one and . . . fix your crooked rakes on the keys!"

Red October gallops. Finally, Aunt Rina, ruddy-faced, flees the room, Romik stomps after her, slams the door, then flings it open, and slams it shut again.

Mama stares at the small kitchen window and the brick wall beyond. "We didn't get our apartment back."

"Stay with us as long as you need," Aunt Kira says.

"No. I need a job that comes with housing. . . . I can sweep the streets."

"Are you out of your mind? Stay with us!" Aunt Rina insists.

"I need a place of my own."

Mama finds a job as a janitor and a groundskeeper in a subdistrict near my school. It comes with a living space, a room in a communal apartment in a residential high-rise. The room is just big enough for our two beds, a small desk, and our old and small wooden wardrobe, where we keep all our clothes. To spruce up the décor, I pin up my drawings on the wardrobe doors. In the winter, the wind blows through small uninsulated gaps around a windowpane of this hastily built state-run building project of the 1970s. I don't mind. I think it is cozy. I am happy with my mama in a place of our own.

Every morning she gets up before sunrise and leaves the lights off so I can sleep in. She dresses quietly in the dark, putting on her vatnik, warm kerchief, felt boots, oiled canvas apron, and gloves. And off she goes to wash the floors and stairwells of residential high-rises like the one we live in now, to pick up cigarette butts and scrub off obscene drawings made by young boys the night before. She takes out buckets of garbage and slop from the stair landings between floors and carries them to the dumpster in the common yard. Then she shovels the snow or sweeps the streets with a broom. Homeless cats live in these buildings, helping with upkeep by catching rats and mice. But sometimes Mama finds furry corpses of these cats hanged by twine from hot or cold water pipes, dripping with condensation, in the basements. The older boys kill them after getting high on the fumes of household glue. Mama cannot look at these cats. She calls

in her partner, a woman from a different subsection. The woman unties the twine and throws the little bodies into a dumpster. On such days, Mama comes home in a dark mood. She asks me to play my guitar. I play it softly, she listens and dozes off, then wakes up in the middle of the night and can't get back to sleep.

She gathers our documents and reapplies to OVIR for an exit visa. The application states that her elderly mother lives abroad alone and asks for the agency's consideration to allow us to reunite with her. The application is denied. The stated reason: "Not in the interests of the government." Six months to wait before applying again. Mama steels herself for another heart-breaking call to Grandma. "It's a *no.*" The same reason. . . . In six months . . . Yes, we will. You have to stay healthy."

"Will I ever see my mother again?" Mama asks Aunt Kira after the call.

"You will. Something has to change," she replies. But I don't know if anyone believes it.

Grandma sends letters from Ann Arbor, and I am terrified to open them. Each time I expect some catastrophe. An accident, heart attack or some other incurable illness, or words of anguish, sorrow, and remorse for leaving on her own. My body tightens before opening her letter and each time I find the same steady handwriting. "Everything is fine. I am well. I went to New York. I traveled to Israel . . ."

I write back, "We are fine here too. I am studying English. I am doing well at school."

We still call her "Aunt Maria," and our letters are intentionally brief, our mail is read by state services.

Sometimes our letters vanish. Mama numbers and dates them to keep track of which ones went through.

Grandma sends us parcel after parcel with clothes for Mama, me, our aunts and their children, and some for Mama to sell so we have money to supplement her tiny salary. When she gets her parcel, Mama calls her on the phone. "Why do you send so much? Do you spend everything you have on us? You need to take care of yourself first."

"Don't worry, Galia. I have enough."

"Then spend on your enjoyment!"

"Don't worry. I have what I need."

Once a year, Grandma arranges to send us money from Ann Arbor. It's difficult and illegal in Russia. Soviet law prohibits the exchange of foreign currency by its citizens. She cannot make a wire money transfer through a bank or send us a check. She has to find someone in Leningrad who is about to emigrate and needs to get rid of his or her Russian rubles and get dollars in America. Soviet law restricts the amount of cash to be taken out of the country. Grandma gives a sum of money to her contact in the US, while the emigrating person pays my mother in rubles at an agreed-upon rate. These exchanges are a leap of trust. Once Grandma gives away her money, there is no recourse if the other party refuses to do their part. And yet Grandma keeps looking for these opportunities. When an agreement falls through, she finds another.

The money she sends, a small amount by American standards, is colossal wealth here in Russia. No more living from paycheck to paycheck. No more borrowing a ten-ruble note from a friend at the end of the month to buy bread and milk. We have enough to live comfortably and to travel. We go to Odessa by the Black Sea in the summer. We fly to

Tajikistan in the winter. We take a tour of the Golden Ring, a collection of medieval towns near Moscow, known for their authentically Russian beauty. Every time we travel, Mama calls Grandma to thank her for this gift. I marvel at the vastness of this country, the range of climates and biodiversity, its ancient cultures, and the charm of its towns and cities. And yet the luxury of visiting these places feels strange to me—both regrettable and undeserved. I want nothing more than to leave.

Yuri Andropov dies on February 9, 1984. Konstantin Chernenko takes over as our new leader, the General Secretary of the Communist Party of the Soviet Union. No one cares. There is no all-school assembly. My classmates don't follow politics, nor do our parents, and probably none of our teachers. We don't read newspapers, most of it is a lie. The government exists in a different orbit from ours. They might as well be on Mars.

Mama takes our documents and application to OVIR. I think, Please, let us go to my grandmother. The request is denied: "Not in the interests of the country." Another six months to wait before the next try.

I have turned fifteen. I sign up for an after-school English class to improve my conversation skills, but I take a seat in the very back row where no one will see or speak to me. From there, I notice a handsome young man who sits at the front of the class. Broad shoulders, sandy cropped curls, soft baby fuzz over his sunburned nape. He is a couple of years older than me, and I think he is a grown man. He tells the teacher that he serves in the Navy and needs a foreign language to get

some rank. Language is not his thing. He can't remember the past tense of irregular verbs or most everything else. When he stumbles, I whisper the correct answers to him from my back row. He repeats them out loud but never looks back or gives me any attention. I must be too young for him. But on the last day of class, he suddenly asks me out. I am so embarrassed I trip over my feet. He doesn't laugh. We meet at the Summer Garden near Nevsky. It's a gorgeous sunny day. He brings a bouquet of roses, so big and thorny I can barely hold it. I don't know if I should carry it in front of me, as I might if I were carrying a flag, or lay it in the crook of my arm, like a kitten, or heads down, like a closed umbrella. No one had ever given me flowers before. He says that I look pretty, and I laugh nervously. He tells me about his plans to rise in the ranks of the Navy, ready to give his life for this country. He wants to defend the vulnerable people who cannot stand up for themselves, women and such, girls like me. I can see that he wants to impress me, I am not blind. I also once felt patriotic, as he does now. It is a pure and selfless feeling. But the more he talks, the more I feel the distance growing between us. He seems quaint and naïve. He knows nothing that I know, but I can't share my facts. I notice that he has a gait of a donkey. He leans to kiss me. I turn my head at the last second, and he lands on my ear. What a waste of a pretty bouquet.

Yuri has moved to a room in an apartment on Schastlivaya, Lucky Street, near our old home. On my way to school, I see him going to work and run toward him. He opens his arms and awkwardly hugs me, then keeps walking to the metro.

The first and only time I visit him is at this place on

Lucky Street. It is not a social visit, I have to pick up a package. He lets me into the apartment but asks me to wait in the hallway. I peek into his room. It is tiny, no bigger than ours, with barely any furniture and impeccably clean. There is a small desk, a wooden wardrobe, and a narrow metal bed, like the one you would find at a hospital or a summer camp, with canvas held in place by wire springs instead of a mattress. Easy to move. I step closer and see a black-and-white photo of a boy pasted on the side of the wardrobe, the only adornment in the room. The boy in the photo has curls and big dark eyes, which grow bigger the more I look at him. He seems happy and soft, as a child should.

"Who is this?" I ask Yuri.

"Ilyusha."

I force a smile and hush a ping of dislike for this cheeky boy. Would Yuri's son be a goody-two-shoes or prankster? Would he have played house and shared radio-trucks with Seryozha and me? Would he catch lizards in the pond and let them go, or crush them as boys do sometimes? Why did he never come to our parties? This photo is the first thing Yuri sees when he wakes up in the morning and the last before going to bed. Why doesn't Yuri want us to meet him? I think it's because the boy is full of trouble. That's it! Or is it because he doesn't want his son to know about us? Separate folders for different parts of his life. Or just being cautious? Having no fear for himself, he might not want his son to know about refuseniks or dissidents. He may simply want to give his son a cloudless sky.

"Nice boy, this Ilyusha." I say to Yuri when he comes out into the hallway. He doesn't respond.

He hands me the package and walks with me outside.

We have not seen Big Sergéy and Little Seryózha since before Mama's trial. They stayed away. They didn't try to contact me while Mama was away. Nor after she returned. Perhaps Sergéy didn't want to make our situation worse, he too was constantly watched by the police since his wife was claiming political asylum in America. Or perhaps he just was too busy. Yuri kept in touch with him and once in a while gave us his terse updates. We learned that Sergéy had divorced his wife and remarried. Enough with drawn shades, enough waiting. He must have wanted to finally give his son a two-parent home. A few years passed. Then Mama got a call from Yuri. I watched her forehead turn pale, her hand rising to her temple, her mouth forming a silent letter *O*. Through the receiver I hear isolated words. Sergéy. His new wife. A car accident.

They were in a cab when another car crashed into them. Both died. The cab driver survived. The burial is tomorrow.

"Who's behind this, Yuri?" Mama explodes.

He cuts her off, "Keep your thoughts to yourself."

"Who will take care of Seryózha?

"His mother."

Sergéy's cousins organize a small wake at his home. Everyone tells stories about him being kind, generous, the life of the party, a devoted father raising his son alone, and what a fine young man his son has become. They say all this turning to Seryózha. He listens and looks down at the floor. He doesn't cry. Nor is he courteous. He snaps at little kids when they tug at his shirt asking for something. No more radio-guided trucks rammed into the wall for laughs. Mama and I stay

with him for the next few days. He sits in his father's work chair, his toe on the treadle of a Singer sewing machine, and listens to Black Sabbath.

His cousins help him take documents to OVIR. Several weeks later, Seryózha is on a plane headed to New York to reunite with his mother—finally, OVIR did not object to his departure. He is sixteen and cannot remember her.

Mama says to me, "If something happens to you, I will go insane. Life will make no sense. I will stop living."

"Why should anything happen to me? Keep away your bad thoughts and keep yourself safe."

"But if I don't think bad thoughts, the bad will creep from behind and catch us off guard. No, I would rather not think good thoughts rather than have my dreams crushed again."

Easter is almost here and even though no one speaks about religious holidays, I want to go to church in Sergéy's memory. This wish brings out a confused brew of feelings—curiosity and embarrassment. My early school lessons still ring in my ear: watch out for crafty priests and their tall tales. Yet lies are all around us. I find a Russian Orthodox church that offers services on Sunday. I hesitate before opening the doors. Should I turn around and leave? Will they tell me that I don't belong there? Will they eat my soul?

I make myself walk in. The church is dim. Light flows down in narrow ribbons through the cloudy glass of the cupola. Faded frescos of saints glow on the whitewashed plaster walls. In the dark, candles throw light onto old women's eyes, cheeks, wrinkles, and locks of gray hair under

their black shawls, turning them into demons, and those demons into virgins.

The flames glow, reflected in the gilded iconostasis. Everything becomes a mystery. The incense cloaks what is left unsaid in a smoky gauze. There are shadows, ghosts, secrets, and there is something unfathomable, as if the walls were about to burst, letting out sparks and fire, the beasts of Bosch and the saints of Raphael. They might swirl and sweep me off the floor and I will fly through the air, like a trapeze artist. None of this happens, only the promise of something uncertain. Melting wax clings to the candles; it is lumpy, like sap on a pine tree. The priest, dressed in a long black cassock, with a sparkling cross on his broad chest, swings the censer like a pendulum. The air smells of myrrh, of the damp floor, and of bleach. The priest sings out prayers in a low baritone. Parishioners chime in with dissonant mutters. The echo carries, evening out their song.

There are no seats in the church, people pray standing. An old woman, wearing a black dress and woolen stockings with seams at the backs of her legs, crosses herself three times, whispers her prayers, and falls to her knees on the stone floor. I think to myself, Give her a chair, she is too tired to stand. But she crosses herself again and prostrates her body before an icon with a candle she has lit in someone's memory. Then she can't get up, and a man helps her up by the arm. Students, young women in light cotton kerchiefs, and young men walk tentatively along the back wall. Their footsteps, shuffling, and the sputter of flaring flames promise a season of change.

Drawing with Erasers

AT THIRTEEN, I BEGIN to draw ceaselessly. I find simple objects that no one else would ever notice, much less find worthy of art. A ball of yarn, a head of cabbage, a pair of beat-up shoes. In the woods I draw tree stumps. In the zoo I spend hours with a sketch pad, drawing every creature that's willing to remain still. I mix strokes of different colored pencils to find the right hue for a parrot's feathers, a fox's fur. I sketch dozens of gazelles, yaks, and bison. A lackadaisical orange lion mesmerizes me with his motionless stare. I placate him with small talk and keep drawing. "All right, sir, fair gentleman, aren't you looking glamorous this lovely morning?"

A woman and her little son peek over my shoulder. "Look at this big girl sketching!"

They praise me. I blush and move to another display. I draw polar bears, splashing in a pool, then hippos, then macaques. I find this place hopeful and reassuring. The raw smell of animals is soothing, the logic of their movements enchanting. The grace with which they bear their entrapment is inspiring. They are content with the beauty of their existence. Their indifference to me gives me peace. My art lets me be part of them without their judgment.

Suddenly, I feel free. Limitless, alive. No longer numb. I am part of everything that surrounds me. There is color where once there was only gray.

People search for freedom. Some go looking for it in the rift zone, where the Earth's crusts are slowly pulling apart. Some take boats down the Amazon River, fly into space, or jump out of planes with parachutes to experience a few moments of free fall. Armies go to war to bring freedom to others, believing that their kind of freedom is worth killing for. In many languages, we sprinkle the word *free* like a dash of salt: free bird, free spirit, free press, free lunch, free-for-all. But what does it really mean? To me, freedom is a clean sheet of paper and its boundless possibilities.

I find my grandfather's art box stored away in our room. I take off the lid, the fine, tart smell of flaxseed oil and turpentine flows out. I hold a piece of old burlap that he used and rub my fingers against its rough surface. I touch his brushes where his fingerprints are fossilized in dried paint, his charcoals, and tubes of paint still sticky from bits of oil seeping through cracks in the creased aluminum. I imagine these things alive in his hands, melding his fantasy and memories. There is something that I can't quite put into words. The mystery of his life spins an invisible thread into mine.

I want to study art. Mama calls her artist friends for advice. One of them asks how old I am.

"Thirteen."

"It will be difficult to start that old. You will have a lot of

catching up. Art is a rigorous discipline. Drawing, painting, composition, and theory. There are many different techniques and media to learn. Copying from the Greek antique works. You will need to study anatomy for figure drawing. It's a classical training. Good art schools are very selective. Most children start studying art when they are very young."

After the call Mama tells me, "Don't worry, you'll catch up. Van Gogh began painting at twenty-seven."

At the First City Art School, an after-school program, I am about to meet with the principal, with little hope of being allowed to enroll. Georgy Nikolaevich is waiting for me in his office. An elderly man, dressed in a three-piece brown suit, freshly pressed, he is perched on a tall three-legged stool you might find in the eighth-grade physics lab. When he sees me, he coughs in spasms, then gets up slowly from his seat. "Well, well . . . a sketchbook . . . yes . . . let's see . . . aha, lions."

I want to turn around and run. What a joke to draw lions at thirteen!

He looks carefully at each drawing. "Yes . . . All right. . . aha . . . It looks like we have another old geezer as a beginner."

He means me, and continues: "We will have a full class of oldsters like you . . . Come back on Monday, five o'clock, second floor . . . Bring your paints and brushes . . . We might find a scrap of paper for you here."

"Thank you."

"Don't forget your lions."

My new art school is in the center of Leningrad, off Griboyedov Canal, which looks bright to me now. On Monday I go back, emerging from the subway at Nevsky Avenue, where my mother used to take her long walks when she was a girl. Here are Field Marshal Kutuzov and Barclay de Tolly next to Kazansky Cathedral, with its cringy Museum of the Inquisition. I wave to them and leave them behind. I walk on with my own new set of watercolors called "Leningrad," twenty-four little cups of paint with Italianate names—yellow cadmium, yellow ocher, light red iron-oxide, terracotta, cobalt, umber . . . Next to my art school, there is a suspension footbridge over the canal with gilded-winged lions. I stop to pet their wings and make it my good omen. Then I walk up to a wide oak door and press all my weight against it. The door creaks as it opens. The air smells of warm clay and paint. The walls of the foyer are lined with student artwork. The voice in my head screams, You will never paint like that! I hush that voice.

The studio on the second floor is filling up with old geezers like me, the beginners. I pick my seat. There are no easels, only old chairs with high backs, two for each student—one to sit on, the other to set up our drawing boards and tools on. The drawing boards are well worn, with many splats and splashes of different media, but smooth, a perfect surface to draw on. And yes, the teacher hands each of us not a scrap but a large sheet of a brilliantly white paper. I set down my paints and brushes, pencils, erasers, rugs, sponges, and a cup of water. Let's begin!

Years have gone by, but I still remember my teachers at the First City Art School, the middle-aged women with soft voices, gentle footsteps, unmanicured fingers, and graphite

powder rubbed into the narrow wrinkles on their wrists. I spent hours watching these hands patiently draw over my artwork, showing me proper technique in the same way that a music teacher would demonstrate the correct handling of an instrument or the expression of a musical phrase.

Nína Egorovna begins her lessons in drawing by saying, "A drawing is a painting in monochrome, but more rigorous and less forgiving. It doesn't have the color to distract your viewer. Drawing is the king of fine arts. And remember, a good drawing begins with a good eraser. You can draw with them too. Let's take a look at your erasers. Yes . . . yes . . . the pink ones—throw them out. Does everyone have the white erasers? Yes? Now let's sharpen them."

To sharpen our erasers, we have to rub them against plywood boards. I go at it. Large crumbs of white rubber roll down onto my knees and the floor. I keep going. My arms and elbows begin to throb.

"Ready, Nína Egorovna!"

"Let's see . . . No, not ready. The eraser slowly needs to be as sharp as the edge of a blade to pick out the fine detail of your drawing."

"Won't it slice the paper?"

Witty remarks get no attention. The erasers melt away, like tiny blocks of soap. Then finally, when my arm is about to turn into a puddle, she says, "Good job. And now, we'll sharpen your pencils. No, you can't use your pencil sharpeners. We'll be using razor blades for more precision. Please be careful with your fingers. And do pick up all your shavings."

Then Nína Egorovna teaches us how to apply the pencil strokes on paper, something I thought I knew since kindergarten. It turns out I know nothing. Each pencil stroke is a

character in the cast of this play. It has many jobs. To sculpt the form. To bring out the texture. To create chiaroscuro.

"Think carefully about what you draw. Don't assume that you know the object because you've seen it before. Take a fresh look. What is its personality? Proportions? The relationship to surrounding objects? Look at its *textura*. Wood has long fibers, you need to draw it with the tip of your pencil. Glazed ceramics have highlights and reflections, notice how they change depending on where you stand. Look for the inner logic of each form. Only then will your work be believable."

She sits down at my drawing board and takes my pencil. I watch, spellbound, as her goddess's hand makes the paper come alive before my eyes.

The lesson in painting begins after drawing. Galina Petrovna, my painting teacher, squints at the watercolor I just finished. I am quite proud of my work. She sets it next to the still life, steps back, and squints again.

"Many fine qualities. Yes. Your watercolor shines in this corner." She circles her finger around a small area. "But the rest is all mud. The tonality is wrong. The perspective is distorted, your tabletop is about to roll off its legs. Please take a sponge and wash it off and start over."

Hours of work are taken away by the heartless sponge. A pale magenta spot persists like a swollen bug bite. The wet paper turns rough and scabrous. I want to cry.

Vera Anatólyevna takes us out to paint *en plein air*. She collects all our black paint. "There is no black in nature. The tree trunks could be blue, reflecting the sky, yellow with highlights from the sun, green if they are covered with moss and fir needles, or any other color. Take a good look. Use all of your paints. Why haven't you touched your umber, sienna, emerald, cobalt blue, carmine? If you can't live without blacks or grays, mix your own. Green with red. Lilac with lemon. Blue with orange. Each gray will be its own. And remember, never paint with 'open,' unmixed paints. That's too basic. Find your color! Make it come alive."

The Russian word *zhivopis*, painting, comes from the words *zhivói*, alive, and *pisát*, to write. To a Russian, painting is the writing of life, life chronicles. Art is viewed as a sacred object, the Truth. This comes from icon painting in the Russian Orthodox ritual. The belief holds that icons can perform miracles. Devout Christians pray to icons in churches and put them in the "red corners" of their homes. In Soviet Russia, art is revered as a view into a hidden dimension, the revelation, the truth that can't be told in any other way.

Russian art is full of color. I remember the color of my grandfather's paintings. They were like a field of wildflowers with bits of dew in the early summer morning, like the forest floor with leaves, grass, moss, cones, and beetles, with colors of infinite variations. His brushwork was the thick texture of paint and caverns with hidden passages to covered-up layers. But it has been so long since I've seen them, they begin to melt away from my memory. I am beginning to forget how they look.

The Academy of Art offers figure drawing classes. I remember two giant sphinxes sitting by its main entrance when Grandmother took me there years ago. I decide to take a class.

In the studio, old easels are set up around a raised platform. Students take their places and set up their sketchbooks, charcoals, and chalk. I wonder how many of these young people are here for the first time. Who was here a generation ago?

A model steps onto a platform. Two minutes for each pose. I take a deep breath. Timer starts . . . I sketch a curved centerline of the woman's spine . . . a tipped intersecting line of her shoulders . . . all right . . . it looks like a balance scale now . . . here is the swivel for her neck and her head . . . Time is up! I exhale. Paper rustles. The model takes a new pose.

Time stretches, then curls into a tightly wound coil. My mind wanders, and Grandma's stories come flooding back. I slide back to half a century ago. Here in the 1930s, it is early morning and soft sunlight, bouncing off the river, filters in through the grid of tall windows, making the walls into a geometric puzzle. Here she is, my grandmother, Lucia, young and lovely in her white blouse and fitted skirt sewn with silver thread, coming to work. Last night, she was out late at a dancing hall with friends. This morning, she is very tired. Her boss, Rector Brodsky is not in yet, so she slips into a small side room for a quick nap on the couch until a friendly cleaning lady comes running. "Get up, Lucia, the Rector is here."

Now the esteemed and charming Nikolay Punin appears, asking her, "Do you know what post-impressionism is, Lucia? No? Then come to my lectures!"

She comes to sit in on his lectures and learns about

post-impressionism, expressionism, and the avant-garde, all of which is banned in Soviet Russia.

And here is Felix, a gifted student from Boris Ioganson's studio, who seems to always find reasons to come to her office. A few weeks ago, he invited her to a play. She waited for him, but he never showed up. Afterward, he earnestly apologized, saying that he had got lost . . . in his painting!

I slide along the time coil. Now it is the Siege. The tall windows, looking out to the Neva, are taped with strips of paper, like a game of tic-tac-toe. The metronome ticks and tocks, so everyone knows when it is safe to be in the street. Tick . . . tock . . . tick . . . tock . . . Then there is a piercing sound. The sirens start howling, bombs dropping.

Tick, tock, tick, tock. Time is up. The model turns . . . Back in 1941, it is winter. The sun sets early and it gets dark by three o'clock. The studio has no light or heat. Students work by the light of a candle and pull up floor planks to burn in the iron heating stoves. During the Siege, students, professors, and staff who haven't left the city move to the Academy to look after each other and after the artwork that is stored there. Everyone is starving, many are failing. A room downstairs has been turned into a medical ward. Lucia receives notes from there that reads, "Please help, I am dying." She runs to a canteen to get a piece of candy, a lifeline that might save that person's life.

Felix is in the medical ward, wounded and feverish with typhoid. He should die any day now. He should die in Leningrad the same month as his parents die in the shooting fields of Ukraine. But a miracle takes place, and he begins to recover. Slowly, slowly. He comes out of the medical ward and goes up to his studio to paint during the scant hours of

daylight, then by candlelight. There are hardly any oils or canvases left. He paints with black and brown over a rough burlap—the colors and texture of the Siege. He presents his thesis painting between air raids. He says that his work is about being torn from darkness. "The painting must tell the truth, so that later people can remember our life."

I am back in the figure drawing studio of 1985. It is warm and well lit. Sanguine and charcoal grate against paper. My hands look like the fur of a calico cat. Students step back from their easels, squint, and look over their work. Tick, tock, tick, tock . . . Time is up. The model gets up and twists her body into a different pose . . . Charcoal and sanguine rasps, paper rustles, and the wooden floor creaks under my feet. Here I am at his studio. I have come home.

On the Ladders

SOMETHING BEGINS TO CHANGE in Leningrad. I feel it, like salty air that arrives from the sea before it rains. Small changes spread like a spiderweb, like thermal cracks on glazed ceramics. The old Manezh, the central exhibition hall, shows fewer paintings with party leaders and farmers in their spick-and-span chrome utility vehicles in the utopian golden wheatfields. Young artists paint personal moments: A Muddy Spring. A Cat on a Windowsill. An Overweight Cyclist. Aging Women at the Bathhouse. The private supersedes the communal. Incidents replace ideology.

The Hermitage opens a post-impressionist exhibition brought from Western Europe. Thirty years ago, such paintings would be locked away in the museum's vault. Now they are shown in the main gallery. Mama and I go to see it on the first day it is open to the public. There is a long queue to get in, which starts outside at the Palace Bridge, weaves along the Neva and the Winter Palace garden, then continues inside through the main foyer and up the grand stairway. Once in the gallery, people walk slowly, silently, gently pressing against each other, stopping at each painting cordoned off

by rope barriers. All you hear is "ooh" and "aah" and feet shuffling.

An old man points at the painting and whispers, "I know this one from a reproduction . . . Never thought I'd live to see it in real life."

The museum guard says nervously, "Citizens! Please! Step back. Do not point. Do not touch."

The House of Youth opens an exhibition of young Leningrad artists. I never saw anything like it before. In the middle of the gallery, there is a large portrait of a sunny-side-up fried egg, *en face*, magnified tenfold. The bright yellow yolk bulges out into the third dimension. An enormous black fly sits on top. Old visitors in tweed jackets shake their heads, How is this art?

Here I see paintings made on crude wooden planks salvaged from broken tables that once stood in common yards. Canvases that have old rugs, screws, keys, and crumpled newspapers glued to their surfaces and drenched in paint. There are "open," basic colors, taken straight from cans of industrial enamel. And there are paintings that look like children's drawings or orthodox icons but with sacrilegious hunchback dwarves. Wheat fields do not recede toward the horizon and there is no depth or perspective of any kind. Visitors and artists huddle together in the crowded gallery. And everyone stops at the grand fried egg.

"I just ate one like it this morning . . . the fly too."

Change keeps strolling down the streets. *Fartsovsh-chiki* (black marketers) openly sell used jeans, brought from Finland, on the corners of Nevsky. Night clubs organize

concerts of Russian rock groups Aquarium, Kino, DDT, and Alisa. Young Baptists introduce themselves to me on the bus: "Sure, G-d exists. Come to our services."

Chernenko dies on March 11, 1985. A new leader is announced the next day, the General Secretary of the Communist something. Who cares? I don't bother remembering these titles. Mikhail Gorbachev, his name is, I think. A year later there is a talk of *glasnost'* and *perestroika*. Arrh! They each come up with their big slogans. "Socialism with a human face." "De-Stalinization." "The Thaw." We've heard it all. Nothing ever changes here.

Again, Mama takes our documents to OVIR. Again rejected. "Not in the interests of the state." She calls Grandma to tell her of another delay. I hear her say "*if* we ever get out," instead of "*when*."

But Grandma moves the conversation toward practical things. "What kind of coat do you need for the winter? Would you like a pair of warm waterproof boots? With insulated inserts? And in what colors?" She tells us about her trip to the "amazing town of Frankenmuth, the Little Bavaria of central Michigan." She went to Greektown in Detroit, and a Polish town, Hamtramck. Oh, the foods you can find there! Just like her childhood. She mentions that she has a job as a nanny for an infant and a toddler.

Grandma doesn't tell us that she takes two busses to get to the house where she works, and it takes her over an hour to get there. It would take fifteen minutes by car, but she does not drive, and Ann Arbor public transport does not run like clockwork. When the bus is late, she walks to be

there on time. She loves these children and speaks Russian to them. They adore her. She never mentions how worn out she is at the end of the day. She earns four dollars an hour, cash. She spends none of it on herself. She sends it to Mama or uses it to buy clothes for us, her cousins and friends in Leningrad. She also sets some of it aside for her synagogue and a Hasidic rabbi in Ann Arbor. We know none of that.

Still Mama worries, "Why do you need to work? You should take care of yourself!"

"This job helps me not to think about how much I miss my children," Grandma replies matter-of-factly.

Chernobyl's reactor had an explosion on April 26, 1986. There is no public announcement for several days, but then the rumors begin to circulate. People who listen to the BBC learn about it first. Then finally the government confirms it—the meltdown, the explosion, a small amount of radiation allowed to escape. As a cautionary measure, it is advised to stay indoors for the next few days. People in Ukraine send their children to Leningrad to get them away from the radiation, but the wind blows north and everyone gets exposed. During the days between the accident and its public announcement, Mama has worked with gardeners, planting young trees and greening up her subdistrict. After the disaster, any faith in the government has been shattered. No one believes in the Soviet dream. The fables of Communism burn out at the Chernobyl reactor.

I graduate from high school and apply to Mukhina Art Institute, a selective school that accepts only a quarter of its applicants. I have to sit for an exam that lasts several days. There are three specialty subjects tested—drawing, painting, and composition—and two liberal arts disciplines—Russian literature and Soviet history. If I fail any one of these exams, I will fail it all. If I pass, then the scores for each exam will be added up. The applicants with the highest scores will get in.

The painting exam lasts three and a half hours. We have to paint a still life in the medium of our choice. I choose watercolor. When I work, others come by to look. I know I will do well on it. Then five hours of drawing, another still life. I do fine. For the composition, we are asked to create a professional designer rendering of a car. I watch other applicants take out their drafting tools, stencils, drafting curves, and airbrushes. I have never drawn a car or looked at one long enough to tell a hood apart from an axle. An hour later, I'm still trying to get my bearings, while all the others are putting highlights on the chrome bumper trim. Crash and burn, I take out my ink and brushes, I will draw my cars looking like wild creatures—a truck with the horns of an antelope, a motorcycle that looks like an anteater.

There is a week of waiting before the results are announced. I am not anxious, nope, I am not. Why worry if I know I have failed the composition exam. Out of curiosity, I go to the institute on the day when the lists of accepted students are posted in the corridor by the admissions office. A crowd of hopefuls have gathered there. I elbow my way to the front and find my results: high marks for painting, drawing, and literature, an average for Soviet History . . . and a 3- for composition. It is a very low score indeed, but not

a fail. My overall number is high, and I have been accepted.

I swell with pride—I am going to college! I want to yell this to every passerby in the street. But I cannot mention it even to my closest friends. If any wires get crossed, if my family's story gets out, I will be expelled from college before I begin. So when my old classmates ask what I'm doing this year, I say that I don't know yet. They sigh, thinking that I failed my college exams. I have to accept this. Bragging comes at a high price.

Some invisible hand has cut my life in two pieces. In one, I am a college student. In the other, I am waiting to leave. My fellow students go to rock concerts, fall in love, and plan for the future. Not me. I make no plans. I am here treading water.

Mama takes documents to OVIR. Again we wait.

Thinking back, I will remember this time as being fraught with uncertainty, with anguish. I will also realize that it was a gift. Time to wait is time to be. It taught me to look inward and reach for the sky when nothing else is within reach.

Years later I still wrestle with my mother's question, Why did it happen as it did? There are many reason. Yet the one that anchors every explanation is the fact that we were cut off from our roots. The tyranny of secrets kept us from learning about our heritage and our faith. We didn't know the scale of suffering before us that would have served as a forewarning. We didn't know where we belonged. Without this knowledge, it is impossible to understand oneself.

It is the fall of 1986. Mama and I go to the synagogue for Simchat Torah. A happy festival, it marks the end of the yearly reading cycle and the beginning of the new one. In the Soviet Union, it has become the symbol of resistance, the day when Jews gather at the synagogue and dance in the streets, carrying the Torah scrolls in their arms.

In late October, the sun filters through clouds softly, leaving no shadows or glare. This time the gate to the synagogue is wide open. The trees have shed most of their leaves, putting the synagogue on full display. It is radiant. Its arched entryway and white-and-terracotta stone ribbons look jovial, the fluted cupola spirals into the clouds. People stream in, forming islands, then, as the courtyard fills in, they meld into one body, young and old, one people, stoic and unbreakable. Torah scrolls, dressed in purple and blue velvet, rise above them, a chain of beacons against the sky. I watch handsome young men and beautiful young women stepping in and out of the dance circle. I feel an instant kinship with them. Jewish songs that they sing in Hebrew, Yiddish, and in Russian translation seem familiar and give me comfort. Someone lets me touch the velvet of the scroll and I feel a jolt of electricity, the faith of my ancestors coming home in my soul.

This is the story I want to write. But it's a lie. The truth is I feel a jab of cold air tugging at my coat. I feel uneasy, a stranger in my own religion. When children are raised with religious practice, it becomes a part of them, as natural as breathing. Learning it as an adult is a steep hill to climb. I feel out of place in this lovely courtyard that is full of life. Disjointed, disconnected. My eyes move from one face to another, straining to find someone familiar. Mama asks if

anyone knows Lev Furman, the man who taught Hebrew classes several years ago.

I watch the young men dancing. Their beards, not yet full but overgrown, look strange to my eye, accustomed to cleanly shaven faces. Their dance is self-conscious, recently learned. This should be a joyous festival, but there is no happiness, no laughter to go along with the rhythmic movement. They dance in defiance. I find myself in awe of their courage. These people risk losing everything that Soviet life has to offer: a university education, secure jobs, freedom from police scrutiny. They sacrifice it for the right to dance with a Torah, to sing Jewish songs in the synagogue's courtyard. I, the wicked child, look at them, and wonder, What does it mean to *you*?

In the far corner of the courtyard, two men stare coldly at the dancers. Blank, vacant eyes, black leather jackets, thugs of the Secret Service. And again, as in years before, I feel an uncontrollable anger. I want to walk up to them and dance in their face. No, I want to kick my foot in their ribs, to feel the impact and keep kicking until each of them falls down to the ground, bleeding, contorted in pain. This rage is the reason I must leave this country, I can't lose myself to this hate.

I stand still and listen to the Jewish songs. And then, oh . . . there comes an excruciating pain. The music that I never learned suddenly becomes familiar, as if I had heard it before I was born, as if there were a genetic cue to remind me of what has been lost.

> *Hevenu Shalom Aleichem*
> *Hevenu Shalom Aleilchem*
> *We come to greet you in peace*

The dancers weave me into their circle. The building and the street start twirling. Window arches and white-and-terracotta ribbons wrap around me, then melt away. Tears and a choking ache cut off my breathing. I leave the circle, then the courtyard. Outside, street traffic muffles the melodies. I steel myself. I will learn all those songs. I will learn Hebrew. I will learn the prayers. I will teach them to my children. One day I will keep climbing that hill.

Notification from the KGB arrives. Mama is to appear for a meeting on the given date at Liteyny Avenue 4. Bolshoy Dom, the Big House, the headquarters of the KGB, with a prison and an interior courtyard, where political prisoners have been shot without trial. Mama crumples the paper. "What else do they need from me?" She looks at the paper ball. "Throw it out? They will send it again. Or snatch me off the street. One way or the other, they will get me."

She packs a bag. Toothbrush, pen and paper, a change of clothes. "Alëna, if I don't come home tonight, go to Aunt Kira."

Yuri comes the next morning. He and Mama leave together. He carries her bag, she takes his arm. I don't wave goodbye and do not follow them with my eyes from the window. There is no lucky street nearby.

A few hours later, she returns.

"What happened, Mama? "

"The walls are listening here."

We go outside and walk down Lenin Avenue, then Marshal Zhukov Avenue, lined with young trees that Mama planted in the spring. Once we are some distance from our

house, she looks in every direction to make sure that no one is following us. "I arrived at the KGB, they took me to an office upstairs. A man was waiting for me there, a typical KGB agent, forgettable, unremarkable face. He said, 'Please, sit down.' I remained standing by the door. He asked, 'How would you like to help us?' I stayed silent. He said, 'You were involved in larceny. We also know that there is major corruption at Kosmétika. You worked with Kosmétika's director, Vladimir Stasov. Tell us how he participates in this corruption. Give us a statement and we will help you.' I said, 'No! I was never involved in larceny. There was no crime. *Your* agency sent me to prison. I had nothing to inform you during my trial and nothing has changed.' He wished me good luck. I was free to go."

"Why do you protect Kosmétika, Mama?"

"They did not hurt me on purpose. I have to believe that. And I don't want to cause any harm. Never build your happiness on the unhappiness of others. But there is also another reason—I will never become an informant. I will not put myself up for sale. I will not peddle for their favors. There are always those who buy people when they are at the bottom but it's a trap. These transactions will last a lifetime. Wherever I would go, they would follow me . . . I don't want to live on a hook. If you and I ever leave, we will go on our own."

She remains silent for a while, then lifts her head. "You know, something is changing! I could hear it in the voice of this KGB agent. The way he looked at me. There was something . . . uncertainty? . . . Let's go to Latvia for your school break!"

"Russian pigs are coming," whispers the Latvian train conductor as he watches passengers board the Leningrad-Riga train at the Rizhsky station.

"You don't know who's coming here," Mama zings back at him as we march onto our train.

We spend the week getting lost in the winding streets of medieval Riga. Here the change is palpable. Students and other youths are gathering in the city squares, tension is growing. Triggered by *perestroika*, *glasnost*, and the Chernobyl disaster, their protests will begin, in part, as an environmental movement, a response to Moscow's imposing plans on their land, and will lead to a revolt against the Soviet occupation. In a few months, the Singing Revolution will begin. In the next several years Latvia, Estonia, and Lithuania will be the first three Soviet republics to separate from the Soviet Union and become independent democratic states. But for now, there is brewing anticipation in the air. I take it all in.

The year is now 1987. "Let it be a good one. And if not good, then let it be peaceful." Mama says.

Yuri invites us to celebrate New Year's Day with his friends in the country. There are sleigh rides and spiked apple-honey drinks, which I try, and everything turns into glazed mosaics. I stand at the edge of a clearing, waiting for the horses. Yuri is waiting with me to help me get settled. I look at him. He has aged. More creases and brown spots under his tired eyes. There is gray in his mustache. Or perhaps it's just frost. The cold wind turns his face red, and a small drop forms at the tip of his nose. I feel a flush of incandescent tenderness. I want to wipe it off with my handkerchief.

I want to put my palms against his face to keep him warm. I want to kiss his forehead. I'll do none of this nonsense, he has his own clean handkerchief and can't stand familiarities.

I climb into a sleigh, he helps me in and covers me with a warm blanket. Horses neigh. Steam rises from their black bodies. The sleigh takes off. Bells clink. Fir trees creak. Sleigh runners leave narrow tracks in the snow. I look back. Yuri, my love, turns into a black drop of ink in the field of white.

Mama and I receive permission to emigrate in March 1987. We open our two empty suitcases that have been waiting years for this moment. I pack my Olympic bear that has turned gray from the dust, my flowery rooster, and Mama's sad horse with peeling paint. We take our Khokhloma crafts and theater binoculars, which will be of no use anywhere. We will not give them as gifts or sell them at the flea market in Rome. We will keep them as a reminder of why we left. Mama gathers what remains of Grandfather's sketches and a roll of his Babi Yar paintings that Grandma left behind. We won't leave anything here. Leningrad's Ministry of Culture gives their permission, no questions asked. We do not wait until the end of my school year.

On the day of our departure, Yuri comes with a car to take us to the airport.

"What will I do without you?" Mama asks him.

"You are with your daughter."

And you with your son, I think, and look away. We walk behind the bulletproof glass. Customs agents lazily paw

through our luggage. One of them sneers, "You won't find your place there, you'll be begging to return."

"Son of a bitch," Mama says when we clear customs.

"We will be fine. We'll have a good life, Mama."

We board our airplane. The engines fire up. The airplane starts moving, gains speed, and lifts off. Out the window, Leningrad retreats, gets smaller and smaller, and finally turns into a toy.

As a small child, I watched airplanes flying overhead, with my grandmother holding her hand to my forehead like a visor to shield my eyes from the sun. The flying dragons, the wonder of her childhood and mine. On a clear day, an airplane leaves behind a white trail, thin as an arrow. The trail foams and widens, first becoming a ladder, then a stairway in the sky.

Memory

And again, the black of the waves
splashes along the Neva,
the air, choked with smoke and soot,
the bulkheads' poisonous red,

Those cold winter mornings, the funnels
giving off their ominous steam,
and the powerful vaults of iron
towering over me.

The endlessness of the ladders,
the keening cry of the wind,
and infinite gray padded *vatniki*
marching, as if into battle.

In March—the sad slush and the weight
of uncertain unease, and one's feet
without even a shudder, sink into the earth,
as into the flesh of the heart.

Summer on tankers is sultry, southern—
the wearying rays of the sun,
the crushingly stifling bulkheads,
the rumble you'll never outshout.

That day—spots of red—wounds,
the farewell nods of the cranes,
and the sense that my dear ragged jacket
will end up in a warehouse "archived" . . .

Like a drop of ink in a downpour,
these memories blur and dissolve,
but the smoky factory funnel
still reaches up—a black hand.

—Galia Lembersky, Leningrad, Russia, 1967

Acknowledgments

LUCY FLINT, MY FRIEND and editor extraordinaire, saw this manuscript through from its earliest drafts and numerous revisions to the final typeset pages. Lucy, your exquisite language, certainty of the importance of this memoir, and unflagging patience with absent articles are the force that carried me forward. Writing is stepping into the unknown, and doing so in a non-native language is double jeopardy. With you, I can take this risk.

Joseph Polak, you found the perfect words, affirming the immeasurable value of writing and memory. Your courageous memoir inspired my own. After I completed my manuscript, your thoughtful comments prompted me to look deeper. Reizel Polak's beautiful poems and prayers brought peace in challenging times. Our conversations continue to broaden my world.

Barbara Rodriguez's remarks and thorough, methodical analysis, shared gently, came at a perfect juncture in my writing, helping bring order to the unruly tracks of memory.

I am indebted to Karen Boss for rigorous edits of an early stage of the manuscript and the unexpected praise that came at a time of doubt. To Kevin Stevens for the candid feedback that guided my later revisions.

I am grateful for Roz and Mark Kinzer, who anchored my family's first years in Ann Arbor. As I write, I always imagine you reading this story.

Thank you, Jessy Kaner, for your hospitality at your London home and years of advocacy for Soviet dissidents; I am grateful that you were one of our earliest readers. Many

thanks to ChaeRan Freeze, Sylvia Fuks Fried, and Ori Soltes for your comments and more.

Alison Hilton, thank you for your constancy, perfectionism, and clear-eyed advice on the final draft of this manuscript. I am grateful for the gift of your late-night responses to my urgent emails, and for the cicadas—the mystics of the wild—that animated our silent work.

Heartfelt thanks to Boris Dralyuk for the translations of Galina's poems. To Whitney Scharer for the beautiful book cover. To Grace Peirce for the graphic design. To Amaryah Orenstein for bridging literature and business. To Alessandra Anzani for giving a home to this memoir at Academic Studies Press. Thank you, time and again, to Matthew Charlton for guiding it through the intricacies of the publishing process.

I am grateful to Andy Richard and Tzviyah Rosenstock for years of friendship and laughter. To Howard G. Stern, for Schumann's Nocturnes and the riveting beauty of your religious service.

My children gave me the reason to retrace my past. Vitaliy, you inspire me to look toward the future. And my mother, the most remarkable, charming, stoic, creative . . . Okay, you don't like all this praise—very well, I will not write about you.

Y.L.

Glossary

Babi Yar (Women's Ravine): site of Nazi massacres on the outskirts of Kiev, Ukraine, during World War II

Barclay de Tolly: Minister of War for the Russian Empire at the time of Napoleon's invasion in 1812

bekitzer: in Yiddish, "quickly"

Berdichev: city in Western Ukraine where Felix Lembersky was raised

Bózhe moi: "My God"

Gorky: city name between 1932 and 1990 of the current Nizhny Novgorod in Central Russia, one thousand kilometers from Leningrad. During the Soviet period, the city was closed to foreign visitors to safeguard Soviet military research and production. It became a place of exile for Soviet dissidents, including Andrey Sakharov. The city was renamed by Stalin to honor the Russian author Maxim Gorky, a founder of Socialist Realism. *Gorky* means "bitter" in Russian

Ispolkom (Ispolnitelniy Kommitet): district executive committee, a governmental group that oversaw state, economic, and cultural affairs. It supervised the implementation of programs designed by higher-ranking state agencies, was responsible for community development and planning, developed proposals for local budgets and presented them for approval by the Soviet deputy. The Ispolkom included regional, city, and district branches

Kaif: in Soviet slang, "pleasure." The word may have come from Arabic, where it also means "cannabis crystals"

Kazeniy dom: state facility that includes a jail, courthouse, state hospital, and related functions

KGB (Komitet Gosudarstvennoy Bezopasnosti): Committee for State Security, the main security agency for the Soviet Union from March 13, 1954, until December 3, 1991

Khímiya: chemical plants where prisoners were forced to work during the Stalin administration, whose name became an informal term meaning exile with compulsory labor

Kiev: capital of Ukraine and site of the notorious Babi Yar massacre

Khrushcheba (pl. *khurshchebi*) or *khurshchévka*: five-story apartment buildings cheaply constructed during the Khrushchev administration in the 1960s

Kommunálka: shared apartment

Krestí, aka Kresty Prison: prison in central Leningrad, now Investigative Isolator No. 1 of the Administration of the Federal Service for the Execution of Punishments for the city of Saint Petersburg. The name Krestí (Crosses) is taken from the shape of its two intersecting buildings, completed in 1890. During the Soviet period, Krestí was used mostly for pretrial detention. It was greatly overcrowded—a cell designed for six inmates would often hold more than twenty. While its primary function was to house common criminals, many Soviet dissidents were held there. In 1983 its conditions were deemed too poor for the incarceration of women and minors

Kutuzov, Mikhail (1745–1813): Field Marshal for the Russian Empire, and Commander-in-Chief succeeding Barclay de Tolly during the Napoleonic war

Leningrad: city name between 1924 and 1991; known as Petrograd from 1914 to 1924 and Saint Petersburg from 1703 to 1914 and again from 1991 to the present

Mishúgeneh: in Yiddish, "crazy person"

Mnogo-etázhka: multistory building

NKVD (Narodniy Komissariat Vnutrennikh Del): People's Commissariat for Internal Affair), the interior ministry of the Soviet Union, a precursor of the KGB and the MVD (Ministry of Internal Affairs)

Novostróiki: new building or new development

OBKhSS: state law-enforcement agency for combating economic crimes, under the authority of MVD. Formed in 1937 and dissolved in 1992

OVIR (Otdel Viz I Registratsiy): Department of Visas and Registration, an agency under the MVD, the Soviet police who registered foreign visitors to the Soviet Union and issued permissions and processed documents for Soviet citizens to go abroad

Papirosi: unfiltered cigarettes

Paradnaya: formal foyer

Pyatyórochka: five-ruble bill

RSFSR (Russian Soviet Federative Socialist Republic): largest and most populous of the fifteen Soviet socialist republics of the Soviet Union (USSR) from 1922 to 1990

Rusaya (fem. form of *rusiy*): light brown

Shmóni: "prison searches" in Russian criminal slang. The word *shmon* may come from the Hebrew *shmone* (eight), since in the Soviet gulags body searches were conducted at eight o'clock each morning

Sáblino Penal Labor Camp for Women: labor camp in the village of Sáblino, forty kilometers from the center of Leningrad

Sladkoéshki: "sweet-tooth darlings"

Vatnik (plur. *vatniki*): cotton-padded coat worn outside for manual work

Zóna (zone): in Russian colloquial speech, a penal labor camp. Also known as *koloniaya*

Credits

Page iii: Felix Lembersky, *Stairway* (Nizhny Tagil), gouache on paper, 1958

Page 1: Vladimir Mayakovsky, "Conversation with Comrade Lenin," 1929, https://www.marxists.org/

Page 58: State Anthem of the Soviet Union, 1977 version, lyrics by S. Mikhalkov and El-Registanc, translator unknown, https://www.marxists.org/history/ussr/sounds/lyrics/anthem.htm

Page 99: Felix Lembersky, untitled drawing (Nizhny Tagil), ink on paper, 1958

Page 159: Galina Lembersky, "Poem to Mother," 1981-82, translated by Boris Dralyuk, 2019

Page 186: Galina Lembersky, "My Little Girl," 1982, translated by Boris Dralyuk, 2019

Page 197: Felix Lembersky, untitled drawing (Nizhny Tagil), ink on paper, 1958

Page 249: Felix Lembersky, untitled drawing (Pskov), ink on paper, ca. 1956-58

Page [251]: Galina Lembersky, "Memory," 1967, translated by Boris Dralyuk, 2019

CPSIA information can be obtained
at www.ICGtesting.com
Printed in the USA
LVHW112302141022
730677LV00001B/1